Conception and design
Editorial staff, Casterman, Tournai, Belgium
Reader
François de Peyret
Design assistant
Marie Vanesse
Drawings
Stéphane Olivier
Jacket design
Alain Rivière
Styling
George Dolese
Acknowledgments
Véronique de Mareuil
and Pierre de Gastines
for Philippe Deshoulières;
Au Bain-Marie, Paris;
The Conran Shop, Paris;
Didier Lestrade;
Maison Minier, poultry.

Photographic credits
Alain Rivière: 8, 13, 15, 16, 18, 20 (above left, center left, below left), 21 (center
right, below right, above left, center left, below left), 24, 26, 28 (above and
below), 30, 31, 32, 34, 40, 41, 45, 46, 52, 57, 76, 78 (above and below), 79, 82
(below), 84, 85, 86, 92, 94, 97, 98, 99, 110, 114, 115, 128, 133, 134, 135, 136, 137,
138, 139. Christian Sarramon: 6, 10, 11, 14, 17, 19 (above and below), 20 (above
right, center right, below right), 21 (above right), 22, 25, 29, 36-37, 39, 42, 44
(above and below), 48-49, 50, 53, 54, 55, 60, 64, 65, 66, 67, 68, 70, 71 (above and
below), 72, 73, 74, 77, 80, 82 (above), 83, 87 (above, below left, below right), 89,
90, 91, 95 (left and right), 100, 101, 102, 103, 104, 105, 107, 108, 111, 116, 119
(above and below), 120, 122, 123, 124, 125 (above left, above right, below), 126,
127, 130, 131, 132, jacket back. Jean-Michel Labat: 58, 63, 113, 118. Jacques-
Louis Delpal: 27.

Copyright © 1994 Casterman, Tournai, Belgium
English translation copyright © The Vendome Press

Published in the USA in 1995 by
The Vendome Press
1370 Avenue of the Americas
New York, NY 10019
Distributed in the USA and Canada by
Rizzoli International Publications
through St. Martin's Press
175 Fifth Avenue
New York, NY 10010

Library of Congress Cataloging-in-Publication Data
Delpal, Jacques Louis.
Gourmet Guide to Paris / by Jacques-Louis Delpal;
photography by Alain Rivière and Christian Sarramon.
p. cm.
ISBN 0-86565-959-1 (hard cover)
1. Restaurants — France — Paris — Directories. 2. Paris (France) —
Directories. I. Title.
TX907.5.F82P373 1995
647.95443'61 — dc20 95-15364
CIP
Printed and bound in Spain

Gourmet Guide to
PARIS

Jacques-Louis Delpal
Photography by Alain Rivière & Christian Sarramon

THE VENDOME PRESS

Menu

À la carte

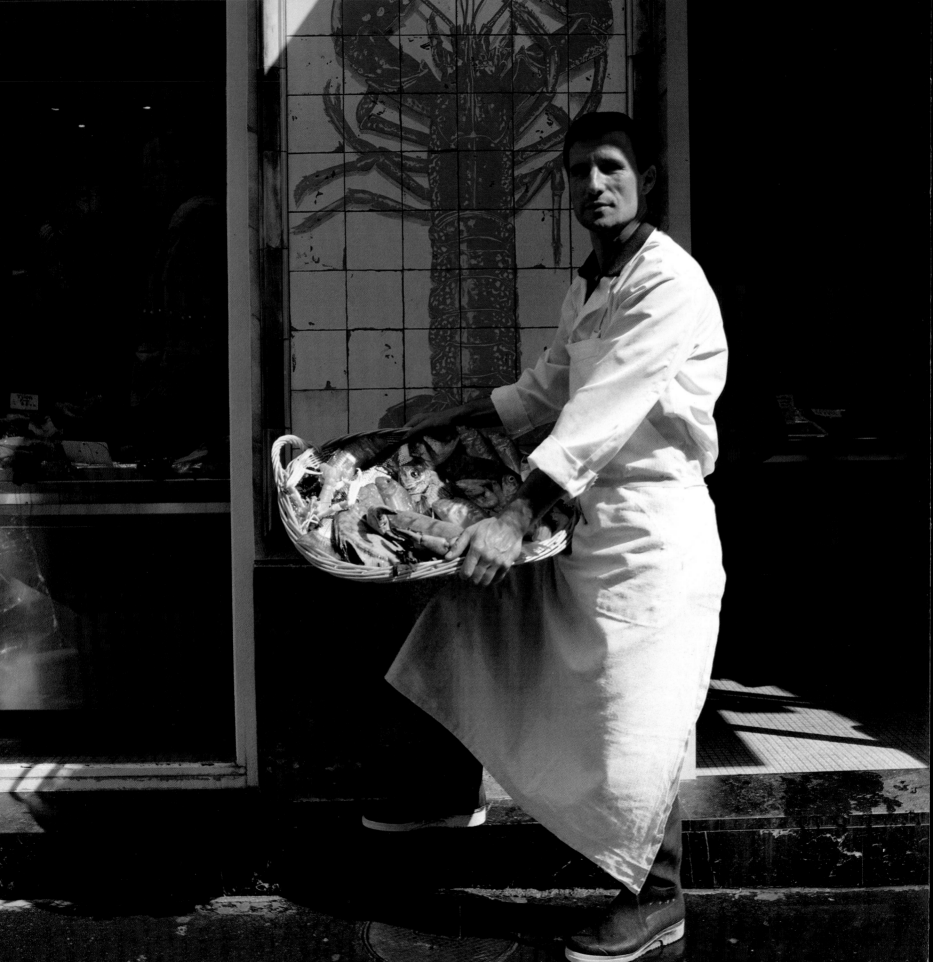

P*aris has no land for cultivation, but it can claim the whole of France as its market garden.*

Paris gathers in flavors from the provinces and the whole world, mingles tastes, refines, crosses, and composes culinary music in both major and minor keys, integrating popular repertoires with the grand scores of high gastronomy. Paris offers everything in its market stalls and on its tables — the best and the worst. It launches new dietary fashions and adapts those introduced elsewhere. Paris, which has no cuisine of its own, never ceases to invent and reinvent cuisine.

Elsewhere in France, regional foodstuffs have given, and still give, a certain tone to the dishes of even the most imaginative chefs as well as to those of home cooking. In the capital, with its throngs of tourists and its population of 2,200,000 at the center of a vast urban complex spread over the Île de France, the culinary repertoire responds to the needs and means of an enormous clientele, not to local changes in what a land planted with concrete no longer provides. Good chefs frequently work "close to the produce," but they never employ it "à la mode de chez nous," meaning the region around Paris, and the produce never evokes the Île de France. Other than food critics and a few of their readers, who cares where the Dutournier flat beans come from, or the Robuchon veal, the Faugeron beef, the Michel Rostang or Guy

The open-air fish market attached to Le Dôme, Montparnasse's famous brasserie, is one of the best in Paris. Located in the Rue Delembre, it is also one of the very few such markets that still make deliveries to private kitchens. The manager, Jean-Pierre Lopez, prides himself on stocking only the best and freshest of fish, whether from oceans or lakes, temperate seas or more exotic waters. The produce is expensive but often exceptional in quality.

Savoy chickens? These excellent materials all reflect the qualities of specific parts of France and the people who bring them to market, but they are also as "Parisian" as the chefs in charge of the kitchens, who may be from places as diverse as the Landes near Bordeaux, Poitou, Corrèze, or Dauphiné. Paris – the magnetic hub of highways, railways, and airlines – draws sustenance from the whole country, appropriating great and modest chefs alike, and reaping the benefits from the endless flow of international traffic.

The wholesalers of Rungis, the giant market on the outskirts of Paris, bring in produce from the gardeners, hunters, and fishermen of deepest France and beyond its frontiers, including seas near and far. If there are no Parisian spécialités – apart from the hard-boiled egg on the bistro counter or the ineffable bifteck-frites, both now somewhat eclipsed by the plastic-wrapped and quick-frozen fare of fast-food restaurants – the cuisine of the great Parisian chefs, many of them with provincial roots, have frequently put the la before gastronomie in Western cookery. This occurred most notably during the Restoration (1815-30), the frivolous decline of the Second Empire (the eighteen-sixties), and the early days of nouvelle cuisine (the late nineteen-sixties), when Guérard and Senderens were sharing their discoveries and Jacques Manière began steaming everything. (Parisian chefs matched their provincial colleagues during the post-1968 renaissance, when Paul Bocuse, the Troisgros brothers and Alain Chapel were proving themselves formidable innovators within the context of traditional practice.)

A stroll from the halle couverte, or big covered food hall, to the small chic boutique, from the grand restaurant to the corner café, and from the market street to the market square encourages eating, while also enabling one to devour the city visually. The joy of gastronomic and tourist guidebooks, the new world of food offers a hundred different, rewarding rambles through gourmand Paris, some of them mindful of limited funds, while others are frankly élitist (a polite way of indicating their elevated prices). Here, in Gourmet Guide to Paris, we have chosen ten flâneries or promenades – their number limited only by the pages available – designed to stimulate the appetite, mainly for the cuisine of restaurants that are distinctly Franco-French and "très parisien."

Other books may lead the curious to stroll through the Chinatowns of the 18th arrondissement and Belleville, the streets where kosher cookery reigns, the neighborhood around the Bastille, and the huge markets, such as Rungis, on the exterior boulevards.

On 20 December 1927, La Coupole first opened its doors to the kind of cosmopolitan crowd that has loyally patronized the huge brasserie ever since. The creation of Ernest Fraux and René Lafon, brothers-in-law, one from the Aveyron and the other from an Auvergnat family, La Coupole became a virtual home from home for le Tout-Montparnasse as well as le Tout-Paris. Among those frequenting the restaurant, the bar, and the terrace café were the writers Cocteau, Aragon, and Cendrars, together with the artists Foujita, Kisling, Vlaminck and, much later, Yves Klein. Sixty years after its opening, La Coupole, which had long since become a leading symbol of Paris, underwent a general overhaul that left the great house reorganized and its famous décor respectfully restored. The instigator of this process was the Alsatian Jean-Paul Bucher, financed by the enormous success of his Flo group during the last quarter-century. While preserving its own special mystique, La Coupole now belongs to a group that includes the Brasserie Flo, the Terminus Nord, Julien, Le Vaudeville, Le Boeuf sur le Toit, and the brasserie as well as the café within the Printemps department store.

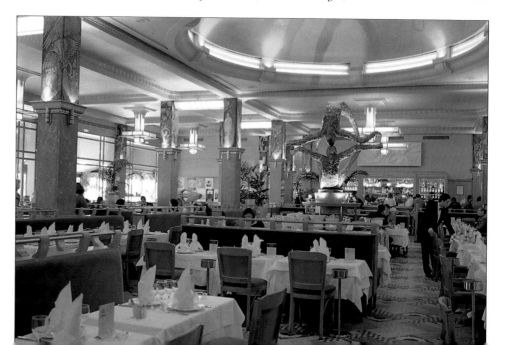

We could then ask Jean-Paul Bucher to take us from Flo to the Boeuf sur le Toit, looking for new dishes or the various kinds of couscous, the latter now as Parisian as choucroute or cassoulet, peasant dishes appropriated and cosmopolitanized a century ago.

Ought we to prepare a menu of our omissions? The epicurean reader, or anyone with a good ear, would know that a city capable of inventing the word "restaurant," which after all means "restoring," a continuous, ongoing process, could never be contained within a single illustrated volume. De haut niveau, pratiques, sympathiques, banals, accueillants, exécrables, qualité/prix (the latter particularly apt at times of economic "crisis") – restaurants of all these familiar types have flourished everywhere in the capital for the last two centuries, most of the best ones situated in the neighborhoods along the western end of the Right Bank. Barometers of evolving tastes and habits, they bear witness to a rich history steeped in a psycho-sociological brew of culture, economics, agronomy, and culinary technology.

In Paris, restaurants form part of the overall décor, in the same way as the covered and open-air markets in five thousand different locations, businesses still close-packed in some streets but sadly absent from quarters dehumanized by the spread of office buildings and banks with their blind façades. Restaurants in the grand manner or simply grub houses, bistros and fast-food outlets, brasseries, little neighborhood restos, fashionable cantines, Chinese or Italian cafés, not-so-Italian pizzerias, crêperies (Breton pancake shops), rôtisseries, tearooms, snack-bars, pubs, ambassades or "embassies" (moderately priced restaurants or brasseries specializing in the cuisine of a specific province of France), grand-hotel restaurants, gargotes (greasy spoons), cafés-restaurants – all together the eating venues of Paris provide the discriminating diner, the finicky nibbler, the curious, the snob, and the simply hungry with an embarrassment of choices. They also offer ample opportunity to deplore or to enjoy the encroaching internationalism, which we welcome even though it may have a leveling effect on standards of quality, as in New York or Tokyo, where French chefs have extended their influence.

Visits to market stalls, with stops at boutiques, depend upon one's gastronomic sophistication, cultural interests, openness of mind, visual acuity, and bank account. Even if eating well requires less than the wealth of Croesus, one still needs an income several times greater than the minimum wage in order to dine in a three-star restaurant and appreciate how its cuisine became what it is. Initiation into this exclusive world can be less ruinous

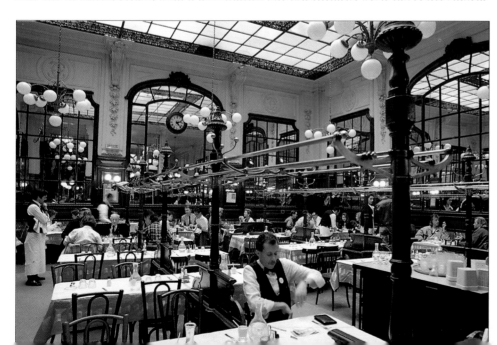

Montmartre's Bouillon Chartier has been in business since 1898, with its original décor still miraculously intact and its prices still remarkably low. Flooded with cool light from a vast skylight and surrounded by a frieze of metal fretwork, the dining room retains its *fin-de-siècle* atmosphere from a century ago. In continuous use even today are the coat racks suspended between columns and the famous little numbered compartments for storing the napkins of regular customers. This oldest yet still extremely busy part of the Chartier group exudes the spirit and poetry of another age.

Butchers figured large in the economic and political history of medieval Paris, when they clustered around what became Les Halles on the Right Bank and Place Maubert on the Left Bank. The Tour Saint-Jacques bears witness to the mysterious allure of the meat man's calling, for it served as the bell tower of the Saint-Jacques-la-Boucherie church. Today the profession is diversified, to the point where there are even butchers on the staff of restaurants. To regular diners at Baumann-Marbeuf, Albert Faucheux is a familiar presence, known for the steady hand with which he carves up sides of Bazas and Angus beef before allowing the meat to age for two or three weeks in his enormous refrigerator.

1 2

in the provinces, where some of the grands remain affordable. Several of the restaurants featured in this book are undeniably expensive, even very expensive and well beyond the means of the average French citizen. But too expensive? Businessmen, like art dealers, theater producers, newspaper and book publishers, and those they report to, do not claim to patronize restaurants for the mere love of it.

Certain restaurateurs could easily have put more on the plates and less in their own pockets, especially during good years. Nevertheless, a cuistot – whose work is both hard and long – has the right to be just as financially rewarded as his clients with expense accounts. Moreover, the best chefs use costly materials, undertake a great deal of hand work, and occupy many meters of high-rent space. A mediocre performance cleverly tricked out or well placed involves more than a pure talent for making flavors explode. A young and gifted chef, with his wife in charge of the dining room, can excite Paris for years while holding his prices at a reasonable level, but to do so he must sleep standing up and work like a zombie, give up all private life, and make do with premises that his clientele will find depressing the minute prices begin to quiver upward. Chances are that this cuistot will end very badly!

Restaurants have been proliferating in Paris for centuries. Before that, in Paris as elsewhere in the world, there were only inns feeding their lodgers, or taverns where the jug counted for more than the plate, or traiteurs offering meals under limited conditions. Choosing among diverse menus was out of the question, not to mention ordering à la carte! The end of the Ancien Régime coincided with the arrival, in Paris, of a new alimentary régime – la gastronomie. All the rage among the privileged classes, it began with the princely residences and in the hôtels or mansions of the upper bourgeoisie and then spread, once the Revolution had deprived the chefs of their employers. The cooks and their staffs moved out of service to the aristocracy and entered that of the public, at a time when the paralyzing system of the medieval guilds was collapsing.

In this, London, it should be admitted, had led the way, with its famous, well-managed, and heavily patronized taverns. When Beauvilliers opened his first establishment, well before the storming of the Bastille, he named it "Grande Taverne de Londres." However, it was in Paris – where gastronomy was to develop into a literary art – that one Boulanger, a bouillon merchant and the king of sheeps' trotters in white sauce, introduced the term "restaurant."

The word designated dishes that restored. It became the "sign" for maisons conviviales – places where people gathered to eat and drink – which became increasingly well-managed, much to the chagrin of the traiteurs, who lost their exclusive right to serve ragoûts but still tried to enforce their monopoly. In fact, the Parlement of Paris simply decided that sheeps' trotters and other dishes were not ragoûts, following which the Revolution suppressed all guild privileges. Lamy, Beauvilliers, Robert, and Les Frères Provençaux achieved success before the fall of the Bastille. Méot and Le Boeuf à la Mode made a fortune while the heads rolled.

In 1806, Grimod de La Reynière singled out twenty-six establishments in his Almanach des gourmands. Today Paris harbors more than a hundred restaurants with Michelin stars, among them a good ten with the maximum number. And there are as many starless dining places of special note, some for their hospitality, others for their unusualness, a whole series of extraordinarily diverse, sympathiques establishments, and a galaxy of cafés-restaurants behind their neon signs. Not every promenade is gourmand, but the gourmet savors Paris à la carte and therein discovers his bliss.

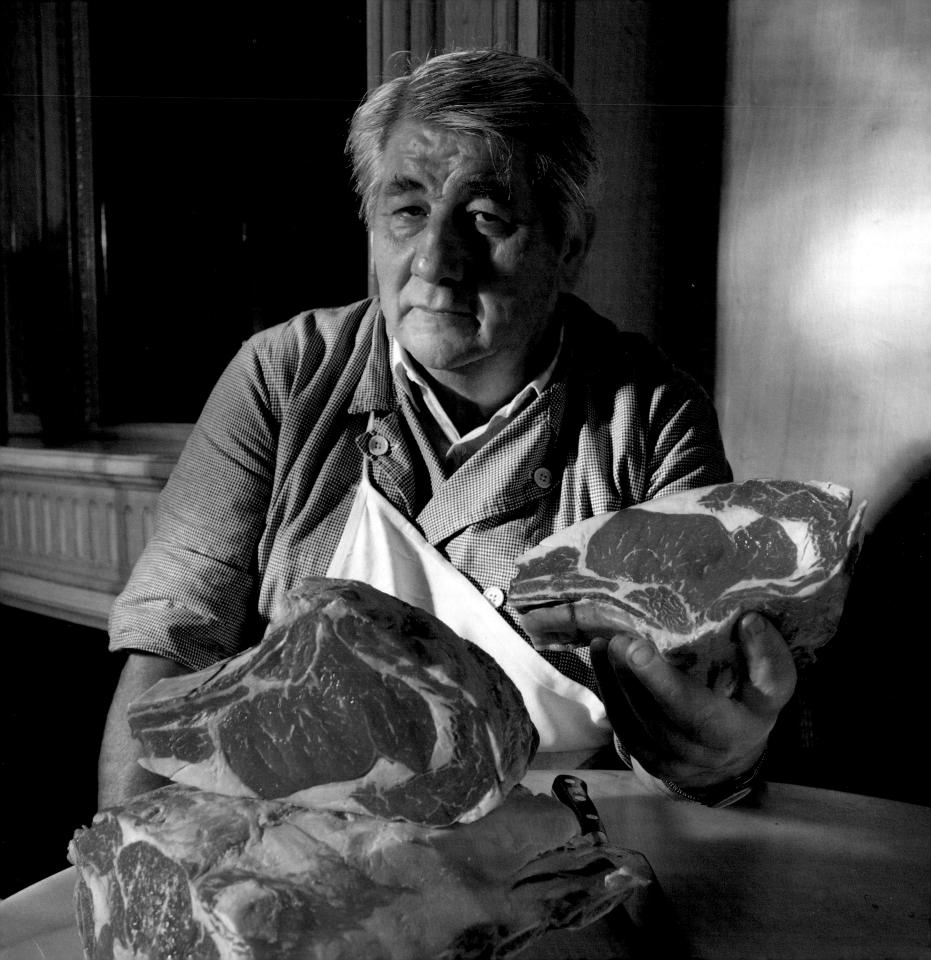

1 4

Philippe Serbource, a very Parisian Bourguignon and a
chef without frontiers, serves one of the best *cassoulets* in
Paris at the Auberge Pyrénées-Cévennes in the old
working-class Faubourg Saint-Antoine quarter north-east
of the Place de la Bastille. He is also, however, the local
king of *paella*, as well as a generous dispenser of
mussels. Whatever the dish, his customers can count on
plates heaped with delicious food.

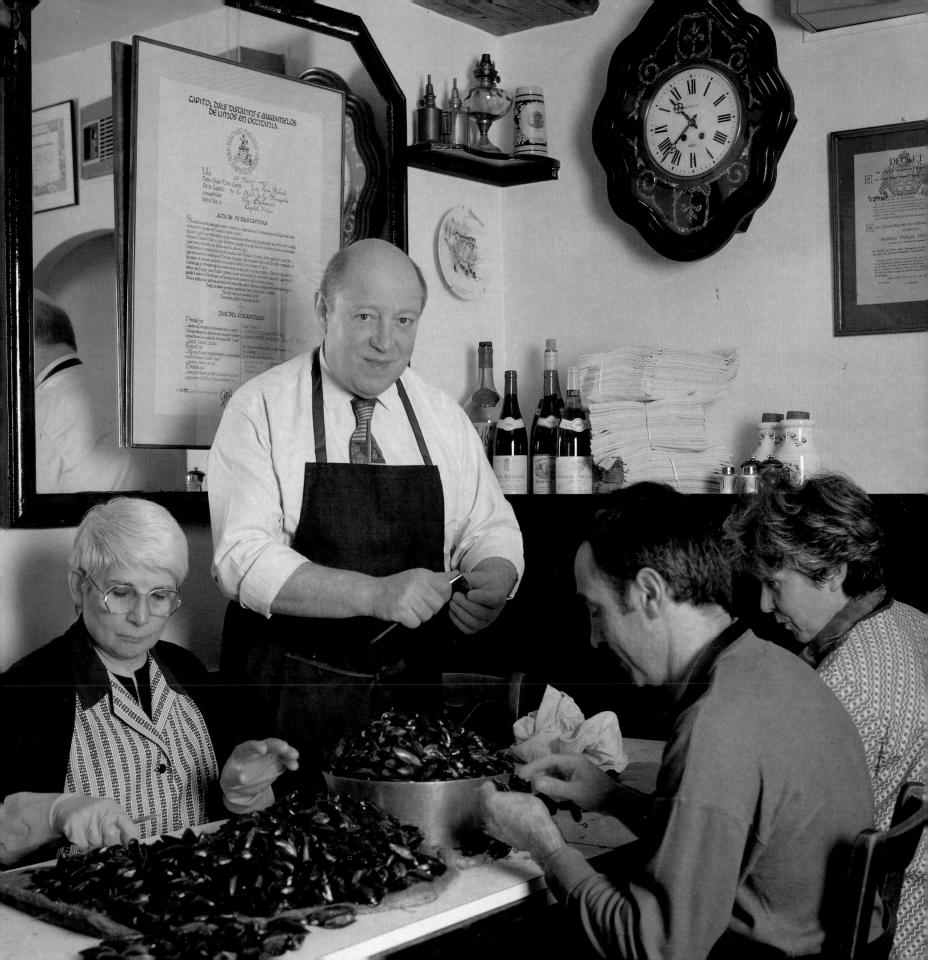

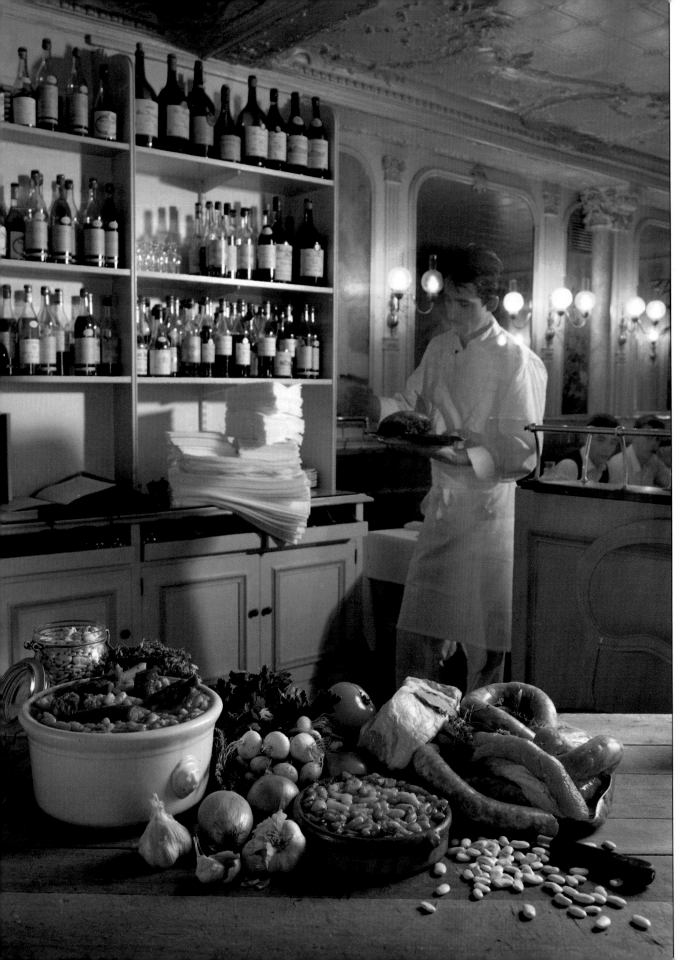

The many flavors of Gascony, along with specially invented dishes, can be had at 40 Rue Taine, a mere few steps from Place Daumesnil (Félix-Éboué) in the Bercy neighborhood. Here, in a well-ordered bistro, Alain Dutournier, together with his wife Nicole, began building his Parisian reputation in the early nineteen-seventies, long before he created the far more ambitious Carré des Feuillants in the Rue de Castiglione. More than twenty years later, the modernized but charmingly old-fashioned Trou Gascon continues to combine tradition and innovation reassuringly free of preciousness and pretense, thanks to the steady guidance of Nicole Dutournier.

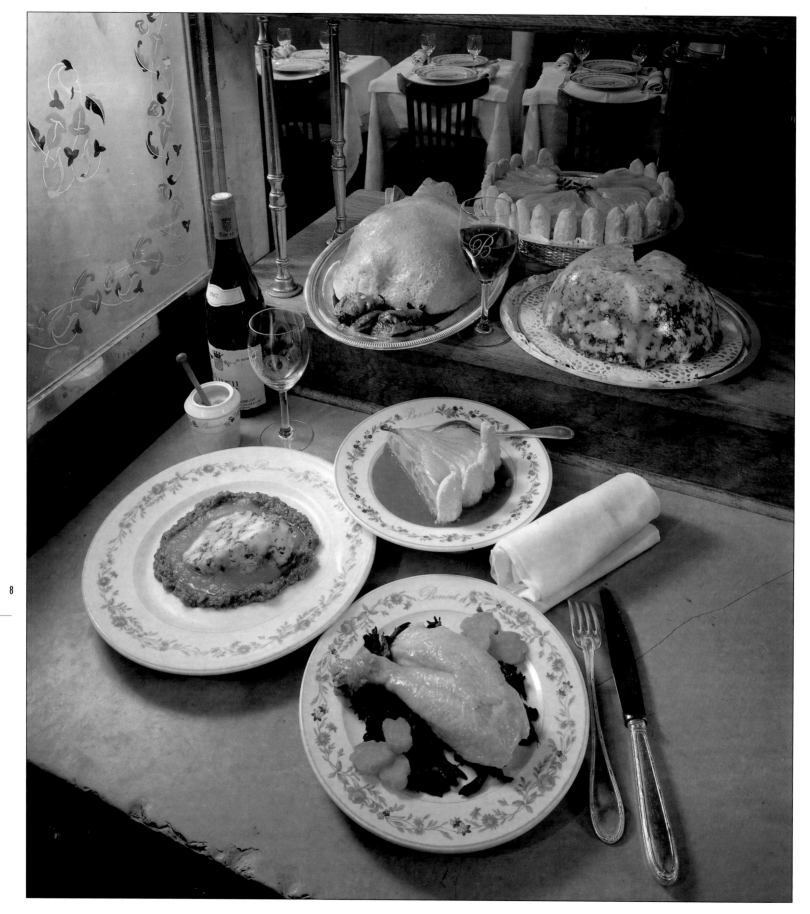

The name of this bistro, Au Petit Riche, was chosen in ironic acknowledgment of its proximity to Le Café Riche, one of the most celebrated *grands restaurants* of the mid nineteenth century, closing only in 1916. Located at the corner of Rue Le Pelletier and Rue Rossini, Au Petit Riche retains its pretty eighteen-eighties décor, complete with fruit and vegetable friezes, *trompe-l'oeil* flowers, huge windows, and panels of etched glass. By keeping late hours, the bistro attracts an after-theater clientele from the *grands boulevards*, rewarding its diners with a fine *cuisine bourgeoise* that remains characterful despite the bistro's being part of the SHB group, a major presence around Lyons and in Burgundy. This hotel and restaurant chain was established about twenty years ago by Christian Lameloise, the brother of Jacques, chef at the three-star Lameloise in Burgundy.

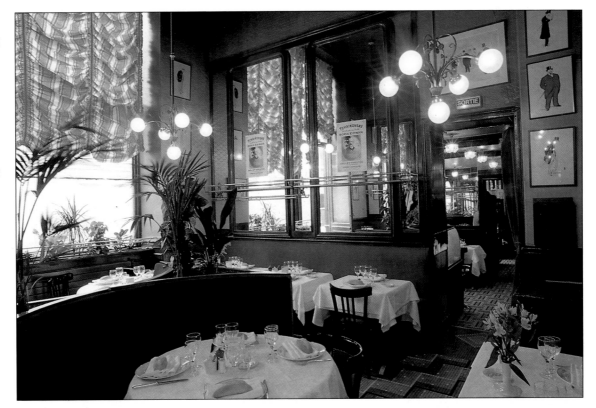

Le Bistro du Sommelier belongs, unsurprisingly, to Philippe Faure-Brac who was voted the best *sommelier* in France in 1987-88 and the best in the world in 1992. Needless to say, he urges his chef to cook with wine. In serving his customers, moreover, he considers that each well-prepared dish has its wine, just as each wine has its dish, often in highly original combinations. Gradually, the world's best *sommelier* leads his customers across the vineyards of France by way of his cellar, which is outstanding. A small, relaxed house on the busy Boulevard Haussmann, Le Bistro du Sommelier exists for those who like the best possible relationship between the glass and the plate.

Michel Petit's pleasant, friendly restaurant in the Rue Saint-Martin is a true bistro only in the Parisian sense of the term. This means a steady supply of robust fare for those with good appetites, a long-famous *compotier de boeuf à la parisienne*, and serious desserts. The house's excellent Beaujolais help soften the impact of the *addition*, which does not altogether resemble that of the traditional bistro.

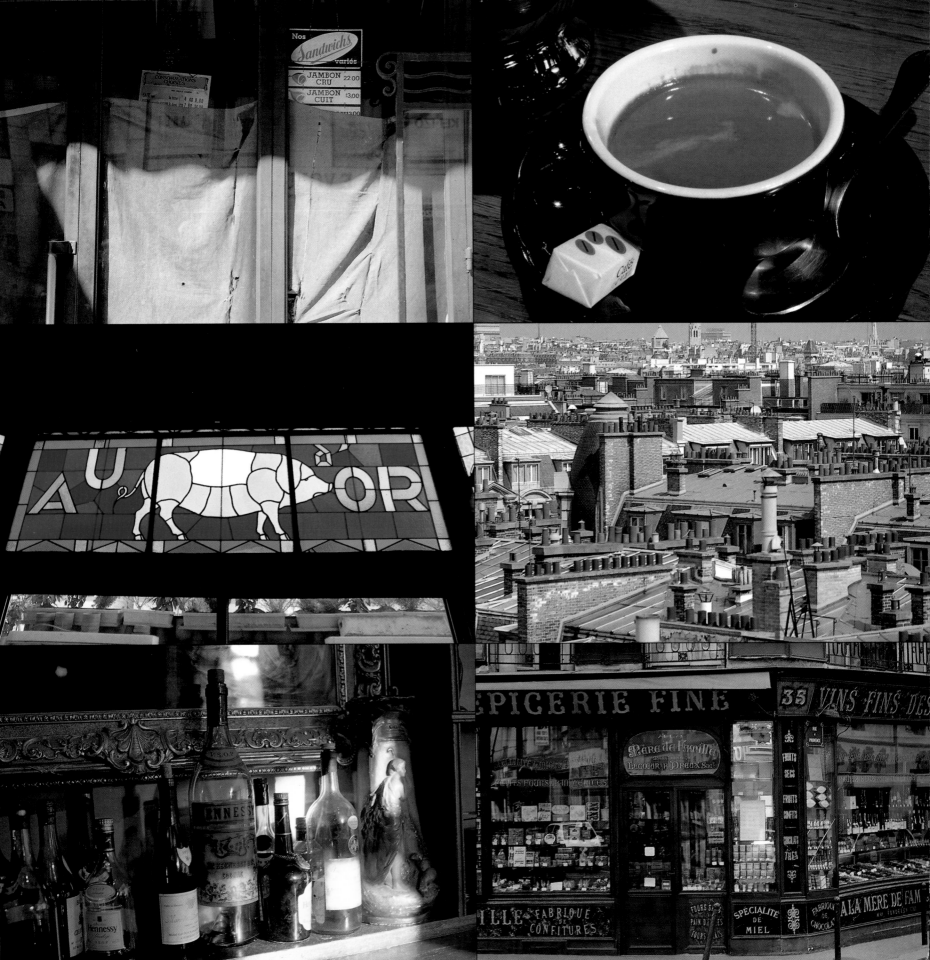

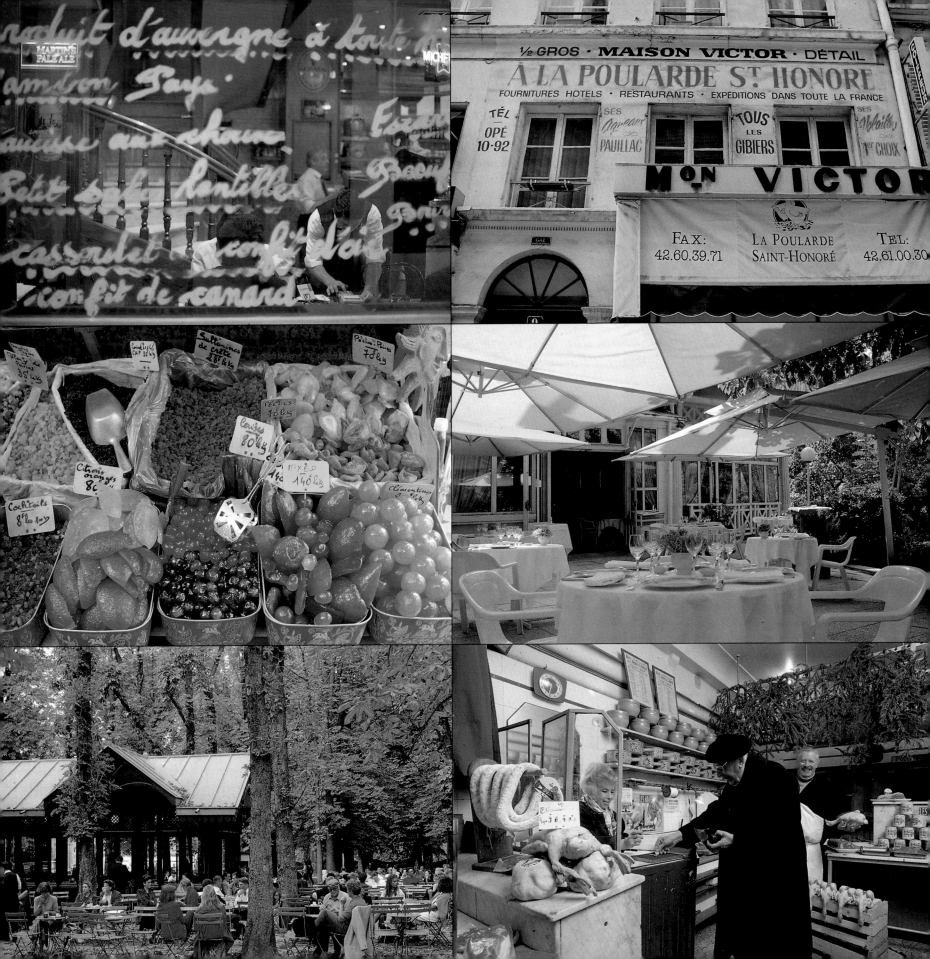

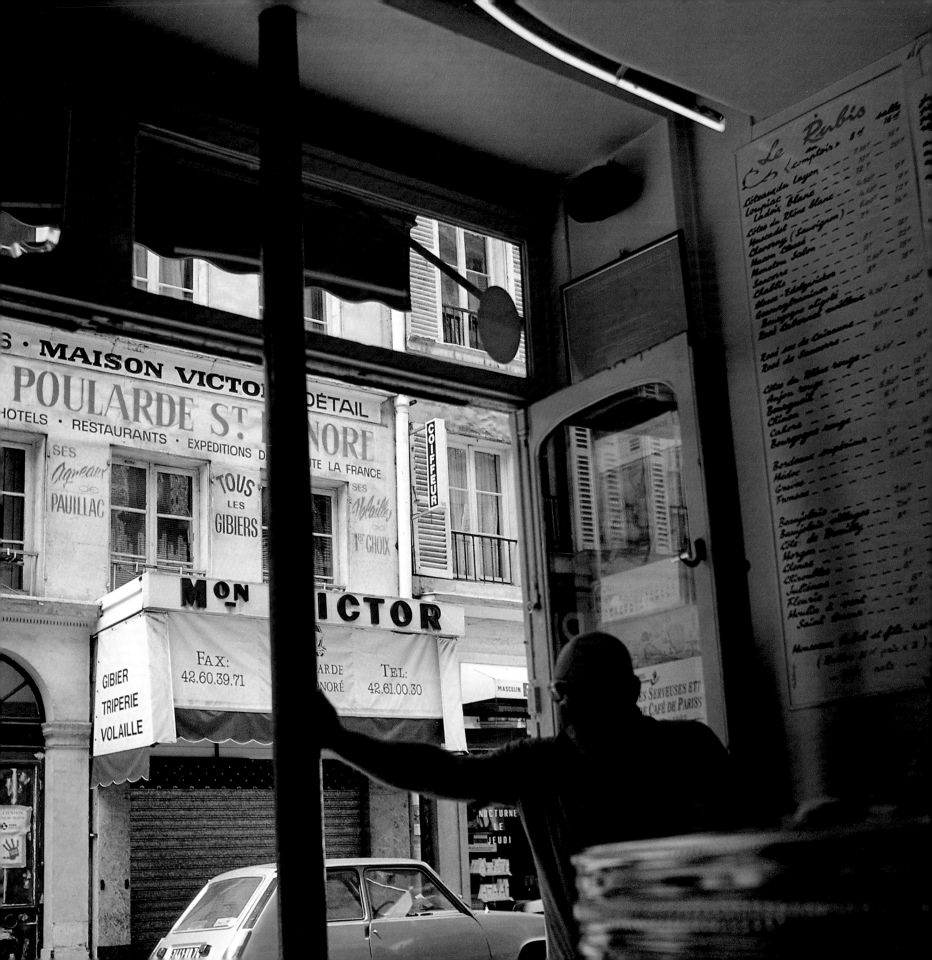

Throughout 1872, Émile Zola haunted Les Halles, those immense iron and glass sheds built in 1854-66 to house the central food markets of Paris and immediately seen as the symbols of a triumphant modernity. Climbing over the broad, tent-like roofs, exploring deep into the basement *triperies*, and generally taking stock of the whole vast area, Zola displayed all the avidity of the practiced gourmand, as he compiled his notes for *Le Ventre de Paris*, the huge novel the Realist master set in the heart of Old Paris. The action begins in 1858 before the architect Victor Baltard had completed the new machine-age pavilions so emblematic of Les Halles. A century after Zola had discovered "the landslide of food that occurs every morning in the middle of Paris," Baltard's great mercantile palaces were pulled down to make room for the *trou des Halles* – the "Halles hole," punningly translated – which is now filled with a commercial forum still struggling to forge an identity of its own.

Today the real food markets are at Rungis, cold, functional places accessible only by automobile. It would now be hard to imagine the old Halles quarter as it was at the end of the nineteen-sixties, engulfed every night in a massive traffic jam, a bottleneck enormously complicated by the hyperactive presence of newspaper offices clustered in the same neighborhood. *Combat, Paris-*

Le Rubis, an old-fashioned bistro in the Rue du Marché-Saint-Honoré, offers a zinc bar, banquettes covered in imitation leather, good "little" wines, decent pork fare, and a number of good family-style dishes.

Presse, *France-Soir*, *Paris-Jour*, and *Le Parisien libéré* were already "rolling" on thunderous rotary presses when the first delivery trucks came rolling into Les Halles with their cargoes of fresh fish. Meanwhile, other heavy vehicles were pulling away from the pressrooms smelling of fresh ink, just as tons of vegetables were being unloaded for distribution to the market's various wholesale dealers. Today, this preposterous but productive scene has been replaced by its polar opposite: throngs of "cool" adolescents loitering in trellised, fountain-strewn gardens laid out over a cavernous underground hub station and around the new Halles shopping and entertainment center. Its population of underage idlers would be hard pressed to visualize that former world of hardworking men and women in the midst of cacophonous, reeking toil and turmoil, the whole orgiastic spectacle devoted to food – *la grande bouffe* – piled up in staggering heaps of fruits and vegetables, meat and fish, eggs and cheese, herbs and spices. A bewildering but efficacious nocturne of raucous, seething hustle and bustle.

Baltard, responding to a call from Emperor Napoleon III ("umbrellas, only umbrellas . . . iron, nothing but iron"), built his pavilions on a site long reserved for the alimentary trades. As early as the twelfth century there had been "les Champeaux," a market which gradually spread over what was drained marshland. Philippe Auguste (*r.*1180-1223), the King who surrounded Paris with a circuit of defensive walls and paved the city's streets, commissioned buildings to house drapers and weavers, although these were eventually obliged to share their premises with other merchants. The new structures were called *les halles*, or *halla* in Frankish, meaning "covered places."

Passed down through the centuries, the name finally stuck, even though the market has now moved far away, to the colossal facilities of Rungis. Instead of traveling, the name has remained attached to the old quarter, now occupied by the shopping and entertainment center mentioned above, the "Forum des Halles," a much-maligned crater filled with concrete and surrounded by skeletal pavilions with graceful fan vaults of white metal and glass. The upper or ground level includes formal gardens, with greenery, flowers, fountains, and vine-enlaced pergolas.

This new commercial center, albeit "cruelly screwed down into the entrails of Paris" (according to Jack Lang, a former Minister of Culture), offers a thrilling worm's-eye view of the Gothic buttressing around the choir of Saint-Eustache. It also attracts a lively crowd during the day, but then turns dark and falls asleep once the shops have closed. After midnight, this hollowed-out world, where only quick-frozen croissants and fast foods are to be had, bears no resemblance whatever to that of the old Halles, a universe vibrant with revelers, vagabonds, and the merely curious, all mingled together with the workers responsible for the nourishment of Paris.

Le Café Costes proclaims its radical contemporaneity at the very heart of old Paris, a site formerly occupied by one of Paris's oldest markets. Today it lies a few steps from the Fontaine des Innocents and halfway between the banal modernity of the Forum des Halles and the powerful high-tech presence of the Centre Pompidou. The creation of Jean-Louis Costes, an Aveyronnais, the café boasts a décor that must be counted among the great successes of the talented Philippe Stark. Along with the handsome interior, remarkable chairs, and delightful terrace come very good *croque-monsieurs*.

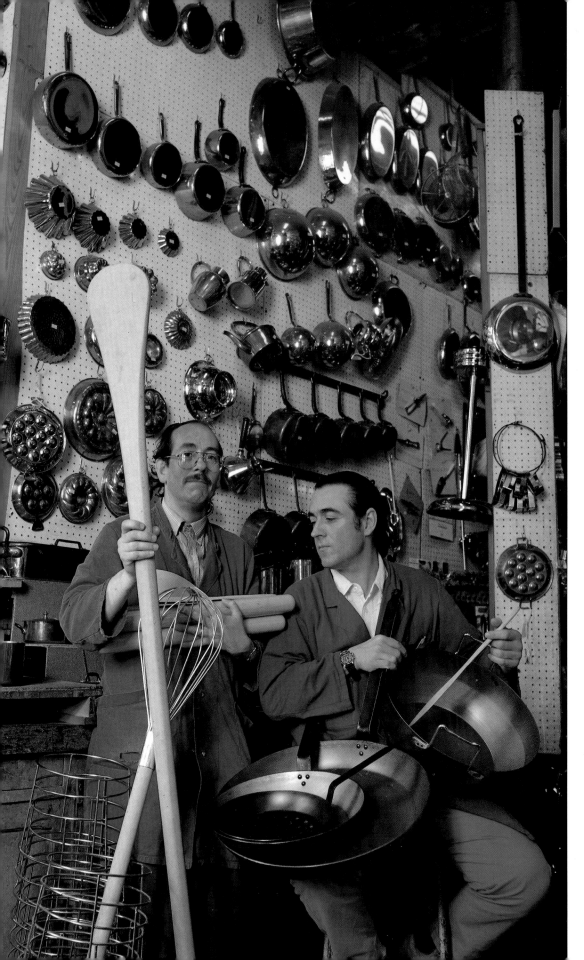

Zola's descriptions are famous. Aragon added to them in *Les Beaux Quartiers*, in which, without exaggeration, he described the life of Les Halles: "It was not possible to proceed at one's own pace, since a way had to be found around the stevedores, the vehicles, and the jumble of produce piled between the darkened bourgeois dwellings, whose lower floors blazed with pot houses and shops with half-lowered blinds. Massive, adroit men with bare arms and powerful muscles seemed to milk the formidable udders of the wet-nurse night. Tons of greenery tumbled on to the glistening pavement. . ."

Le Cochon à l'Oreille, 15 Rue Montmartre, displays a series of large ceramic pictures that provide a visual narrative of life in the old Halles, complete with all its frantic, early-morning activity and the relaxed gossip that followed at dawn. This precious eye-witness account, dating from about 1910, entered the Historic Monuments registry in 1984, which guarantees that it will remain on the wall of the memorial bistro.

At La Petite Couronne, young loafers and other *zonards* have replaced the tramps and good-for-nothing/ready-for-anything sorts who held court here in the days of Les Halles, mainly in the square around the beautiful Fontaine des Innocents, a work primarily by the sixteenth-century sculptor Jean Goujon. In the late eighteenth century, before the outbreak of revolution, the site was taken over by a market – the Marché des Innocents – which replaced an ancient cemetery that had fouled the air for eight hundred years until it was closed and cleared away.

Forty generations of grave-diggers had buried some eight million bodies here. The local living were already up in arms by 1554! Nonetheless, linen sellers, second-hand clothing dealers, and public scribes proved hardy enough to brave the stench and transform the galleried ossuaries into commercial arcades. The arrival of the Marché des Innocents in the same area as the ancient Champeaux market helped turn the poor cemetery into a space for hundreds of people bringing their garden produce to market or shopping for their kitchens.

Such a rich past can hardly be evoked by the neighborhood McDonald's, with its big bay windows and broad terrace opening on to an esplanade cluttered with idlers and musicians. Nor is there much historical resonance in the Café Costes, a typical eighties eatery done up by Philippe Stark at the corner of Rue Berger.

An echo of the old Halles also hovers in the names of the restaurants where *le Tout-Paris* once rubbed shoulders with butchers, muscular handlers, merry women, and perhaps even poets when it came time for everyone to sit down and have a post-midnight supper of onion soup. Ancient as their names may be, these restaurants radiate an atmosphere quite different from that of their old market days; still, they benefit from the overall revival of the neighborhood, which has become a magnet for a multicultural society of Parisians, suburbanites, provincials, and foreigners, of all ages and social conditions.

One of the most celebrated addresses is 6 Rue Coquillière, where Au Pied de Cochon is noisily open to the public around the clock. A hundred employees work in shifts in this willfully nostalgic brasserie (with a completely revamped décor), which has not closed its doors since 1946. The seafood displayed outdoors is of the utmost freshness, and the *andouillettes* (chitterling sausages) and pigs' trotters are served in portions as generous as those offered by the *tripeurs* and *charcutiers* of yesteryear. The "Temptation of Saint Anthony," an all-pork speciality, was not invented for tourists!

Au Pied de Cochon, a vast two-story brasserie with a view of the drum-shaped Bourse de Commerce (Mercantile Exchange), which occupies the site of the old wheat market, had been acquired in the years between the two World Wars by an Alsatian entrepreneur named Blanc, the father of the present owners, Pierre and Jacques Blanc. They reign over an empire, one that is exclusively Parisian, unlike that of Jean-Paul Bucher, the head of the Flo group of restaurants. The Blanc organization includes establishments with quite different atmospheres: L'Alsace on the Champs-Élysées, Le Grand Café Capucines, Chez Clément, recently opened, Le Procope, L'Arbuci, and Charlot "Roi des Coquillages." These are all located in areas which remain alive in the evening or which are revitalized after dark, by the proximity of cinemas and night spots.

Restaurants of every type line the Rue du Louvre and the Boulevard de Sébastopol, the two north/south streets that bracket the rectangular Halles quarter and separate it from the Beaubourg to the east. Rarely very good, although sometimes good, they more often prove to be mediocre with, here and there, a phonily "prole" or "cool," populist or minimalist orientation. They are also not very expensive and not very Parisian, the result of too much effort to be ultra-Parisian.

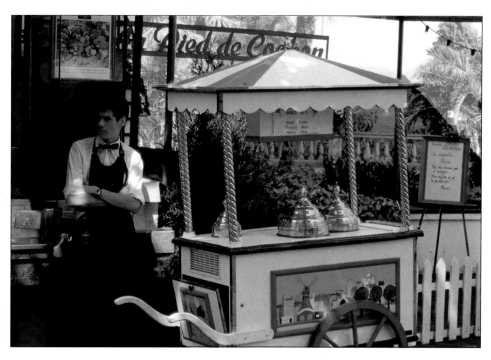

The quarter fairly burgeons with *les étrangers*, meaning "ethnic" restaurants, from the Italian Main à la Pâte, which has now aged a bit, to the Portuguese Saudade, from Vellini to Velloni, and from the Chicago Meatpacker to Joe Allen, whose "Made in the USA" has also aged but without being improved thereby, which merely confirms it as an institution. There are also the myriad low-budget Chinese eateries and the elegant Chez Vong. The Rue Rambuteau, a Parisian outpost of Brussels' Léon, is a *sympa* source for Parisians devoted to *moules frites* (fried mussels), but the atmosphere is less genuinely "ethnic" than that of the original on the Îlot Sacré in the Belgian capital.

For something authentically French, as in the old days, one has only to visit La Tour de Montlhéry, an exemplary establishment with an undefinable décor (which merely adds to the authenticity) and a reputation for hefty portions, *boeuf gros sel*, and china designed by Moretti, for twenty years a regular in the house. In the Rue des Prouvaires there is the equally French Louchebem, a "bistro" with a décor by Slavik, a star retro designer of the eighties, and a commitment to meat, the consequence of its symbiotic relationship with the butcher shop next door.

A few steps away is the Rue de l'Arbre-Sec, a street once dominated by fruit wholesalers. Here Adrienne Biasin hovers like a feisty matron over the two dining-rooms of Chez la Vieille, her super-bistro, today more

Au Pied de Cochon, famous as one of the most popular cafés associated with the old Halles Centrales, still sells oysters outside on the Rue de la Coquillière. Today the restaurant is the flagship of the Blanc brothers' group, which has a central management and some 600 employees but no central kitchen. With the Blancs, the address and the neighborhood are always good, today at the Porte Maillot in the former Cour Saint-Germain, yesterday Chez Clément in the Boulevard des Capucines. Bit by bit they are extending their influence over Paris. Recently *relooké* or refurbished, but still a great symbol of the Halles quarter, Au Pied de Cochon was acquired and relaunched by the present owners' father, between the two World Wars. Open around the clock, the old restaurant still serves grilled pigs' trotters to night owls in the early hours when the rest of Paris is just rising for the day.

Dehillerin, a very serious and quite astonishing bazaar full of culinary instruments, is one of the last witnesses to a not-so-distant past when Les Halles were a magnet for so many within the restaurant world. Yet today the shop stocks and sells every conceivable kind of accessory, indispensable, useful, or potentially so for professionals and informed housewives alike. Here, the equipment of chefs and cordon-bleu cookery fills the walls, shelves, and display windows of a highly specialized emporium that has been in business for well over a century.

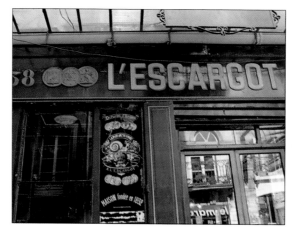

At L'Escargot Montorgueil, in the Rue Montorgueil, the signboard and the decorations alike signal the dominant feature of the menu — snails — but the beautiful mirrors within reflect other dishes as well. The house offers traditional fare and a Belle Époque setting with echoes of the Second Empire.

original décor, such as the wooden façade dating from 1875. The enormous gilded escargot on the canopy and the little escargots slithering over wrought-iron foliage, like the stylized snails in the scrollwork of the spiral stairway, itself coiled like a snail, confirm that L'Escargot has been feeding the public ever since the Belle Époque. Meanwhile, the great horns of plenty filled with oysters declare the bivalve to be a speciality of the house. Do they echo some old vocation once established on this approach to Les Halles? Indeed, Paris's oyster market formerly spread over the area, until eliminated to make way for the Rue Étienne-Marcel.

than ever a favorite haunt of discriminating eaters. It is nothing short of miraculous how big plates filled with gorgeous food appear out of her tiny kitchen, tasty fare that makes one eat too much and sometimes even drink too much. Was not this the spot where, according to Rabelais, Panurge led Pantagruel astray? Already in the Middle Ages, inns and *auberges* dominated this quarter.

Now we should recross the Forum gardens, which have their charm, provided one likes to hang out with dropouts and has no objection to youth *en masse*. L'Escargot Montorgueil, at 38 Rue Montorgueil, underwent extensive refurbishment in 1900 and was intelligently extended in 1978, but it still retains some of its

Rue Montorgueil, so called because it led to a small hill contemptuously known as Mont Orgueilleux (Haughty Hill), served as a reception center for the catch from France's northern ports. (There was also a Porte des Poissonniers, or Fishmongers' Gate, a name that survives at the end of the interminable Rue des Poissonniers.) It was also the meeting place for numerous wholesalers and merchants alike. This street with its age-old commitment to alimentary matters had evolved into something distinctly Parisian, devoted to affairs of the heart and the palate by the end of the seventeenth century. It boasted, for instance, a hotel well known as a lovers' rendez-vous, among whose personnel figured

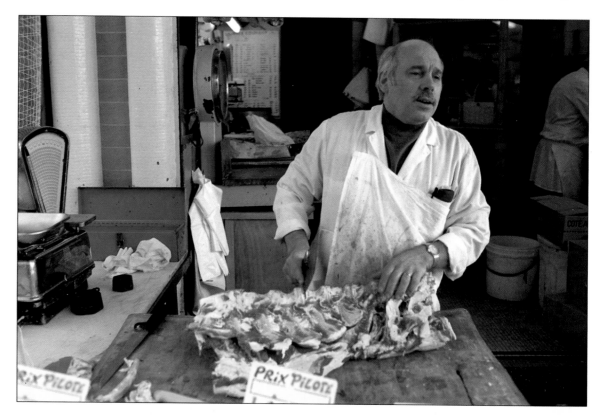

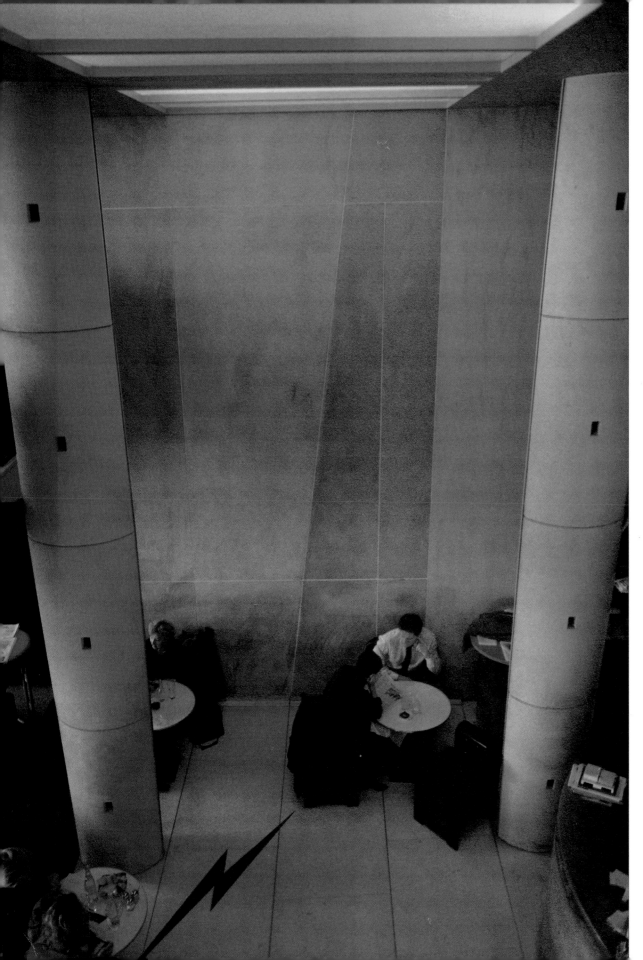

Le Café Beaubourg can be entered from 100 Rue Saint-Martin or 43 Rue Saint-Merry; either way leads into the world of Christian de Portzamparc, one of the best among contemporary architects. He designed not only the soaring, nave-like dining-room, with its eight colossal columns, and the ultra-modern toilets housed under neo-medieval vaults, but the whole ensemble of furniture as well, a project completed in 1986. More recently, Portzamparc created the chairs now spread over the terrace, where every seat affords a view of the open space in front of Centre Pompidou aswarm with a motley array of fire-eaters, soapbox orators, strumming musicians, itinerant artists, and idling students. For the hungry, Le Café Beaubourg offers a terrific brunch, a variety of *croques*, and quite good sandwiches.

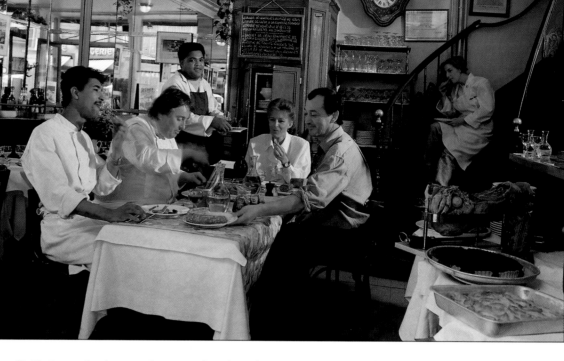

Le Grizzli, a bistro as old as the twentieth century, underwent prudent rejuvenation in 1990 but continues to serve copious meals derived from the bourgeois or quasi-peasant repertoire. When Bernard Areny redid the place he took such care to preserve an authentically original décor that it ends up seeming almost a parody of the real thing. This photograph, shot at 11:30 in the late morning, captures a classic *déjeuner du personnel* (staff lunch) at which the owner breaks bread with his chef, Patrick André, who would appear to be as good at consuming food as he is at cooking it.

one "Mlle Lange," subsequently none other than the Comtesse du Barry. The first Rocher de Cancale (Rock of Cancale [a fishing port in Brittany near Mont Saint-Michel], a once famous name) stood on the corner of Rue Montorgueil and Rue Mandar until it moved to the intersection with Rue Greneta. A society of song writers and worldly bon vivants met there and published a periodical, *Le Journal des gourmands et des belles,* to which Grimod de La Reynière contributed.

A short distance from the Rocher de Cancale, where Balzac often had his characters dine, a *traiteur* (caterer or prepared-food vendor) sold oysters from the English Channel at the Rocher d'Etretat. Grimod de La Reynière, who ran an oyster bar in the Rue Montorgueil, declared these "fruits of the sea" the best in Paris and predicted, in his *Almanach des gourmands,* that the accumulation of shells would eventually form monstrous rocks.

Parmentier established a school for bakers in the Rue de la Grande-Truanderie, whose wholesale and semi-wholesale grocers were the objects of Grimod's mockery. Here, too, the Norman Alexandre Pharamond served *tripe à la mode de Caen,* beginning in 1877. And tripe, along with Coquille Saint-Jacques in cider, remains the great speciality of the Alexandre Pharamond restaurant, which was completely redecorated for the Exposition of 1900. Still in place are the concave corner windows, the pâte-de-verre panels, and the frieze of aubergines, carrots, and onions punctuated by medallions representing pots full of tripe.

The Pompidou Center, a formidable high-tech carcass pulsating with all manner of cultural activity, constitutes one of the great monuments of Paris. Its associated plaza teems with a thousand and one spectacles, sometimes a source of rubbish in the area, while its huge hall and exterior escalators teem with the public's constant coming and going. The Pompidou Center, in brief, is a cheerful, multicultural venue for everyone who is multinational in cultural taste and has an interest in every variety of contemporary art. Crowning the whole is a spacious rooftop terrace, where one can eat simply with only the sky above, while enjoying one of the most beautiful of all views over Paris, a visual panorama encompassing some two-thirds of the city. Intimately near, but not too near, Paris willingly surrenders to anyone who lovingly deciphers her mystery. From the Eiffel Tower, the capital resembles an immense, slightly surreal relief plan. From the top of the Pompidou, however, the eyes virtually

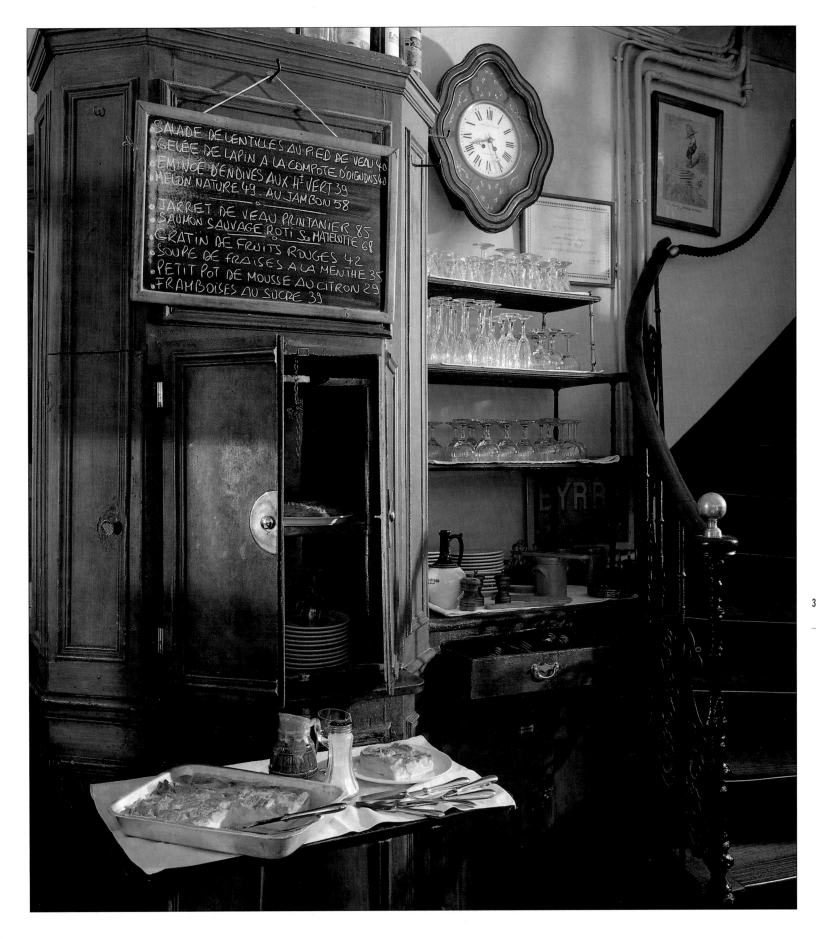

touch the roofs and mansards, with a familiarity which is almost indiscreet.

Opened in 1977, this giant high-tech structure designed by Piano and Rogers shelters a comfortable library for serious study, the national museum of modern art, a variety of galleries, and IRCAM directed by Pierre Boulez, whose music computers are located under the Saint-Merri *plateau*, the most delightful piazza in Paris. Big exhibitions, such as *Paris-Moscou*, *Paris-New York*, and *Matisse*, attract great masses of people to the Pompidou Center, where countless foreign visitors mingle with Parisians and French provincials. On occasion gastronomy itself has been a curatorial subject, notably in the show entitled *Châteaux Bordeaux*, a tribute to the elegance of the Médoc. Many visitors make do with something elementary in the rooftop snackbar, but you can wander at random into the small, picturesque streets of the surrounding neighborhood for an average meal in any one of numerous restaurants with pretentions to trendiness. But even when choosing a fast-food place, you could find yourself in attractive surroundings, as in the superb buff-colored house now occupied by a Free Time outlet.

Around Les Halles, worthwhile addresses can be counted on two hands. The Ambassade d'Auvergne, well kept, convivial and interesting, remains exemplary. The old neighborhood was already in severe decline when Jo Petrucci took over an abandoned restaurant and created L'Ambasssade d'Auvergne (a name with a past history but forgotten at the time). This hardworking Aveyronnais, who had known the area at its most lively during the late nineteen- sixties, lived through some bad moments while construction was under way, but when he finally opened it was with an awesome cuisine from the heart of France. Jo Petrucci was taking a gamble; his fellow Auvergnats seemed content enough to ignore the highly flavored dishes of their native region in favor of 'fast food'.

Jo Petrucci has now retired, leaving his daughter, Françoise Moulier, to watch over the sumptuous stretches of *aligot*, an astonishingly elastic cheese purée. The house is three hundred years old (with a façade protected by the Historic Monuments registry) and the menu immutable, although lengthened in recent years to include lighter dishes meant for a clientele less attuned to the Midi as well as for the smaller appetites of evening diners. Marvelous hams hang from the overhead beams,

and the charcuterie is exceptional. The Ambassade, which draws not only from the Pompidou but also from the Musée Picasso and the neighborhood art galleries, retains its atmosphere of timeless conviviality. The *table d'hôte* is still there, on the ground floor. Even foreigners feel at ease in the Ambassade d'Auvergne.

The Rue Saint-Martin, together with the Rue Saint-Jacques on the Left Bank, constitutes the main north/south axis of Paris. It follows the Roman highway that served Lutetia, built across the marshland from which today's Marais quarter takes its name. No. 20, in a section that was rebuilt around 1855, and recently shaken by work on an underground garage implanted, painfully, in the bowels of Old Paris, has been the location of the bistro/restaurant Benoît for more than eighty years. Michel Petit, the latest heir to the family business, has preserved the décor as well as, more importantly, an appetizing menu worthy of a place in the museum of taste. Red mullet, sole, and Pauillac lamb allow one to dine well without putting on weight, but habitués of this amiable house prefer to rise to the challenge of *compote de boeuf, cassoulet maison*, and fine big bourgeois dishes like those served by the Lyonnais *mères* (women chefs) of a quarter-century back. Prices, justified by both quality and quantity, have nothing of the bistro about them. With an excellent Beaujolais included, the bill can easily come to 500 francs a person.

Almost directly opposite, Bernard Areny waited until work on the underground garage had been finished before opening up his pleasant, tranquil terrace, invitingly spread over a short length of the pedestrianized street. Le Grizzli, an authentic bistro (everything is original) has a mainly Parisian clientele, with an admixture of foreigners from the Beaubourg; it positively exudes cachet, from its antique cashier's desk, its serried ranks of bottles aligned before a mirror, and its stairs spiraling up to the floor above. Areny, attached to his establishment more like an Auvergnat than a graduate of a hotel school, welcomes his clients, gossips about the latest goings-on in the ever-changing neighborhood, and sometimes, at the end of the day's service, sits down with another notable fellow restaurateur. Areny remains open late, well after his competitors have put away their casseroles. Le Grizzli is for those who like hams as they used to be, *harengs pommes à l'huile*, robust country cooking, and the small fruity wines of the Marmandais.

The Ambassade d'Auvergne appears to represent the Aveyron as well as the Auvergne and to have always been at 22 Rue du Grenier-Saint-Lazare. However, it was only in 1967 that Joe Petrucci acquired the wonderful old building and began reclaiming it from near-total dilapidation, well before anyone could have imagined the nearby Centre Pompidou and the clientèle it would bring into the quarter. Now the Ambassade is protected by France's Monuments Historiques, which doesn't prevent the Petruccis from hanging their cured hams and sausages from the overhead beams. Now managed by Françoise Moulier — seen here with her father, Joe Petrucci, and her mother, together with chef Patrick Hun and Francis Panek, the head waiter — the Ambassade d'Auvergne remains exemplary in its dedication to regionalism and quality. The menu abounds in splendid pork fare, *boudin* with chestnuts, stuffed cabbage, and cheese dishes, such as *aligot*, an elastic purée made of Cantal cheese, potatoes, and garlic. For weight-watchers, it also includes reassuringly lighter dishes.

Palais-Royal, Louvre, Place Vendôme – the Paris of kings, Haussmann's Paris, Paris still glorious even today, Paris jammed with traffic yet somehow protected, where Parisians spend more time moving from one place to another than actually living, where the myriad tourists are caught up in the vast museum now wonderfully revitalized, thanks to ten, fifteen years of *Grands Travaux*. The neighborhood is not one for that elusive bargain or the mythical, quintessential bistro. However, Michelin has awarded several pairs of stars to local establishments, while GaultMillau one-ups its rival by granting three as well as two toques. Is it possible, then, to take a gourmet's tour through an area so dominated by history and finance? Perhaps it would be better simply to repeat a few of the old, hackneyed stories which for a century and a half have helped gastronomic writers to flesh out their copy.

The illustrious Grand Véfour, the pride of the Palais-Royal, belongs to the national patrimony of France as much as to the Taittinger family group. Alain Dutournier, a Landais and one of the most talented *quadras* of contemporary cuisine, lends his Gascon accent to Le Carré des Feuillants, a splendid two-star/four-toque restaurant on the site of a former convent church for which Henri IV laid the first stone. On an entirely different level, the accent of south-west France can also be

At Le Carré des Feuillants, in the Rue de Castiglione, Alain Dutournier, a proud Landais in love with his native Chalosse, retains a strong regional accent, perhaps with a twinkle in his eye. However, there is nothing traditional about the décor within his splendid restaurant, where some of the walls have been painted, as here, with hallucinatingly *trompe-l'oeil* images.

found under I.M. Pei's sparkling glass and steel pyramid in the courtyard of the Louvre. Here, the Gersois André Daguin, a gastronomic Olympian who oversees Le Grand Louvre, a large restaurant with a somewhat stark décor but with excellent quality relative to price.

At the Ritz, it is the solid Guy Legay who assures L'Espadon its two stars. In addition to this elegant dining venue, Legay also offers a short menu in the hotel's super-discothèque/bar/late-night-restaurant run by Michel Gaubert, a young but excellent chef formerly at Castel. The Ritz is not particularly famous for conviviality, but the professionalism of Legay has earned unanimous praise even from gastronomes unfamiliar with the great hotels. The skills of the *sommelier*, Georges Lepré, are also awesome.

Two stars and two toques adorn the neighboring Goumard-Prunier, an historic and now revived seafood restaurant, whose sumptuous Art Nouveau décor was much mourned after the restaurant closed some years ago. For fine old décor and good bistro food in the *grand-bourgeois* manner there is Chez Pauline, and for serious cuisine, there is Pierre-au-Palais-Royal, formerly Pierre-Traiteur.

You may occasionally have to wait a little time for your table at Chez Angélina, the tearoom and pâtisserie in the Rue de Rivoli, where the chocolate is as unctuous as ever. A favorite gathering place of delightful if elderly ladies from the *Beaux Quartiers*, Angélina attracts the young and the beautiful as well, their taste for chocolate being no less keen than that of their parents and grandparents.

In the second half of the nineteenth century, when Paris was undergoing a period of great change – being carved, pierced, parceled, and generally improved on the orders of Napoleon III – the completion of the Rue de Rivoli encouraged a great migration towards the future *Beaux Quartiers;* prestigious restaurants were established during the Belle Époque and still flourish today. The élite of the gourmet world has remained attached to the Right Bank, with its more than forty good addresses, in contrast to the mere half-dozen on the Left Bank, even though those include the Tour d'Argent. Even on the Right Bank, nineteenth-century food-lovers felt no great urge to go beyond the Madeleine. And as far as *haute cuisine* was concerned, they kept to the boulevards and the surrounding areas, reveling in the magnificence and formality of the Café Riche, the excellence of the fish,

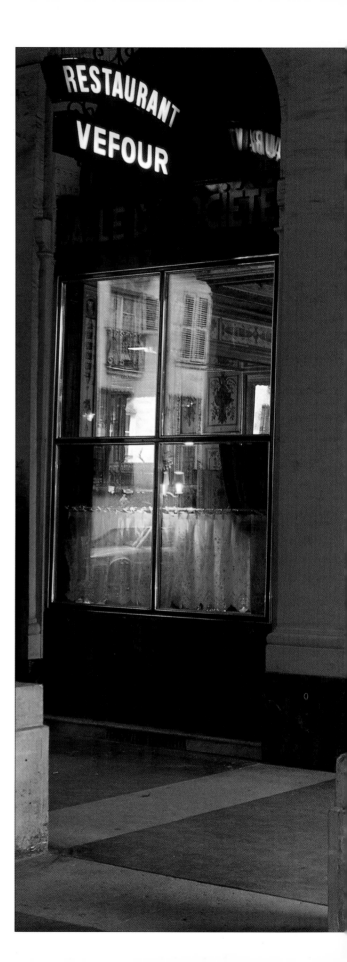

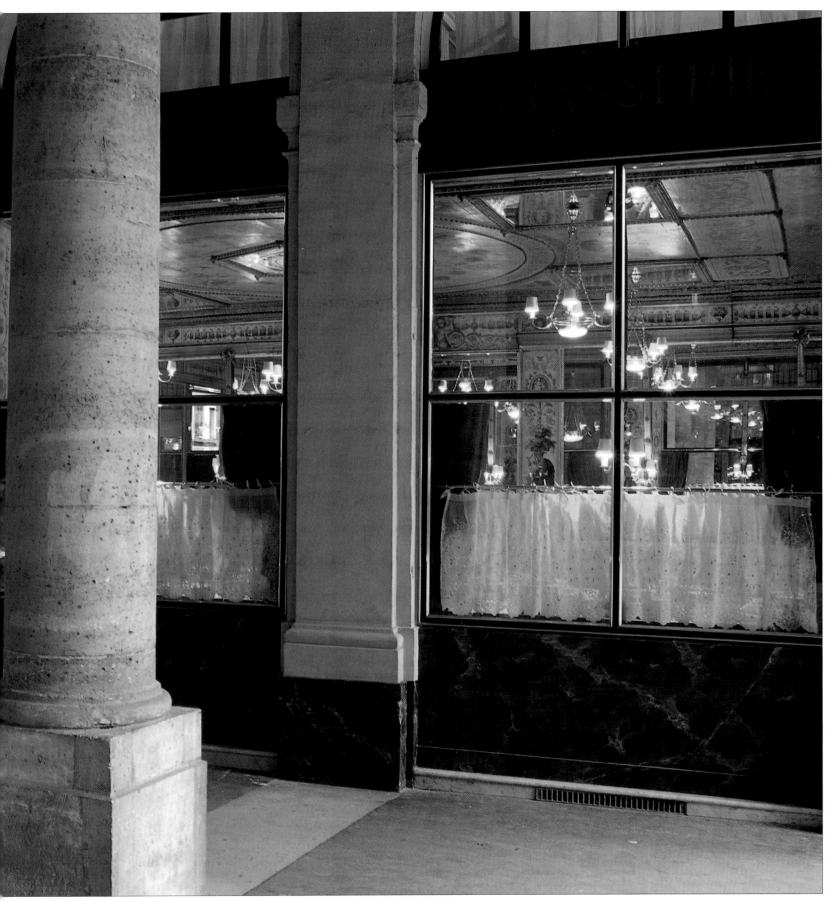

fowl, the service at La Maison Dorée, and the seriousness of the expensive Café Anglais, where the celebrated Adolphe Dugléré perfected Potage Germiny, Pommes Anna, and Sole Dugléré.

The vast colonnaded courtyard of the Palais-Royal emerged in the second half of the eighteenth century as a fashionable precinct. Then, during the darkest days of the French Revolution, it became something of a gastronomic mecca, and remained so throughout the Napoleonic era. Gradually, however, following the closure of the gambling dens and the expulsion of the "nymphs" trolling for clients under the long arcades, the Palais-Royal lost its appeal and even became unfashionable around 1836. The glorious Véry was already teetering towards decline when Balzac had Lucien de Rubempré dine there, as part of his initiation into the "pleasures of Paris." However, the guidebooks continued to extol a pair of establishments in the Galerie du Beaujolais: Frères Provençaux, which did not survive into the Second Empire, even though it retained a place in the history of Parisian gastronomy, and Le Grand Véfour, a beneficiary of the Provençaux's eclipse. The Véfour continued along a somewhat precarious, somnolent path until it was successfully revived after World War II.

The *Paris-Guide* of 1867, compiled by a team that included Victor Hugo, evinced an inclination towards nostalgia, but its enthusiasm for Provençaux and Véfour was real. It placed the two epicurean venues among "the small number of restaurants that are still open and brilliant." The editor, intent upon rediscovering the *grandes cuisines*, persuaded himself that Provençaux had been reborn, under Dugléré, who was in fact not particularly successful, and then moved on to the Café Anglais.

Created in the future Rue Sainte-Anne by three men from Provence (probably brothers-in-law by marriage), the Provençaux who introduced Parisians to the culinary wonders of southern France subsequently moved to the Palais-Royal's Galerie du Beaujolais during the Directoire period (1795-99), at the very moment that Antoine de Beauvilliers was confirming his reputation in the Galerie de Valois. A one-time chef to the Comte de Provence (brother of Louis XVI and the future Louis XVIII), Beauvilliers had opened La Grande Taverne de Londres in 1782 in the Rue de Richelieu, thereby giving Paris its first real restaurant. The Beauvilliers establishment in the Palais-Royal braved some difficult times but finally disap-

peared, as did Véry, which was confused with the equally doomed Petit Véfour, a nearby eatery which had nothing to do with the "Grand" or with a supposed family relationship between owners with similar names. Beauvilliers died in 1817, just three years after he had published *L'Art de cuisiner* (*The Art of Cooking*). The restaurant he founded struggled on until 1825, when its doors finally closed.

The savior of Le Grand Véfour was Raymond Oliver, one of the great chefs of the post-Liberation era and the first of France's "television cooks" (for fourteen years he presented recipes, in association with Catherine Langeais). A native of Langon, the son of an outstanding cook, and the future father of Michel, a keenly inventive restaurateur as well as a television personality in his own right, Raymond Oliver took charge at the Véfour in 1947 and soon cooked his way to glory. Thirty years later, exhausted, he left the Palais-Royal after a violent terrorist attack on the restaurant. Today the Véfour, like the Crillon nearby in the Place de la Concorde, belongs to the powerful Taittinger group, which has entrusted the famous kitchen to Guy Martin.

The *enseigne* or "signboard" bearing the name Café de Chartres, still visible on the garden side of the Palais-Royal (Rue de Beaujolais), recalls the name of the establishment purchased in 1820 by Jean Véfour, a native of the Loire Valley. Much larger than today's restaurant, it comprised three kitchens on as many floors and luxuriously appointed dining-rooms accessible by way of a *porte cochère* in the Rue de Beaujolais. Le Grand Véfour, so named to avoid confusion with the other Véfour, underwent a number of vicissitudes but continued to enjoy an excellent reputation in 1830 when, at the time of the *Hernani* scandal, a high point in French literature of the Romantic period, Victor Hugo was a regular customer. The poet is said to have consoled or congratulated himself over the fuss caused by his play, produced at the Comédie-Française on the opposite side of the Palais-Royal courtyard, by having the Véfour serve him sheep's stomach with white beans.

Following a slow decline, the Véfour lost its qualifying adjective around 1905, by which time it had become a mere bar offering snacks, which by 1917 had descended to the level of using paper napkins! Stripped of its first story, the bistro was rented by an international chess champion, which made it a favorite haunt of chess players who had little interest in serious food. The

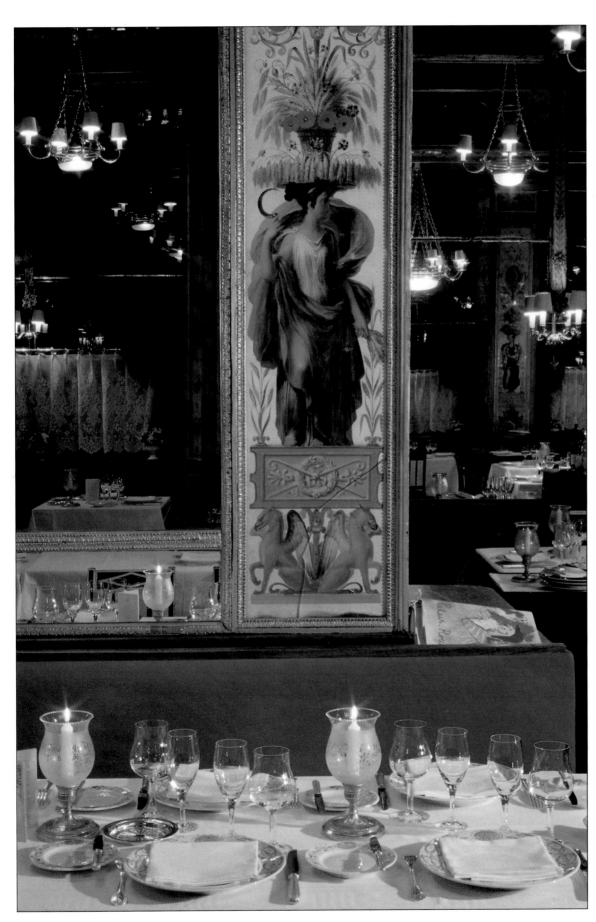

Jean Cocteau once said to Raymond Oliver, the chef who, in the post-war years, gave new meaning to the qualifier in Le Grand Véfour: "I love coming to your restaurant. Here one can relax among the shadows. . . ." However, there is nothing nostalgic about the Véfour in its present state of glory, even though smaller than Le Grand Véfour that flourished during the first half of the nineteenth century, when it filled eight bays of the Palais-Royal on the Beaujolais side and rose through three floors, with a kitchen on each of them. Immediately after World War II, it was Louis Vaudable, the owner of Maxim's, who bought the decayed old Véfour and had it partially redecorated by Colette de Jouvenel, the daughter of the great writer Colette, who had an apartment upstairs in the same wing of the Palais-Royal. A poetic ruin, the Véfour had nonetheless preserved its fragile, attenuated decorations under glass, its glittering mirrors, and its painted ceilings, even if a bit flaked. In the wake of a devastating terrorist attack in December 1983, the restaurant underwent major restoration, which extended to the ancient kitchens in the basement.

historic, protected façade was nothing more than a screen hiding the shabbiness within, according to the historian and gastronome René Héron de Villefosse: "Out of respect for the past, I sat down to a plate of shoe leather surrounded by a sauce of congealed glue. . . Everything bore traces of flies, generation after generation of which had lived here undisturbed. The semi-collapsed banquettes retained the shape of yesteryear's thighs, perhaps those of George Sand or Joseph Prudhomme."

Louis Vaudable, the owner of Maxim's and one of the many Parisians who found themselves in trouble following the Liberation, bought the Véfour and reha-bilitated it as Le Grand Véfour, with the aid of the deco-rator Colette de Jouvenel, the daughter of Colette, who had an apartment upstairs in the Palais-Royal. Success, however, did not come immediately and in 1948 Vaudable turned the place over to Raymond Oliver, an inventive traditionalist who drew on the gastronomy of the south-west and revived a number of old dishes. Colette (at the beginning), Jean Cocteau, and Emmanuel Berl came as fellow residents and neighbors, joined by the great actor Louis Jouvet, Simone Berriau, and several rising stars, among them Juliette Greco, who helped to revive the restaurant, even making it into a kind of club.

In a period without star chefs, other than Fernand Point, who died in 1955, this innovator and reviver of French cuisine became a great celebrity, first among intellectual and fashionable Parisians and then throughout France, thanks to his television broadcasts during the glorious days of black and white.

In *Adieu fourneaux*, Raymond Oliver confessed that his Parisian beginnings had not been all that easy: "I felt that both the décor and the period imposed a cetain style on me. After the wartime privations, the clients believed themselves entitled to at least the appearance of a luxury long absent from their lives. I therefore thought it essen-tial that we hit the high notes, which meant offering a menu in the grand manner. It is true that, during the postwar years, it had not been necessary to be particu-larly inventive to satisfy the public. *La Grande Cuisine*, for most people, boiled down to an odd trilogy: *langouste à l'armoricaine, homard mayonnaise*, and . . . *châteaubriant*! It was with some hesitation I took up again the arms with which I had won my first victories and with which I was familiar: the cuisine of the south-west. But this second formula was no more successful than the first. This time, I was too far ahead of fashion; *confit* and *magret de canard* had not yet conquered Paris."

Whatever his doubts, Oliver succeeded well enough to win two stars from the Michelin in 1949 and three in 1959, a rating the chef kept for almost a third of a century. Maurice Goudeket, Colette's last husband, recalled the happy beginnings: "Raymond Oliver settled into the very special environment of the Palais-Royal with serene self-confidence. . . A naturally imposing man with large gestures, a powerful voice, and the fluency of speech as well as the irresistible accent that marked him as a man of the south-west, Oliver, in the twinkling of an eye, got the whole quarter in the palm of his hand, including its most notorious members."

Le Grand Véfour has now been carefully restored, a project costing thousands of hours of painstaking labor. As a result, no one can now imagine the damage done by the abitrary attack which left several people gravely wounded on 23 December 1983. The restaurant of Raymond Oliver, whose act was a difficult one to follow, has now resumed its place among the best in Paris, thanks to the determination of the Taittingers, who have also completely rebuilt the kitchens. It is now possible to breathe and move about normally in basement rooms

Two-star Guy Legay (classified "*meilleur ouvrier de France*") reigns over the kitchens serving L'Espadon, the luxuriously refined restaurant at the Ritz, recently relocated from the Rue Cambon side of the hotel to the Place Vendôme side. Gracefully versatile in his ability to move back and forth between elegant classicism and the subtly rustic (working miracles when he braises *belles de Fontenay* in smoked bacon), Legay also knows how to insinuate shafts of day and evening light into the shadows of nocturnal living. For this – feeding the hungry after hours – he relies on the elegant annex to the discothèque managed by Michel Gaubert, formerly of Castel.

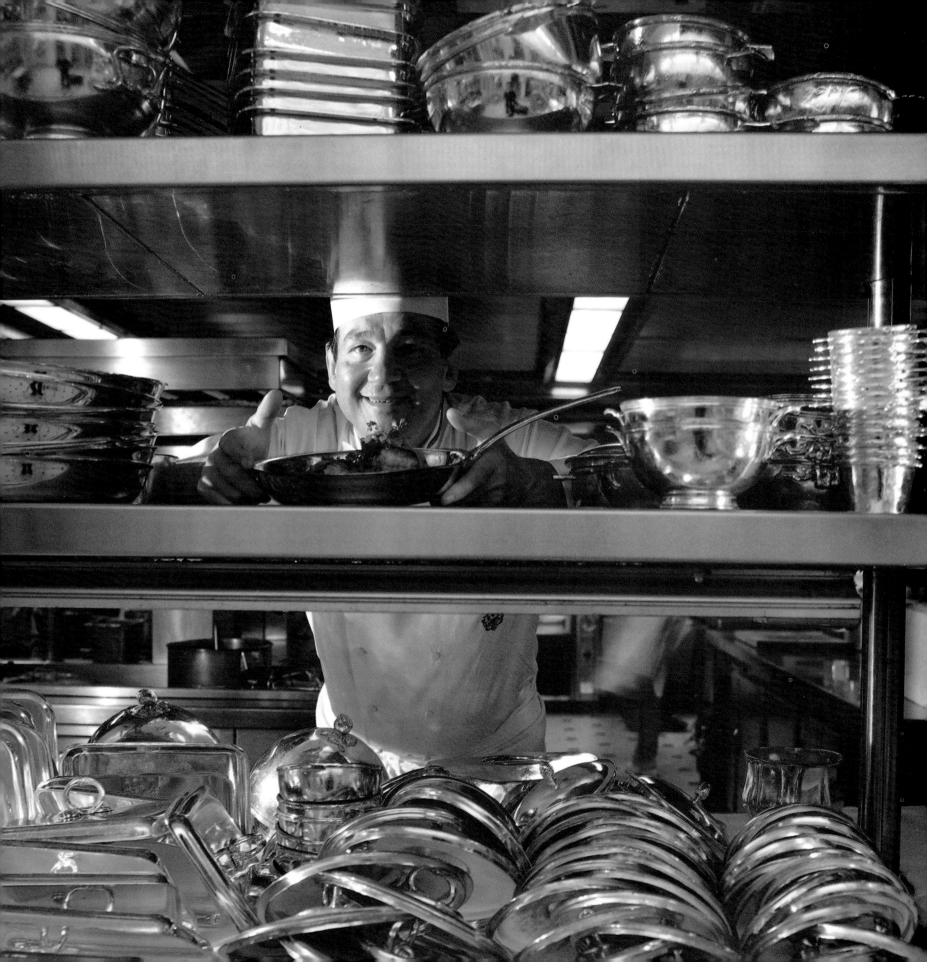

The accents of Auch, Gascony, and the whole of south-western France can be heard, tasted, and smelled at the very heart of Paris! They come from André Daguin, who together with Yves Pinard, created the menu for Le Grand Louvre, an ambitious restaurant located under the glass and steel geometry of I.M. Pei's Grande Pyramide, the skylit courtyard entrance to the Louvre Museum. Here, the owner of the Hôtel de France exercises his culinary personality in a venue characterized by sober modernism. The great palace/museum, which dates from the late twelfth century, when King Philippe-Auguste built a fortified castle or keep, is now richly endowed with worthy cafés, in the Richelieu and Denon Wings, but mostly in the vast new underground areas. These extend from the Grande Pyramide to the Carousel Arch near which there is another pyramid designed by Pei, this one upside down and centered like a pivot for circumambient shops as well as a *zone de restauration*. Here every kind of fast food can be had, from salads and cheeses to half-chickens and chili con carne, served in close proximity to a Virgin megashop, an exceptionally well-stocked bookstore, and boutiques specializing in such upscale wares as Lalique glass.

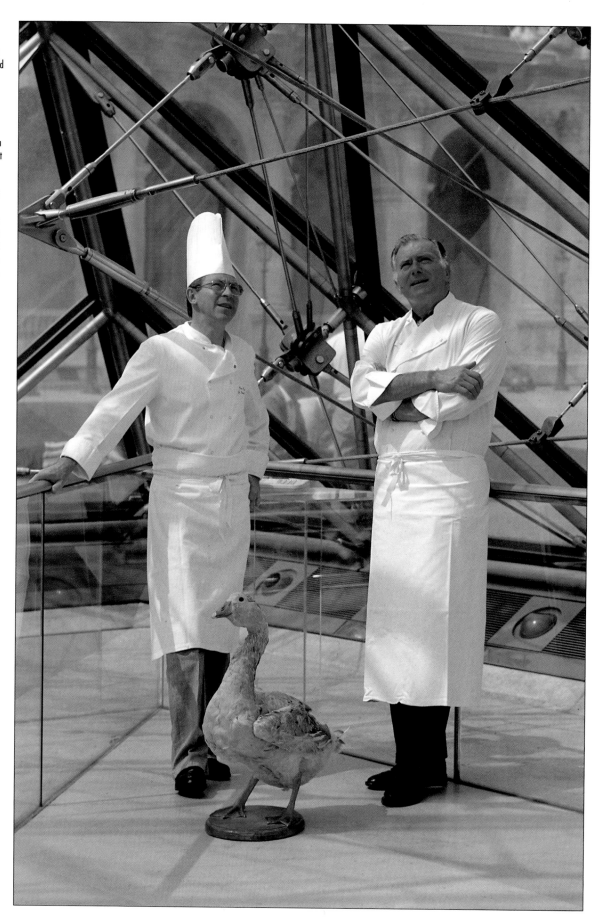

which used to be overheated, impractical cellars, in the days when the master of the house was running through his repertoire.

Now we move a few steps from one palace to another, the Louvre, wondering whether La Joconde (the "smiling" Mona Lisa) was a gourmande. In Oliver's time, a meal in the museum's cafeteria could very well leave one hating the Louvre. The colossal and multicultural palace-museum, crammed with badly presented treasures, was an aggressively unwelcoming place before the recent renovations. These were finished about the same time as the new commercial gallery installed under the Carrousel.

Underground, the patrons of the Virgin megastore facing I.M. Pei's upside-down glass and steel pyramid can sample "the cuisines of the world" after having savored the arts of virtually the entire world. Under Pei's Grande Pyramide, inaugurated by President Mitterand in March 1988, the customers at Le Grand Louvre, a restaurant managed at a distance by André Daguin, eat almost as they would in Auch, in the south-west: *foie gras chaud au raisin, magret de canard au floc de Gascogne*, and so on. The Louvre, visited by several million people every year, is no longer merely a fantastic museum requiring days of attentive study. Now expanded into the immense Richelieu Wing, formerly occupied by the Ministry of Finance, and down to new levels below ground, the richly diverse palace has become a favorite haunt even for Parisians, once a small minority in the galleries. These days it is also normal to eat well at the Louvre, especially at Le Café Marly, a handsome new restaurant in the Richelieu Wing overlooking the sculpture-filled Cour Marly within and the Grande Pyramide without. Here, in good weather, diners at tables on the long covered terrace have a ring-side view of the incandescent, prismatic Pyramid, the ponds and fountains around it, and the lovers reveling in the sheer beauty of it all. There is no better place to spend a summer evening in Paris, and at reasonable prices!

It was in 1986 that Alain Dutournier set up Le Carré des Feuillants in the Rue de Castiglione, not far from the 110 arcades of the Place Vendôme where César Ritz transformed an aristocratic residence of 1705 into the palace we know today. A Landais from Chalosse, or more precisely from Cagnotte, Dutournier won his early fame in the 12th *arrondissement*, at the Trou Gascon in the Rue Taine, where his wife Nicole remains in charge.

Comfortably installed in an old bistro in a quiet neighborhood, too quiet perhaps to permit a restaurateur to earn serious money, Dutournier nonetheless made his mark as one of the best exponents of second-generation *nouvelle cuisine,* some ten or twelve years after Michel Guérard, Alain Chapel, Alain Senderens, and other innovators were recognised by Gault and Millau and given substantial media exposure.

While still in the Rue Taine, where the meticulously restored décor retained its turn-of-the-century character (1890 to be exact), Dutournier lightened the hearty dishes of the south-west with pure, honest flavors, enriching a "Parisian" cuisine whose modernism had often proved artificial. Employing only the very best products from his native province, while keeping up with all the latest discoveries, Dutournier came splendidly into his own around 1980, when he decided to return to central Paris to serve the clientele which hitherto had had to seek him out. So, he moved into a neighborhood known for its palaces and grand hotels, its liberal expense accounts and late nights, and took over 500 square meters of contemporary architecture behind a well-appointed nineteenth century building.

Slavik, the designer of the Bistrot de Paris, the first Drugstore, and so many other bistros in Paris and elsewhere, managed some very special effects when he refurbished Dutournier's Carré des Feuillants. Around what had been an old glassed-in courtyard, he organized the reception area and bar, the dining-rooms, and the kitchen, using as a focal point a central fountain which replaces what may originally have been a watering trough for horses. The result is an unusual, yet peaceful ambience, with a painted décor of almost hyper-realist fruits and vegetables, and hunting scenes. Shortly after he moved into the Rue de Castiglione, the gifted Dutournier slipped from grace very briefly and his menus became more banal, but then he recovered to his best, advocating certain flavors and allowing his talent to come forth in all its originality. Dutournier skillfully plays on several different registers, moving from the world of spices to that of butter and peppers. A "return to India" cuisine? Certainly, in the case of *lapereau vedette* and several magnificently spiced dishes. Meanwhile, the chef also excels in the cuisines of south-western France and the Basque country, treating them with a youthful zest until they take off and truly soar.

Paris draws inspiration from every province of France, the source also of its best chefs, its myriad foodstuffs, and often its best clients. Fortunately, the capital is also cosmopolitan, which means that it owes much to foreigners who, wave after wave, have arrived and assimilated the local culture, simultaneously enriching it with other flavors and habits, cheerfully spicing up the everyday diet, sometimes with real *éclat*.

What Parisian has not learned to handle chopsticks? Who does not enjoy sharing a couscous, whether Moroccan, Algerian, Tunisian, or "Jewish"? Who has not deplored the price of such delicious Japanese specialities as miso soup with tofu, sunomono, and sashimi, none of which Parisians really know how to order. Meanwhile, the Japanese, once adjusted to Paris, learn to distinguish *choucroute* from *cassoulet* much more quickly than Parisians grasp the essentials of their cuisine. Who has not enjoyed the spices of Bengal, or thought of India at the top of the Rue Saint-Denis around the Passage Brady? As the new millennium approaches, Paris has developed a taste for nuoc-mâm and harissa, curry and tapas. Here you can nimbly tour the world, restaurant by restaurant, while waiting for a Russian revival and regretting only that the Africans are less percussive in culinary matters than in music.

Arab Paris is complex, full of surprises, and dominant around Barbès in the Belleville quarter (where Asians are more and more numerous, as well as where the "Tunes," or Tunisian Sephardic Jews, still sprinkle Bokobsa boukha [a Tunisian fig spirit] on their kemia, doing so with the same conviviality as on the edges of the Faubourg Montmartre). It would be impossible to say which couscous is the best, since the Arab community produces so many diverse variations on the basic formula, while every Arab swears that the best is the one made by his mother.

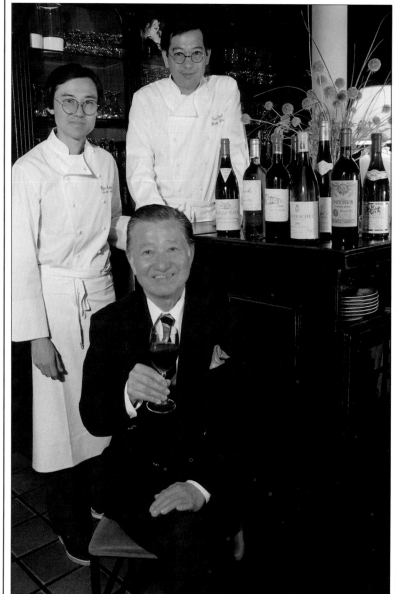

M. Vifian père, a Vietnamese gentleman, was in the dining-room and his wife in the kitchen at their restaurant next to the ancient Gallo-Roman Arena east of the Sorbonne. Then Tan Dinh migrated to the Faubourg Saint-Germain at the far end of the Rue de Verneuil. Robert and Freddy, as good sons of a good family, took up the succession, with papa often gracing the dining-room with his prescence. Pioneers of la nouvelle cuisine vietnamienne, *the Vifians respect tradition but frequently shake it up in the name of innovation. They are also known from Bordeaux to Alsace as redoubtable connoisseurs of wine, whether produced in France or elsewhere in the world. The family have gone as far as investing in their own "château."*

Wally declares itself Saharan, and the Petit Dominique evokes the Jewish/Arab Goulette, while Mansouria, Al Mounia, and the Timgad boast of their Moroccan roots. Today, however, couscous is as French as *choucroute*, *bouillabaisse*, or *cassoulet*, all regional dishes that have become national, or even international. Like the French national dishes, moreover, couscous exists in many different variants. The *nouvelle cuisine* generation has borrowed heavily from Asians, while also taking inspiration from the couscous pan and its steam cookery, a step encouraged by the gradual integration of non-Europeans with the life of Paris. The newcomers succeeded in considerable measure because they proved clever enough to preserve their own uniqueness at the same time that they adapted recipes in a manner that Parisians found easy to like. The immigration now cited as exemplary did not happen in a single day, nor was the sweet-and-sour reaction to it as well balanced as the Asians' sauces. Indeed, it was not until after World War I that a Chinatown began to emerge in Paris and make its presence felt near the Gare de Lyon, followed by a migration of Chinese into the Arts-et-Métiers quarter. A more recent development is the growth and prosperity of an Indochinatown in the 13th *arrondissement*, which began around 1975 when Cambodian refugees occupied the towers along the Avenue d'Ivry. Enterprising, industrious, mutually supportive, these "Chinese" may not have been assimilated, but they are entirely at home in their quarter around the Place d'Italie on the Left Bank. Here it is possible to take one of the most exotic and least costly gourmet tours in all Paris. But the Chinese and their neighboring Asians are also making a place for themselves in Belleville on the Right Bank, where the North Africans have moved on, or in the Rue Rebeval near the border between the 19th and 20th *arrondissements*.

Pity those worried about monosodium glutamate, for "eating Chinese" permits one to dine well more often, or if not so well, then at least for less money, and more often than not served with a smile on an exotic face.

Petrossian, at 18 Boulevard de Latour-Maubourg, represents luxury à la russe *and the flavors of Périgord. The shop stocks the best caviar, the most perfect salmon, and other smoked fish of the highest quality, such as sturgeon, trout, and eel, as well as pirojkis and blinis, in addition to succulent goose and duck* foie gras, confit, *and prepared dishes. Here, one can buy the sublime and ruinously expensive osetr caviar, but also, without appearing ridiculous, salmon roe or tarama.*

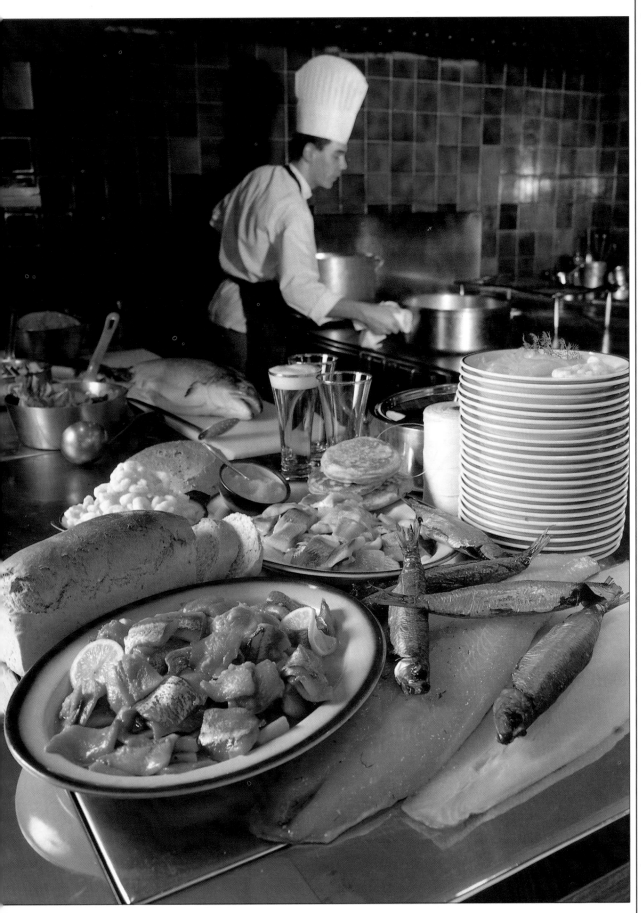

The Vietnamese, who first appeared in Paris during the days of French Indochina, became an important presence around Maubert-Mutualité in the nineteen-sixties and then spread throughout the capital prior to the arrival of the "Chinese" on the outskirts of Paris, mainly on the south side. Not particularly gregarious but unsympathetic to ghetto life and integrated to the point, often, of losing their language after one generation, the Vietnamese have readily absorbed French culture while simultaneously preserving their culinary art, their taste, that is, for crisp vegetables and marvelous soups.

A list of foreigners in Paris who succeed in making the French eat "foreign" would be virtually endless. The Latinos alone, with their red and black beans, their beautiful music, their deep thoughts and brilliant writing, could be the subject of a separate book. From tortillas, chili con carne, and Tex-Mex tacos to feijoada, carioca *cassoulet*, and every sort of pepper dish, the range is extraordinary, yet no one from the Latino community has come forward to compile the list or write the book. Nor is a model to be found among their former colonizers, the Spanish, who today make excellent wine but yield pride of place in matters of food to the Italians. Paris would not be Paris without its many Italian restaurants, which include the various Ritals, Conti, Sormani, Paolo Petrini, Fellini, Velloni, Il Ristorante, Beato, and Stresa, all warm and welcoming, many of them good, and a few superb. Moreover, Neuilly would not be Neuilly without Livio, an unmissable trattoria for the last quarter-century.

As for the English, if they did not persevere during the last century, when they had a good start, they now have their own "embassy," Bertie's, a club-like restaurant in the Hôtel Baltimore near the Étoile, which took off in 1994 and has remained popular at, fortunately, relatively popular prices.

Paris has also proved hospitable to cuisines evolved under the Northern Lights, as the hungry can discover Chez Roger Vergé. Here the excellent Jean-Jacques Guillot offers marvelous salmon, prepared in all manner of ways, and herring by the pot as well as in every style, each of them delicious, and often surprising. Copenhagen and Flora Danica, which share a building on the upper Champs-Élysées, serve a wide range of Northern fare. A rather opulent "brasserie," the Flora opens on to a large patio that fills to bursting on fine days. With its sober, modernist décor, the restaurant is a bit of Denmark on foreign soil where even Swedes feel very much at home.

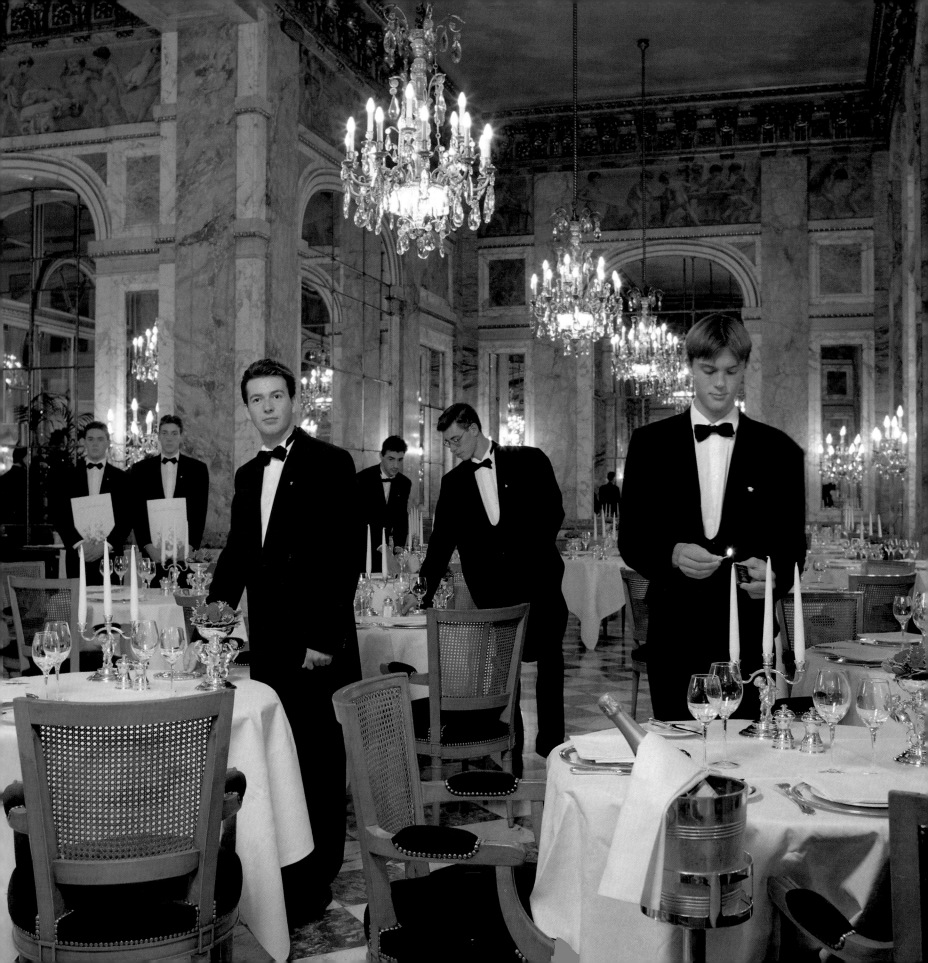

4 7

Majestic Paris, the Paris of the great vistas. Paris still royal enough for one short street to remain Royale, chic enough to be the focus of all the world's glossy magazines, and distant enough for Parisians to forget the neighborhood whenever they are not thinking about luxury and arts of the table. The eastern end of the 8th *arrondissement* is very mixed and thinly populated but full of bustle during business and shopping hours. Here foreign embassies, corporate headquarters, *haute couture*, travel agencies, restaurants, and prestigious food shops abound and coexist. Tables are set and the settings arranged for people of taste to whom the cost does not matter, for those for whom the label and the name are of special importance.

Two short, intersecting strolls – Concorde/Rue Royale and around the Madeleine – give one access to fine table settings and marvelous food, as well as a delicious bit of gourmet history. The first of the walks begins by the Seine on the edge of the Place de la Concorde, where the river flows away under the elegant span of a handsome, wide eighteenth-century bridge directly in front of the Palais-Bourbon (France's Chamber of Deputies). Behind this monument the horizon is punctuated by tall landmark buildings, among them the Montparnasse Tower, the dome of

"Solidly linked to history through its every stone and all its marble parquets," the Hôtel Crillon has in Les Ambassadeurs one of the best restaurants as well as one of the most spectacular dining-rooms in all Paris.

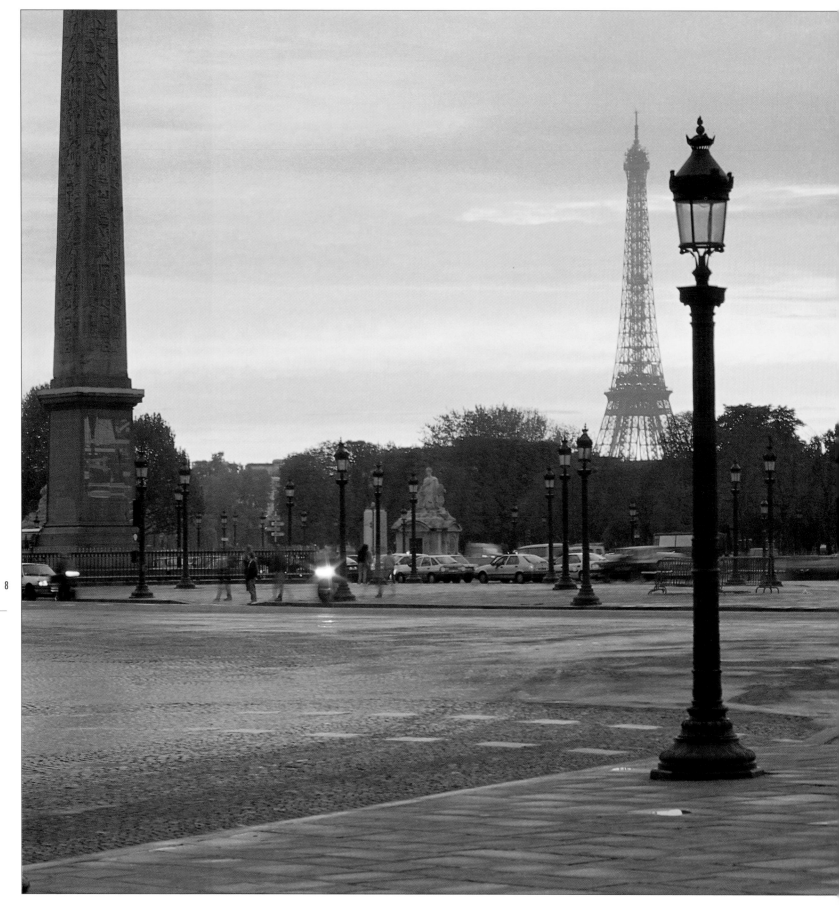

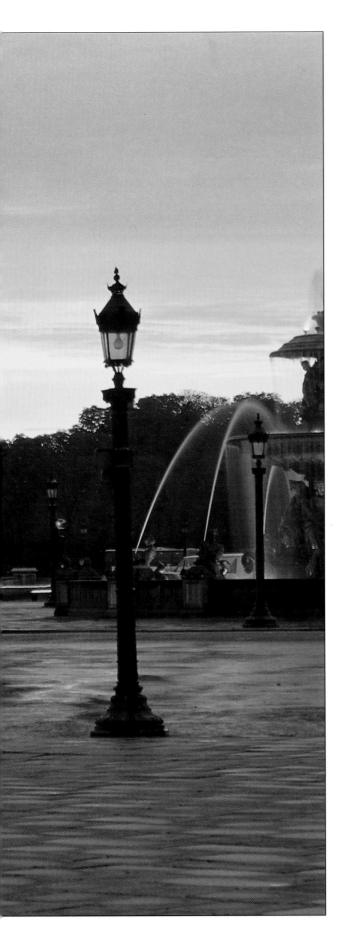

the Invalides, the crown jewel of the evening, the Eiffel Tower gloriously illuminated, and the Grand as well as the Petit Palais. Running perpendicular to the Left Bank façade of the Palais-Bourbon is the axis of the Rue Royale, which crosses, through the Place de la Concorde, the immense perspective marked off by the Louvre Pyramid, the Carrousel Arch, the obelisk at the center of the great square, the Arc de Triomphe, and finally the colossal arch at La Défense.

Although already planned in the mid eighteenth century during the Ancien Régime, the spectacular new Paris seen here did not become fully integrated with the capital until the reign of Louis-Philippe (1830-48). The whole plan of this formal space, including the lower Champs-Élysées, had been prepared in every detail by Jacques-Ange Gabriel, the great architect who had submitted his plans to selected entrepreneurs, all members of the rich nobility and eager to initiate construction, as early as 1757.

In the Rue Saint-Florentin, to the right of the elegantly colonnaded royal *garde-meuble* (furniture warehouse), and across from the Jeu de Paume in the Tuileries Gardens, Jean-François Chalgrin, the architect of the Arc de Triomphe, designed a resplendent *hôtel* or mansion which today functions as an annex to the United States Embassy on the opposite side of the Concorde. Here resided, from 1812 until his death in 1838, that wily statesman and diplomat Talleyrand, who dieted at lunch but feasted at the dinners he gave in the evening, all of them carefully thought out with a chef who had originally worked for the Condé princes. It is said that Talleyrand himself served his guests, but continuously changed his manner according to their ranks, passing from the ceremonious "Please do me the honor of accepting . . ." to a rather curt "Take this or that."

Carême (1783-1833), the founder of France's *grande cuisine* and chef to the greatest princes of his day, began his illustrious career as an apprentice under Bailly, a famous *pâtissier* in the Rue Vivienne who supplied the Hôtel Talleyrand. For twelve years Carême managed the diplomat's kitchens, an experience that led him to write: "[Talleyrand] understands the genius of cookery; he respects it, and he is the most competent judge of the delicate progression of dishes."

Following the collapse of the Napoleonic Empire (1815), Talleyrand and his increasingly famous chef

The Place de la Concorde – originally Place Louis XV and then, briefly, Place Louis XVI – is bordered along its northern side by a pair of twin palaces designed in the mid eighteenth century by Jacques-Ange Gabriel, each of their colonnaded façades 3,779 feet long.

This grand hotel, the Crillon, was, from the start, meant to be fit for the most distinguished ambassadors. Its interiors are so palatial that even kings have felt perfectly at home there. Behind an eighteenth-century façade designed by Gabriel, who took his inspiration from the seventeenth-century Louvre designed by Perrault for Louis XIV, the Crillon is "of all hotels, the one that least resembles a hotel," according to Léon-Paul Fargue, author of *Le Piéton de Paris*.

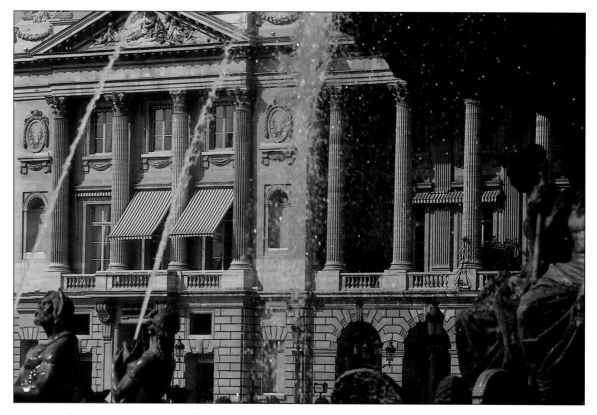

offered one fabulous feast after another to their allies who, after all, had to be flattered by whatever means, but pre-eminently by fine food. The historian and philosopher Jean-Paul Aron collected several crumbs from these banquets in his *Mangeur du XIXe siècle.*

"Carême accomplished prodigies. Talleyrand did not stint either on expenses or on culinary tactics. A very impressive fish was brought in, but a clumsy lackey caused the splendid dish to fall to the marquetried parquet. The Tsar trembled. The winds of impending tragedy blew through the dining room where the fate of the French was being decided. Olympian, Talleyrand gave an order. Immediately, two lackeys entered bearing an enormous salmon, equally pink, equally graceful in its embellishment, which brought immense relief and provoked admiration all around."

The Rue Boissy-d'Anglas, running parallel to the Rue Saint-Florentin on the American Embassy side of the Concorde, evokes another bicentenary, that of Alexandre-Balthasar Grimod de La Reynière (1758-1837). A whimsical and irreverent youth who grew up to become a quick-witted, acerbic, and sometimes destructive and venal critic, Grimod was nonetheless a practiced and enlightened gastronome, today best known for his eccentricities as much as for his writing. The latter consists mainly of the serial

issues of the *Almanach des gourmands* (eight hefty volumes published between 1803 and 1812) and the *Manuel des amphitryons*, which were publicised thus: "*Almanach des gourmands*, or Nutritive Calendar serving as a guide to the ways of eating well, together with a Gourmand's Itinerary for the various quarters of Paris. . ."; "*Manuel des amphitryons*, containing a treatise on the carving of meat at table, the nomenclature of the latest menus for each season, and the elements of gourmand etiquette. . ."

No plaque commemorating Grimod de La Reynière has been placed on the walls of the United States Embassy. Too bad, for the building occupies the site where once stood the Neoclassical *hôtel* in which the pioneering food critic systematically tasted rare victuals, made notes, and wrote his first reports. His father, Laurent Grimod de La Reynière, a wealthy arms supplier and tax collector, had built the residence at the intersection of the Rue Boissy-d'Anglas and Avenue Gabriel some twenty years before the Revolution. After Grimod inherited the house, he soon demonstrated a precocious talent for winning notoriety through the sheer quirkiness of his receptions, the accompanying meals and his amusing observations, subsequently much embroidered.

Grandson of a man who began life as a *charcutier* or pork butcher, Grimod de La Reynière became a friend

of the gourmand/gourmet Voltaire and finally died of indigestion. His background seems to have prepared him well for the historic role he would play in making gastronomy important to the wealthier classes in the period following the French Revolution. He brought *haute cuisine* out of the palaces and into the world at large, while *cuisine bourgeoise* ceased to be the private preserve of the upper middle classes. In this new, liberated atmosphere, everyone with the means developed the habit of comparing menus, looking into the source of foodstuffs, and seeking out the new and the innovative. An *esprit de table* permeated Paris, which made serious eaters more than happy to follow the expert Grimod, who responded with his first *Almanach*: "The heart of most affluent Parisians has suddenly turned into a gizzard; their sentiments have ceased to be anything but sensations and their desires anything but appetites. It is therefore to serve them befittingly that we here, in a few pages, offer them ways, in respect of good eating, to make the most of their *penchants* and their *écus*."

Grimod de La Reynière, the first "media" gastronome, suffered from a congenital deformity of the hands, which caused much bitterness between the boy and his parents. Scornful of his father's social position, he gave a party of such bad taste that it became the subject of endless gossip. This occurred when he persuaded his parents to leave him alone in the splendid family mansion for one evening in February 1783. Anticipating the event, he had sent out seventeen invitations, in the form of a black-bordered announcement, and had distributed tickets giving access to a gallery around the dining room. He thereby transformed his supper into a spectacle, as if it were a royal dinner at Versailles! "You are invited to attend the funeral procession of a great feast to be given by Messire Alexandre-Balthasar-Laurent Grimod de La Reynière, Esquire, counsel before the high court. . . Company will assemble at nine in the evening and supper will be at ten."

Bachaumont, in his *Mémoires secrets*, describes the extravagant meal in detail. It was served on a large table at the center of which stood a catafalque: "The supper was magnificent, running to nine courses, one of which consisted entirely of pork. Following this course, M. de La Reynière inquired of his guests whether they found it good, to which a chorus of voices replied 'Excellent.' He then said: 'Messieurs, this pork is in the style of charcutier so-and-so, who resides at such-and-such address

and is the cousin of my father.' Following another course, in which everything had been prepared in oil, the host also asked if his guests liked the oil. This time he said: 'It was supplied to me by grocer so-and-so, residing at a certain address, and the cousin of my father. I recommend him to you, along with the charcutier."

Subsequently Grimod organized "philosophical lunches" reserved for erudite rebels typical of the pre-Revolutionary period. Beaumarchais, Chénier, and Restif de la Bretonne figured among those who attended these collations, at which *café au lait* and sometimes tea were served, but never wine. The last, according to legend, was drunk in the antechamber, but almost in hiding from the master of the house, who ritually obliged every guest to consume at least seventeen cups of coffee, one after the other. True enough, the beverage was all the rage, with none other than Louis XV preparing it himself for his guests in the Petits Appartements at Versailles.

The great square outside, where Louis XVI, Marie-Antoinette, Lavoisier, Robespierre, and more than a thousand other persons were guillotined during the Revolution, gained its definitive form during the reign of Louis-Philippe, when the obelisk was installed at the center. However, its general form is that planned in the mid eighteenth century by Gabriel, who built the twin façades between which the Rue Royale provides a frame for the Parthenon-like portico of the Madeleine. Behind Gabriel's magnificent façade or screen on the left, the Hôtel de Crillon rose from plans drawn up by the architect Louis-François Trouard. The property was bought in 1907 by the Société des Grands Magasins et Hôtels du Louvre, which also acquired the adjacent buildings along the Rue Boissy-d'Anglas, to make way for one of the most prestigious grand hotels in Paris.

It took considerable work to create the extraordinary hostelry that would provide a home away from home for George V, Theodore Roosevelt, Winston Churchill, Tyrone Power, Charlie Chaplin, Emperor Hirohito, Sophia Loren, Orson Welles, Elizabeth Taylor, Madonna, countless monarchs, and as many stars of stage and screen. Now the pride of the Concorde group, the Crillon, with its 163 rooms and suites, not counting the *grands appartements*, has undergone a number of major restorations. The *salons* are now regilded and their sumptuous parquets renewed; the entire décor now looks fresh as well as elegant; and the marble bathrooms are completely modern.

Around 1990, Sonia Rykiel, whose fashions are on sale in the Crillon's boutique, along with a good selection of tableware, decorated the bar originally designed by the sculptor César. It opens on to the Rue Boissy-d'Anglas, near L'Obélisque, the very Parisian restaurant with a "fast and original gourmand menu." Here, surrounded by handsome *boiseries,* one can feast almost economically, choosing from an array of relatively simple classic dishes and flavorsome country fare, all prepared under the guidance of Christian Constant. This is a good way to sample the Crillon, unless one is prepared for Les Ambassadeurs, the palatial *grand restaurant* with the immense mirrors and all the intimidating gilt and marble, where the check can climb into the stratosphere.

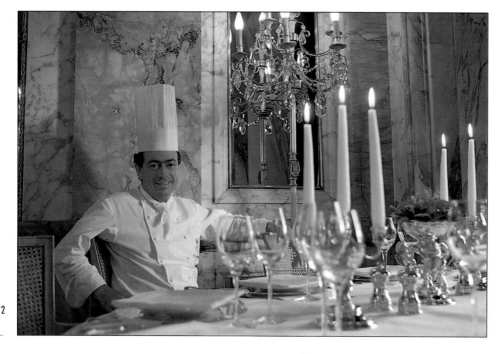

Christian Constant – a veteran of service in some of Paris's best restaurants, including the Ritz, where he spent six years as second to Guy Legay – has now presided for several years over the vast, state-of-the-art kitchens at the Crillon. In this notable hostelry he is responsible for all food services, from staff meals to tea on the patio and the *haute cuisine* of Les Ambassadeurs, *a grand restaurant* in a dining-room of Versailles-like splendor.

Christian Constant is a solid chef who "assures," meaning that he orchestrates everything: breakfasts and room service, staff meals, and food as well as service in the restaurants and the tearoom.

This denizen of grand hotels, who worked at the Ritz for some years, after having been first assistant and then banquet chef at Ledoyen, is certainly not a "grand-hotel cook," in the pejorative sense of the term. Green peppers stuffed with small calamaries cooked like eels, calf's head sautéed in spices, plain-roasted skate's wing, suckling pig's knuckle caramelized in aromatics, Bresse chicken flirting with lightly sautéed Belles de Fontenay – there is nothing fussy or tedious about the repertoire of Christian Constant. Indeed, Les Ambassadeurs has its "straight-

forward" side and a few regional, pleasantly bourgeois accents, all of which help alleviate the overwhelming grandeur of the setting.

Constant works in a basement kitchen that was rebuilt in 1992, without walls but glass-partitioned, not to create compartments but rather to separate heat from cold in a space where everything is in full view. From his office, which is also glassed in, this fit-looking, forty-odd-year old keeps his accounts, writes out the next menu, records his recipes, and coordinates the activities of thirty-two cooks and eight pâtissiers. He provides food for Les Ambassadeurs by way of a service elevator, oversees L'Obélisque and banquets, and keeps an eye on room service, which continues night and day, with a menu of fairly simple dishes capable of surviving the seven- or eight-minute transit from the basement to an upstairs room.

At the Crillon breakfasts are also treated as important: "Businessmen sometimes order three or four in succession, politely joining their guests as they arrive in the morning one after the other. They consume the first one entirely and then nibble at the others, without becoming any the less critical. Look out for orange juice that is too acid, for insufficient fruit. . . Twenty years ago, I would have required twice the staff, and worked uncomfortably in old-fashioned kitchens, with very little variation. Today, I enjoy an efficient and pleasant environment; I take account of the seasons and constantly expand my range. . . But I still care about how a simple omelette or a soft-boiled egg comes out. You order a club sandwich in the restaurant? A guest at the Crillon has every right to expect it to be excellent."

Constant, with his four sous-chefs, manages simultaneously to serve some sixty meals in Les Ambassadeurs (where the menu changes twice a year), about forty in L'Obélisque (whose menu changes every month), and another hundred at banquets, without counting the short bar menu. Then, he must feed the hotel's 150 employees, think up something for the summer patio, and supervise the pastries served in the winter garden.

Close by, in the Rue Boissy-d'Anglas, Aude Clément has filled Au Bain-Marie with such an abundance of table arts, in every style and category, underlining their supreme importance in the Concorde/Rue Royale neighborhood. Moreover, she has done it in a way that sets her shop apart from the other long-established luxury boutiques there. After creating Au Bain-Marie in the Rue

du Mail, Mme Clément began to attract an international clientele from the world of grand hotels and the wealthy of Paris. The great chefs pay regular visits to inspect her utilitarian novelties, unconventional but functional objects, silverware, and china. Mme Clément, who designs many of the items, remains alert to new trends, commissioning individual artists, but leaving them to work freely.

Only the odd-numbered side of the Rue Royale would satisfy the strolling gourmet were it not for no. 16, where Ladurée offers its macaroons and superb pastries in a shop with tastefully traditional moldings which also doubles as an ultra-Parisian tearoom.

Maxim's, at no. 3, boasted three stars until the mid nineteen-seventies, and then disappeared from the Michelin guide, after those in charge of the establishment refused to accept its demotion, which came when the Michelin inspectors finally grew tired of the lobster stew and the Merry Widow crêpes. However, the restaurant is part of the history of Paris, even though the façade and awning give no clue to the splendor inside. It is a "monument," if not a temple of cuisine! Moreover, it was always the *maîtres d'hôtel* or the directors, Albert or Roger, who were the subject of conversation, not the chefs, except of course Alex Humbert, who slipped a few novelties into the traditional menu during the years 1955-59.

Pierre Cardin, the shrewd white knight of 1981, has undertaken to exploit the magical name worldwide and merchandise all kinds of product under the Maxim's name, apparently without the least concern for a robust return to the Michelin fold. He could perhaps take comfort in the point made in 1978 by the former owner, Louis Vaudable: "Maxim's stars are not in a guidebook but rather in the dining-room. We are outside the norm, and it was I who wanted us to withdraw from the guide, if no mention could be made of our unique character. . ."

Maxim's symbolizes a hundred years of a certain kind of Parisian life. In 1862, a group of *glaciers* opened shop in one of the severely elegant mansions constructed in a uniform row according to Gabriel's master plan. The lease allowing for ice-cream and lemonade venders or a restaurant was taken over in 1893 by Maximin Gaillard, a *maître d'hôtel.* Since he preferred to be known as Maxime, the house made its signboard read "Maxim's and Georges," the second name from a partner who later dropped out.

The first customers were coachmen whose masters were dining at Weber's or Lucas Carton's. Together with the young women trolling the quarter, they were a boisterous lot, soon however to be supplanted by wealthy dandies and their expensive courtesans. The clientele with whom the high-bourgeois gentlemen went slumming, in the company of their trophy cocottes, was itself replaced by a *Tout-Paris* not very particular about settling their accounts. By the time Maxime Gaillard died, in the winter of 1895, the house was well known, thanks to its

list of debtors, which had grown dangerously long. Into this situation came Eugène Cornuché, a cook turned *maître d'hôtel* much dependent upon the financial support of the sugar manufacturer Max Lebaudy. Cornuché knew the celebrities of contemporary Paris, the ins and outs of their married lives and affairs, and he had the good sense to cultivate warm relations with the extravagant Marquis Boni de Castellane, who had married the American heiress Anna Gould. With his gift for publicity (free), the master of the house carefully managed the "omnibus," the corridor room just inside the entrance to the restaurant. Here he seated the most recognizable *habitués*, with the result that customers arriving immediately caught sight of Robert de Montesquiou, Jean Lorrain, or Georges Feydeau, the kind of people sketched or caricatured by Caran d'Ache, Forain, and Sem.

In 1899, when Feydeau produced his *Dame de chez Maxim* at the Théâtre des Variétés, Cornuché completely changed the restaurant's décor, which the architect/decorator Louis Marnez turned into an Art Nouveau masterpiece. Artists and craftsmen worked together to translate their School of Nancy style into a supple interplay of mahogany, copper, and colored glass, winding long arabesques into fantastic knots, expanding flowers into great, floppy, stylized blooms, and slipping lissom nymphs out of their clothes.

Maxim's flourished throughout the Belle Époque and suffered little during the Great War, when it entertained well-heeled shirkers and heroic aviators alike. It was here that Yvonne Printemps had a brief fling with Georges Guynemer before falling in love with Sacha Guitry, and here as well that Mata Hari often dined in a private room. In 1920, Yves Mirande brought *Le Chasseur de chez Maxim's* to the Théâtre du Palais-Royal. Gustave Cornuché, who took over from Eugène, his brother, passed the baton to Octave Vaudable, who took on Albert, "the prince of *maîtres d'hôtel* and the *maître d'hôtel* of princes."

Corpulent, awesomely polite, Albert lured back the royal highnesses and *le Tout-Paris*. During the Occupation, he had found himself reporting to a German commissioner. Still, excellent professional that he was, Albert went on welcoming his guests, among them Goering and Otto Abetz as well as Jean Giraudoux, Coco Chanel, and Sacha Guitry. Briefly imprisoned after the

Liberation, he escaped the *épuration* process, perhaps because he had imposed it so often on his clientele, the better to keep it select. Now came a new Belle Époque, along with important changes in the décor, carried out under the direction of Maurice Carrère, a decorator with a background in cabaret. In 1949, Maxim's gloriously celebrated its fiftieth anniversary, a bit late owing to the "dark hours" of 1940-44. Jean Marais read an impromptu speech written by Jean Cocteau: "Maxim's! Are we in ruins bathed by moonlight? No. The décor is intact. The lianas of copper and mahogany interlace mysteriously about vaporous nymphs. . ."

On 1 April 1994, the big clock of little history might very well have rung in the centenary of Maxim's, since it was exactly one hundred years earlier that Maxime Gaillard took over the one-time ice-cream parlor at 3 Rue Royale. It could scarcely have been imagined that the new owner's first name would become a cachet label for all manner of tableware and restaurants, from Paris's Orly and Charles de Gaulle airports to New York and Peking.

A few steps to the right along the Rue Royale are the flagship shops of Christofle and Lalique, an extremely prestigious pair of next-door neighbors. Together they exemplify the arts of the table, of the *salon* table, of *grand chic*, of beautiful *objets*, and "creations" tirelessly reproduced with taste and reserve, of classic artifacts that are never used, contemporary but not radical.

At Christofle the windows on the street and the display cabinets inside are characterised by a sober but compelling elegance. On lavish display are sumptuous pieces of silver hollow-ware, tea and coffee services, whole series of solid-silver or silver-plated flatware, their patterns continued for years (the house repairs and resilvers its old, long-used products), and a hundred different baubles, all knick-knacks for the table. The world-famous house has been in business since the mid nineteenth century, when Charles Christofle and Joseph Bouilhet bought the patent on a process for silvering and gilding metals and then exploited it. The firm is still committed primarily to silver products, but it has also brought out a line of pretty Limoges porcelain in several different patterns.

Next to Christofle is Cristal Lalique with its carefully arranged double *vitrines* full of the subtle fires and flashes of refracted light. The shop, now felt-lined and revamped, has been at this site for the last sixty years. It

extends deep into the building, drawing visitors into a disorienting world of coruscating transparencies, contrasting translucencies and satinations, supple, rounded masses, and crystalline metamorphoses. A door opens into a large paved courtyard, at the foot of which there is a display of Lalique glass, some of the pieces very simple and pure of line, others quite complicated. Nearby are porcelains from Limoges.

The building occupied by Maxim's dates from 1777, when it was built by the great architect, Étienne-Louis Boullée, in keeping with the master plan drawn up by another great architect, Jacques-Ange Gabriel. The famous Art Nouveau interior by Louis Marnez came much later, in 1899, following the death of Maxime Gaillard. However, it underwent restoration or modification on several occasions, the last of which was in 1981, when the couturier Pierre Cardin bought Maxim's and redid the upstairs dining rooms in the Art Nouveau style.

Oddly enough, several of the crystal services include old-fashioned champagne glasses of a sort that no respectable drinker of sparkling wine would serve, given that champagne requires tall, slender flutes like those also found here. René Lalique, who was born in 1860 in Aÿ, one of the most beautiful parts of Champagne, must have known this, but the bubble-flattening cup-like glass was much prized by fashionable ladies during the Belle Époque. René Lalique, founder of the dynasty, was a great artist, with a magical touch when it came to glass-making. In 1902 he transformed his business from a craft into an industry, for which he took over a large building in the Cour Albert I. Subsequently, he handed the business over to his son Marc, who in turn was succceeded in 1977 by Marie-Claude Lalique. A one-time student of the *École des Arts Décoratifs*, Mme Lalique has proved herself a true heir to her grandfather's talent.

Lalique shares the courtyard and both sides of the entrance passage with Bernardaud, since 1863 an eminent name in Limoges, France's most important porcelain manufacturing center. This celebrated firm, known for its attention to tradition as much as for its outstanding technology, offers patterns like those our great grandparents admired, pieces for a pre-Gulf War emir and even plates designed in an understated modernist style. One astonishing service, entitled "Les Métropoles," evokes the great cities of the world and costs almost as much as a trip around the world.

At no. 13, the Cristalleries de Saint-Louis has its extraordinary *vitrine*, a window of almost minimalist displays of fragile glassware, of great luxury and, sometimes, of great art. Foremost in the range are *sulfures* (heavy glass paperweights) that could ruin a really passionate collector and, in small cases, antique pieces that would be the pride of any museum of decorative arts. Villeroy et Boch, closer to the Madeleine Church, represent a descent from the heights of superluxury, but hardly to rock bottom prices. The shop stocks a variety of designs, several signed by French designers. Paloma Picasso, for instance, has worked her way through glass, silver, and porcelain. Alain Vavro, the designer of labels for Dubœuf Beaujolais, as well as the "illustrator" of china and menu covers for both Paul Bocuse and Jean-Paul Lacombe (Léon de Lyon), has created one of the most recent patterns which, however, is not sold here, being reserved for professionals.

Seafood
by Henri Seguin

Since the gourmet promenades suggested by this book do not pass through the Porte Dorée near his Pressoir, Henri Seguin has been good enough to prepare, out of context, one of his most popular assemblages.

Did Seguin once have a careless moment, even a long time ago? If so, today he is up to the best of Michelin's two-star chefs and superior to a number of GaultMillau's 18/20s. But enough said, let's eat! The photogenic platter seen here must be consumed in a certain order, beginning with the scrambled eggs in sea urchins, followed by the oysters soaked in spinach juice and the scallops roasted in salted butter and accompanied by a small slice of pumpkin, and finally the cassolette of mussels stuffed with foie gras.

Jean-Jacques, the sommelier at the convivial house in Avenue Daumesnil, recommends a better than average Chablis from Louis Pinson as the perfect companion for this beautiful composition.

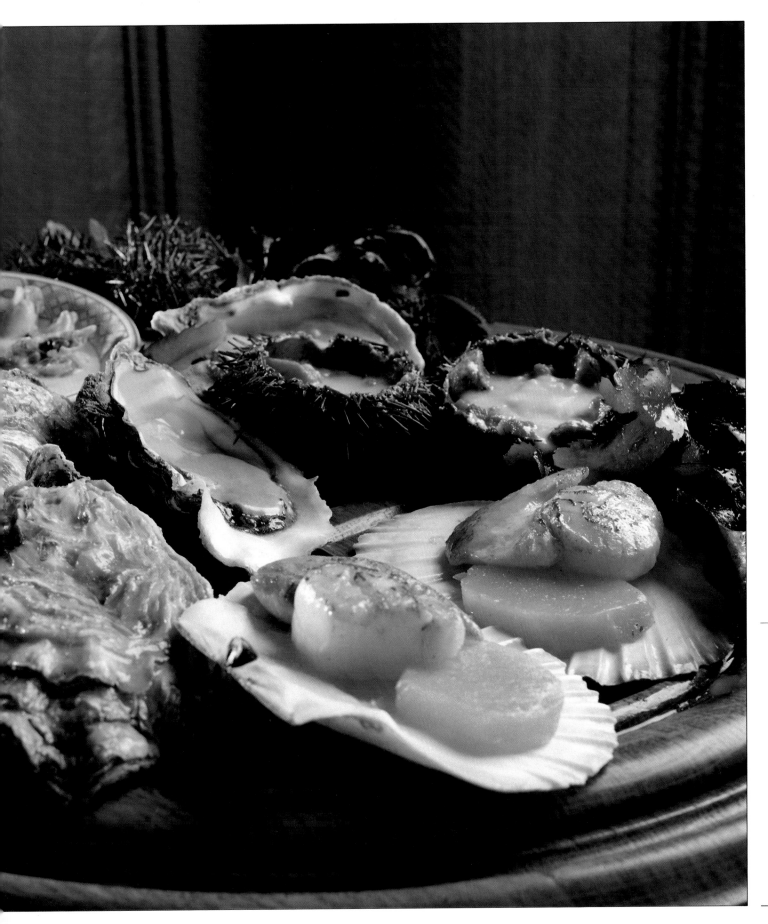

*Seafood by
Henri Seguin*

*Au Pressoir
257 Avenue Daumesnil
Paris XII*

5 9

The Place de la Madeleine, created in the eighteen-twenties around a Neoclassical church of cold but imposing grandeur, has miraculously retained its traditional gourmet shops. They serve a very Parisian public, the same social and economic élite who patronize the opulent shops of the Rue Royale which frames the colonnaded portico of the Roman Catholic basilica, the scene of so many grand weddings and fashionable funerals.

Gabriel's master plan, drawn up in the mid eighteenth century, called for a majestic church at the focal point of the perspective provided by the Rue Royale. It was to replace a modest chapel dedicated to Saint Mary Magdalene. Louis XV laid the corner stone of the new monument designed "to terminate the Rue Royale agreeably," which explains its abnormal north/south orientation. However, the Revolution demolished whatever had been constructed.

In its place, Napoleon wanted a temple dedicated to military glory , and commissioned Pierre-Alexandre Vignon to design one based upon the ancient Maison Carrée (1st century BC) in Nîmes. After the fall of the Empire in 1815, Louis XVIII decided that Vignon's noble Corinthian pile should serve as the pivotal church originally planned for the site. Begun in 1807, the building was not finished until 1845.

Lucas-Carton, famous in the past, has gained a new international reputation as the highly praised and closely guarded fiefdom of Alain Senderens, one of the leading pioneers of *nouvelle cuisine*. Located opposite the portico of the Madeleine Church, the restaurant is a triumph of subtle Art Nouveau design, its *boiseries* and its glass and bronzes dating from 1904-5.

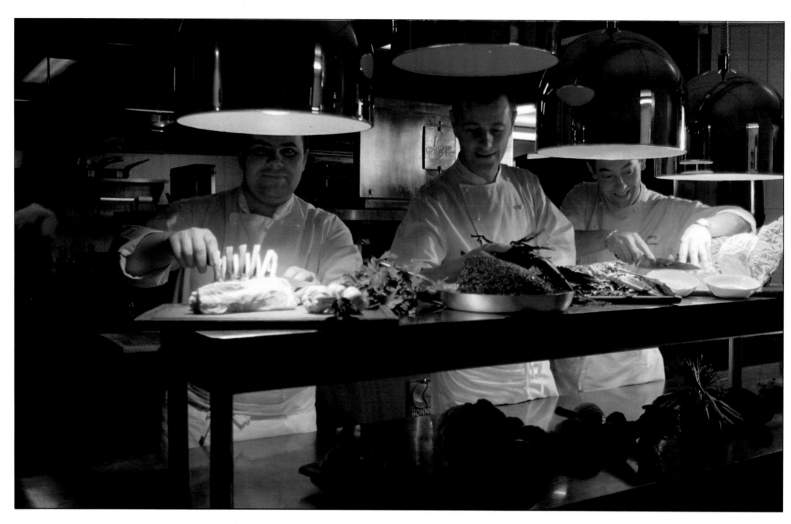

Alain Senderens is sometimes detained by his vineyard in the Lot department or by his often passionate involvement with research related only indirectly to his three-star cuisine. Does this relative absenteeism explain the decision of GaultMillau to subtract a half-point from his top rating in 1994? Be that as it may, the adulated and controversial Senderens does everything to "lock in" his system of working. This means, to begin with, counting on the precision and talent of his excellent chef, Bernard Guéneron (at center) and such first-class professionals as Philippe Peudenier (at left). The team's creations for the spring of 1994 included *langoustines* encased in fried vermicelli and garnished with fresh asparagus and a truffled egg, loin of lamb with cucumbers and ginger, and a delicious big chocolate macaroon.

This huge church, with its wide, lavishly carved pediment atop a tall colonnade, overlooked a popular flower market, now a mere remnant, and an extremely well supplied covered market (until destroyed in 1920, it occupied the site of nos. 25 to 35). Since then, the local alimentary tradition has been surprisingly well maintained, thanks in considerable part to its situation at an important crossroads. The handsome but charmless square is home to no less than Fauchon and Hédiard, grocers, *traiteurs*, confectioners, and masters of fruits and vegetables which are as much a joy to the eye as to the palate. The Place de la Madeleine also harbors the memory of restaurants much frequented by *le Tout-Paris*, one of which survives today. Here, at Lucas-Carton, experts will be debating, well after the year 2000, the personality and motivation of Alain Senderens, a figure at the cutting edge of *haute cuisine*, an innovator of whimsy, given to self-questioning and moods hardly common in his profession. Revered as a creator of exceptional flavors, Senderens reigns over Lucas-Carton, at the peak of a career which really took off when he, along with other members of the culinary avant-garde, helped launch the *nouvelle cuisine* revolution of the nineteen-sixties and nineteen-seventies.

Ralph Lauren's Polo Shop, at 2 Place de la Madeleine, occupies premises originally occupied by Durant, called by one commentator, writing in 1860, "the third wonder in the art of good living" (after the Café Riche and the Café Hardy in the trilogy of now disappeared "wonders"). Its patrons included Maurice Barrès, Anatole France, and General Boulanger, who was dining there on 27 January 1889, when his supporters tried to lead him into the Presidential Palace – the Palais de l'Élysée – some ten minutes away. It was also at a table in Durant that Émile Zola wrote *J'accuse* in one single flow of outraged rhetoric.

At 3 Place de la Madeleine stood Larue, where chef Joseph Voiron created a sauce derived from béchamel and then dedicated it to an elder brother, Mornay. Was

he really the first cook to take traditional béchamel and add egg yolks and Gruyère cheeses to it? Be that as it may, *sauce Mornay* accompanied many a dish until the advent of the so-called *nouvelle cuisine* ushered in by Senderens, Guérard, and other reformers.

Larue was synonymous with *la grande cuisine* for more than fifty years. Its closure in 1954 shocked gastronomes who remembered the restaurant in its glory at the height of the Belle Époque, when Larue also stood for the very spirit of Paris, which Proust himself acknowledged by his regular presence. They also recalled its great years under the aegis of Édouard Nignon, who took the restaurant over in 1908. Today forgotten by the general public, this Breton had worked in the very best establishments, among them Potel and Chabot, the Café Anglais when it was still under the influence of Adolphe Dugléré, and Chez Magny, where the Goncourts met their friends. Larue, named after its founder, a cook of no great consequence, enjoyed a tremendous success in the period before the Great War, and it remained one of the premier restaurants of Paris when Nignon handed the reins over to his nephew in 1921 and thereafter devoted himself to culinary writing.

Lucas, now called Lucas-Carton, occupies an 1839 building which had housed a restaurant as early as the mid nineteenth century. In 1871 it gained a new tenant, an English tavern that one Richard Lucas had opened in 1832 with the purpose of introducing Parisians to the delights of cold roast beef and Yorkshire pudding. Shortly after its arrival in the Place de la Madeleine, Lucas was taken over by the enterprising A. Scaliet, who then installed a wine shop next door. He also had the Lucas interior redecorated in the discreet Art Nouveau manner that happily survives today, its subtle harmony in marked contrast to the flamboyance of Maxim's, created only a short time before.

In 1903, the architect De Gounevitch endowed Lucas with a new façade styled in the Nouveau manner of the day, only for it to be mutilated later on. In 1904, and again in 1905, the sculptor Planel and the bronzier Galli redid the two dining-rooms on the ground floor, where the lovely maple and sycamore paneling remains in place. The wide "basket-handle" or "flat" arches rising and falling across the paneled walls provided a framework for a collection of paintings, now replaced by large mirrors that make the rooms look both bigger and brighter. Bronze sconces in the shape of flower-women combine with the *boiseries'* relief-carved borders of intertwined vegetal motifs and the rare quality of the furniture to create an exquisitely homogeneous ensemble. Splendidly crafted, their fantasy beautifully controlled, the Lucas dining-rooms counted among the most charming and handsome in Paris. This was the setting, drawing much of its character from the use of lighter woods, sometimes attributed to the Nancy master Majorelle, in which Foch, Joffre, Pershing, and French gathered on 10 November 1918 for a dinner at which they fixed the time for the signing of the Armistice the very next day.

In 1925, Lucas was acquired by Francis Carton, president of the Société des Cuisiniers de France, who then added his name to that of Lucas. This great connoisseur of wines, always concerned with quality, played host to many of the period's leading personalities at what was now Lucas-Carton. When his son-in-law took charge, he inherited an outstanding cellar, and then continually improved it, gaining a major reputation along the way. The Michelin for 1937 awarded Lucas-Carton three stars, citing in particular the sole *de ma tante Marie*, the *gratin de champignons Lucas*, and the *bécasse* (woodcock) *flambée*. The average bill, not counting wine, came to 50 francs, which was comparable to prices charged by the best Parisian restaurants of the day, but about double that of a meal in a reputable brasserie.

Lucas remained a serious house after World War II, thanks to good chefs, such as Gaston Richard, under whom Paul Bocuse and the Troisgros brothers did their apprenticeships during the nineteen-fifties. Then came Marc Soustelle, a traditionalist more than an innovator, but gifted and rigorous. After his departure in 1966 came the downfall, accentuated perhaps by the extreme conservatism of Mme Allégrier-Carton.

Courtesy on the part of Gault and Millau towards an elderly lady who had no patience for their sad disenchantment? Diplomatic renunciation of the right to criticize? The two food critics omitted Lucas-Carton from the 1983 edition of their guide, in which, however, they prematurely praised the renewal of Maxim's. They also repeated their admiration for Alain Senderens, whose cuisine they had already described, ten years earlier, as magical and unique.

In 1985, Senderens took over Lucas-Carton, aided by a group of Japanese investors to whom he pays rent, but from whom he takes no direction whatever. Years before he had already done his apprenticeship there, following in the footsteps of Bocuse and the Troisgros. Later he called the Lucas-Carton kitchens of that period "a conservatory through which I do not regret having passed, after the Tour d'Argent, where I had gone following my military service, before the Berkeley." Did it annoy Mme Allégrier that she was selling to a former employee? Senderens continued: "I had opened my first restaurant, Rue de l'Exposition, on 2 April 1968. Not in the 1st *arrondissement*, to avoid all the jokes. I had taken a tiny bistro. I couldn't do much with the equipment on board, and the events of May emptied the restaurants. . . Fortunately, I received a good press, because in building my library, I had rediscovered some old forgotten recipes, which I was adapting to contemporary taste. Then I thought, search for new things, by respecting first of all the produce, by using less fat, by considering health. . . Around 1971-72, when I was getting started in the Rue de Varenne, in a slightly larger space, Gault and Millau discovered that something similar was going on with Chapel, Guérard, and Troisgros, and began talking about *nouvelle cuisine*. . . Michel Guérard, with whom I'm still friends, was then at the Pot-au-Feu in Asnières, no better set up than I was. He said to me: 'Come tonight! I've made something that ought to be terrific, you'll see. . .' The minute I could break free, I went out there, and very quickly admitted: 'Now here's an idea I wish I'd had!' (But copying is out the question.) I returned home promising myself that I too would do something new all my own. Some time later, I called Michel: 'Come and eat this; I think it's interesting.'"

Senderens was still going to the central Halles: "Until the transfer to Rungis, it really had remained a world apart: the nineteenth century in 1968. . . Incredible. I went there to have breakfast with pals just as much as to get inspiration from a new delivery. In jeans or in tuxedo, there was always someone to run into. A great thing at the time, at least for those who patronized Jean Castel, a friend of the best restaurateurs: we could stop in at his joint before or after doing the market. . ."

A native of the south-west, Senderens became thoroughly Parisian while still a young chef. "I believe there are lucky 'gastronomic meridians,' such as that of Paris. It's a city where everything converges. Without knowing why, I sense that I would never have created vanilla lobster in Strasbourg or in Cahors. If I hadn't settled in Paris? I think that I would have played around with local produce, that I would have studied the cuisine of the region. My style may not have evolved very differently, but I would have been inspired by 'grandmama's recipes.' Duck *foie gras* steamed in a cabbage leaf and veal sweetbreads with carrots would probably have shown up on my menu. . . which would certainly have turned out differently."

Senderens received his three Michelin stars and his 19/20 GaultMillau while still at L'Archestrate in the Rue de Varenne, where he was known for the much-imitated truffle raviolis, lobster in a papillote of leaks, veal sweetbreads with asparagus and mushrooms. At a time when he was battling against "modern" sauces thick with butter and calories, he never ceased to admit that he still dreamt of the country. Even when he moved to the Place de la Madeleine, taking all his Michelin stars with him, he and his wife, Eventhia, wavered a little over their decision to remain in the capital: "I had suffered from feeling cramped, and thought of a *relais* or a château. . . I was happy to move into a larger place, at Lucas, but I didn't feel at home immediately. It was a year before I got the measure of the house, still longer to feel, returning from holidays, that it was waiting for me. I felt there was a struggle going on between me and Lucas-Carton. My arrival, with the Archestrate menu, did not suit the panels and mirrors. My cuisine matched the dimensions and ambience of the house I had left. It just was not in keeping with the Majorelle style. There was something missing, so I eliminated dishes that seemed out of proportion with the setting. The décor is too elegant for stewpot cookery."

Sometimes more concerned with his vineyard, sometimes seemingly too far removed from the daily life of the city, as though living a parallel life, sometimes allowing a note of fatigue to slip through, yet always creative, Senderens has continued to evolve. He can still astonish, with dishes apparently put together from nothing, yet strangely pure and fully expressed. He loves wine: "I no longer want to be judged dish by dish, but for the whole of a meal, the marriage of food and wine. A number of my dishes don't work if the wine which goes with them is taken away . . . My *canard Apicius*

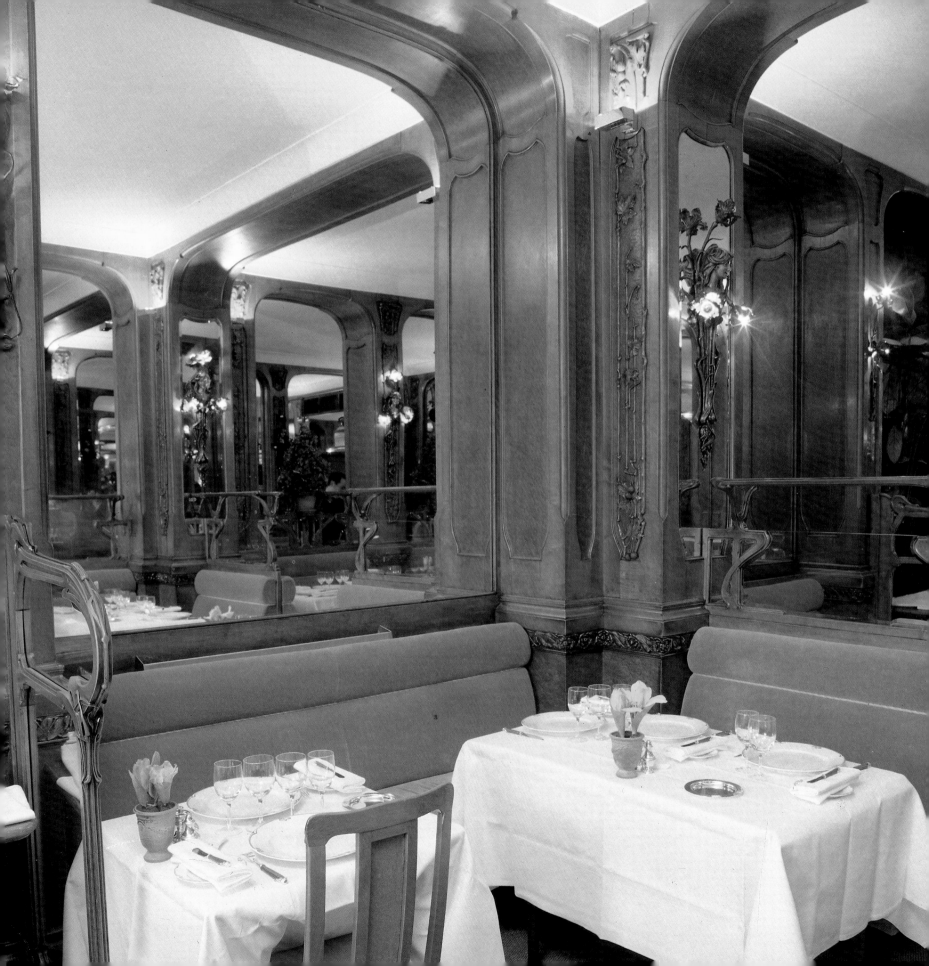

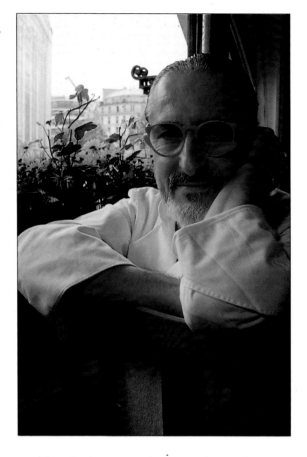

would not be the same without Banyuls. Vanilla lobster without its glass of Meursault is nothing! Sometimes I dream of converting Lucas into a wine bistro! True gastronomy is the marriage of glass and plate. I like to construct a dish for a wine, a work of art proclaiming the identity of a certain piece of land, of one or several vines, of one wine maker."

The clamor of the Place de la Madeleine never penetrates the house of Senderens. At the large Baccarat boutique on the corner of Malesherbes opposite Lucas-Carton the noisy world outside does little more than set off a gentle chiming among the crystal pieces. Here, the beauty comes from the glittering chandeliers reflected in beautiful, costly artifacts – decanters, pitchers, and glasses which invite gentle caresses of fingers and lips alike.

La Cristallerie de Baccarat, now part of the Taittinger empire, always has on display a collection of extraordinary pieces from the last hundred or so years. The house takes its name from the little town in Lorraine where its workshops have been located since the end of the eighteenth century. It is there that the firm combines state-of-the-art technologies with the traditional methods practiced by makers and cutters of glass since time immemorial.

A couple of steps away there is a pleasant wine bistro, L'Écluse, which offers good *bordelais* fare at very reasonable prices. Next comes Tanique, and then Caviar Kaspia, a simple boutique with dining-rooms upstairs, timeless, quietly luxurious, air-conditioned havens with show cases and pictures of the now mythical Russia from which both white and pink Russians emigrated. Arcady Fixon, the president of Kaspia, opened shops at 17 Place de la Madeleine in 1953, but the firm had already existed for almost a quarter of a century. It began as a store near the Opéra which immediately became fashionable, with Diaghilev and the young Lifar among the clientele. There they found caviar, vodka, champagne, and an innovation that would have many imitators: "refrigerated mechanical bars" dispensing caviar sandwiches.

Caviar Kaspia, which has a near twin in London, sells sevruga, osetr, and beluga caviar, from Iran or from Russia, in small pots or in boxes, as well as smoked salmon, smoked eel, Swedish marinated herring, pirojki, and bortsch. The shop also stocks a good *foie gras*. Next door, at 19 Place de la Madeleine, the Maison de la Truffe also sells caviar, from Petrossian, but the speciality of the house is the truffle, which comes from the Vaucluse as does the owner. This *boutique/traiteur* doubles as a decent restaurant offering several *plats du jour* at reasonable prices and several variations on the truffle.

Another two steps and we are at Hédiard, nestling in the corner of the square. There are other Hédiards in Paris, and several distributors of its brand products outside Paris, but the "historic" shop is this one, housed in a freshly refurbished building. Classic in appearance, the beautiful, wood-paneled emporium has on display the best fruits and vegetables from everywhere in the world: asparagus, nuts, and pears from France, gombos from Cyprus, tamarinds from Thailand, sugar cane, persimmons, mangoes, and papayas. It also stocks pastries and delicate confections tempting enough to win a lady's favor, and a good selection of wines, champagnes, and vinegars.

Grapefruit, hothouse pineapple, and certain exotic fruits were just beginning to gain favor when Ferdinand Hédiard was born on a farm in Beauce. Barely in his teens, he left home and took to the road, initially as a carpenter accepting work wherever it could be found.

To survive, he also worked as a shop assistant, which introduced him to the grocery world of Paris, where he donned the black cap common to the trade. Young Hédiard also passed through Toulon and other seaports, discovering along the way exotic fruits of a kind rarely found in the Parisian markets. He decided to make them his speciality.

In 1850, Hédiard opened his first business, the Comptoir des Épices et des Colonies, where he took the innovative step of maintaining a regular stock of fruits and vegetables from the four corners of the globe. Paris soon acquired a taste for these alien foodstuffs. A few years later Hédiard had found his way into the Place de la Madeleine, occupying a small shop at no. 21, where he caught the eye of the fashionable folk dining at the smart restaurants nearby, the public strolling along the Boulevard des Italiens, and the quarter's own resident population of rich matrons. He won his gamble on the appeal of the exotic, by offering "colonial products" with bizarre names, by importing them by the boat-load, and by educating his clientele: "To eat a banana, you remove the skin with the fingers and bite into what remains."

The Second Empire covered Hédiard with all manner of medals and honors, recognizing this pioneer importer of bananas as one of the nation's great men of food. Once exotic foodstuffs became commonplace, the shop still maintained its reputation, thanks to its jellies and jams, its sweets, and the wines in its exceptional cellar. Hampers of fruit, cases of assorted wines, *eaux-de-vie*, and liqueurs proved a continuing success and remain favorite gifts among Parisians.

At the back of the square, behind the Madeleine itself, there is a Nicolas, an outlet for the distinguished chain of vintners, almost intimidating behind its somber windows, and richly stocked with glassware as well as wines, all of a quality consistent with the quarter but at

At Baccarat, tucked away in a corner of the Place de la Madeleine, the most beautiful pieces of French crystal sparkle in all their fiery fragility. Only *savoir-faire* of the most amazing kind could create *vitrines* alive with such luminous transparency and glinting reflections. Yet the art practiced by the universally renowned Cristallerie Baccarat is a very traditional one.

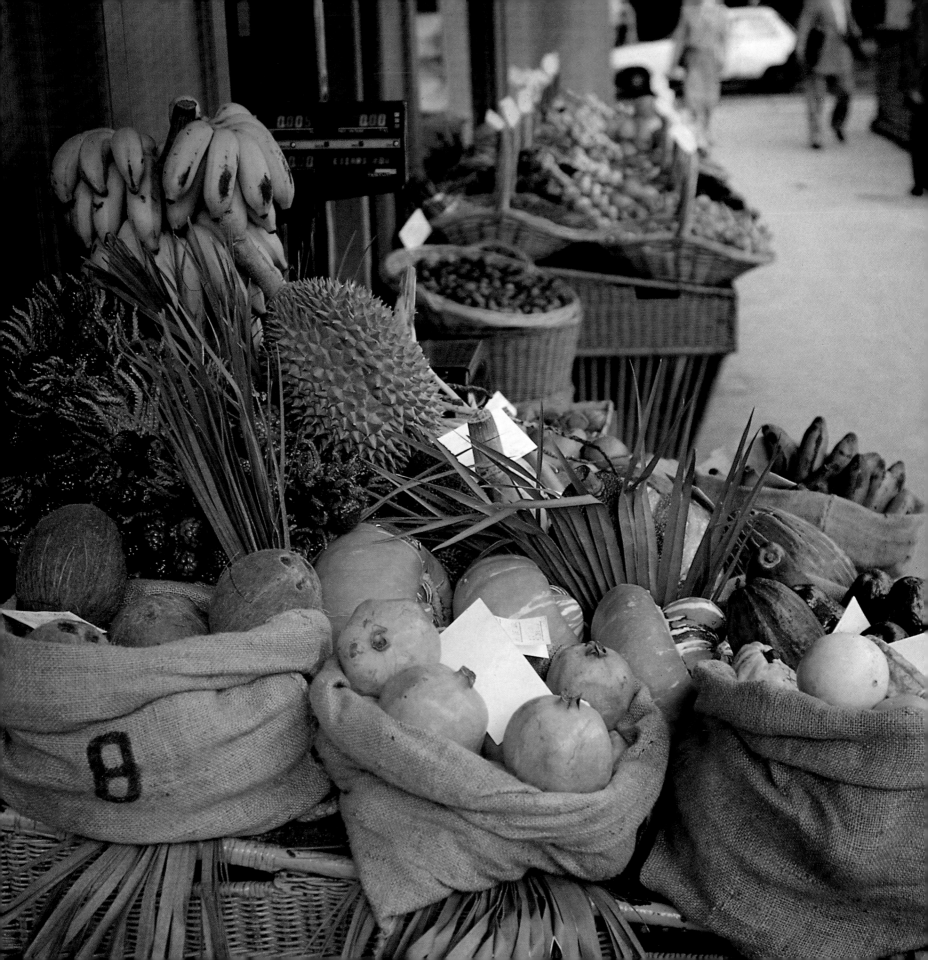

rather more accessible prices. There is also a Madame de Sévigné which, like the sister shop on the Place Victor-Hugo, perpetuates the name of a once celebrated *chocolatière*. The stock includes preserves, various sweets, and delicious *dragées* (sugar-coated almonds).

The most prestigious establishment on this side of the square is Fauchon, whose name, like that of Maxim's or La Tour d'Argent, is part of everyday Parisian vocabulary. Indeed, the shop counts among the key symbols of consumption *à la grande bourgeoisie*. Auguste Fauchon, a Calvados Norman born in 1856, arrived in Paris without a sou, did an apprenticeship under Félix Potin, and bought a pushcart from which he sold fruits and vegetables in the Place de la Madeleine. He opened his first shop at the corner of the square and the Rue de Sèze, then took over the two shops next door at nos. 24-26. To the original *épicier de luxe*, Fauchon gradually added a *pâtisserie,* a *salon de thé,* and cellars. By 1924 the complex of Fauchon shops also included a restaurant.

Auguste Fauchon, who died on the eve of World War II, had no interest in "culinary exoticism" and cheerfully referred to Hédiard anyone desiring the one-time "colonial produce" that today fills an entire window at Fauchon. The shop prospered by trading in the very best products of France: fruits and vegetables, charcuterie, poultry, and cheeses, dry biscuits or cookies, confections, wines, and liqueurs. Meanwhile, Fauchon also excelled as a *traiteur*. After World War II, the house was acquired by Joseph Pilosoff, the mastermind of a new departure. Pilosoff signed a contract with Air France, whereby, beginning in 1953, the shop would supply everything the airline might require in the way of exotic provisions. With this, Fauchon became big business, which grew still bigger under Pilosoff's granddaughter, Martine Premat, managing director since 1986.

Fauchon carries a stock of some 20,000 items, 4,500 of them under its own label. In the Place de la Madeleine, Fauchon can also attract well-heeled customers with a bakery, a fishmonger, and a cheese shop, in addition to the best in fruits and vegetables, wines and liqueurs, *pâtisseries*, and *confiseries*. Without considering the trattoria and other new activities developed at no. 30, annexed by Fauchon II, there are the cafeteria, which has tables and a *croque-debout* (stand-up counter), a shelf full of table articles, a fairly prestigious restaurant, and "Le 30," with its somewhat *cinéma* décor, which specializes in carefully

prepared classic dishes and good desserts. Fauchon, not surprisingly, makes 25 per cent of its annual sales in December – more than two tons of *foie gras*, as many tons of chocolate truffles, twice as many of *marrons glacés*, and enough *boudin blanc* to stretch three times round the Place de la Madeleine.

Fauchon has additional display windows on the Rue Vignon, which makes its own contribution to the gourmet reputation of the quarter. Hubert, who began in the Neuilly market, made quite a splash in the nineteen-seventies with his attractive cheese-filled shop before launching into a restaurant. La Ferme Saint-Hubert at no. 21 is now the fiefdom of Henri Voy, who created a small, pleasantly rustic restaurant specializing in cheese-based dishes. Across the street, ten numbers away from

the Roi du Pot-au-feu, the Maison du Miel, a simple, well-run shop, offers what bees and flowers produce at their best. It stocks not only honeys but such accessories as *pains d'épice* (gingerbread) and a few sweets. The lavender, thyme, heather, thistle, chestnut, lime, and black alder honeys are French, the acacia from China and Hungary. There is also clover honey from Canada.

In the Rue Vignon one can dine classically or just snack. Chez Aubépain sells sandwiches, salads, and Viennese pastries. At Tarte Julie the clientele is not one overly concerned with the arts of the table or convinced that cuisine figures among the fine arts. A comforting thought, given all the pressures at work elsewhere in the quarter.

Hédiard, behind the Madeleine, stocks the most exotic spices but also the freshest produce, the "biggest" wines as well as excellent "little" wines, in addition to chocolates, jams, etc. More than anything, however, Hédiard purveys fruits and vegetables from every region of France and every country on earth. The colors and flavors of the entire world sing out from the shop's stalls on the far side of Vignon's immense Neoclassical church.

A name, a label perhaps, but, in reality, what Fauchon means is an incredible selection of epicurean goodies, fairly high prices, and celebrity far beyond the confines of the French capital. Still, the top-drawer emporium retains a certain irreducibly Parisian spirit that survives the global success worn by the house since World War II.

6 9

The most famous hill in the world? Of course, but better known to visitors from the French provinces and foreigners than to native Parisians. The latter scale the heights occasionally to meet a visiting cousin, or perhaps to poke fun at the "artists" in the Place du Tertre, while ignoring the northern and eastern slopes altogether, a good part of the neighborhood. Once a village and now part of the 18th *arrondissement*, Montmartre has never quite been absorbed into the rest of Paris, retaining instead a certain independence, a commune with its own major and minor roles in history. Although a tourist site *par excellence*, Montmartre only gives itself up to outsiders at its summit, amid the general decay around the steps and gardens of Sacré-Coeur, as well as along a few steep, serpentine lanes intersected by sudden flights of steps.

But which Montmartre? The one that emerges from the roof-tops of Paris, crowned by the all visible Sacré-Coeur? The Butte, the inspiraton of so much writing, looks over older, inner-city neighborhoods, some of which, like Montmartre itself, were integrated into the capital only relatively lately. The name Montmartre, its etymology still in dispute, recalls the heights upon which a medieval abbey long stood, covering the area now occupied by the Place du Tertre, the church, and the upper part of the Rue Lepic. It also designates the boulevards of

The great windmill of the old Moulin-Rouge, which dates back to 1889, still turns at the foot of Butte Montmartre. And the program remains much the same: dinner with music-hall entertainment featuring beautiful tall girls with long legs. While not necessarily French, the girls have no trouble evoking those *p'tites femmes de Paris* who are said to have stimulated the fantasies of men all over the world.

another world, that of Toulouse-Lautrec, the Moulin-Rouge and the *chansonniers*, the world of "pleasure and crime," of the Barbès market and the very popular Lariboisière market, whose many stalls use the Métro viaduct for cover.

It is as much the zoom lens of personal interest as the facts of history and urban development that accounts for these conflicting visions of Montmartre. A wide-angle lens would legitimately include in this chapter the *mairie* (town hall) for the 18th *arrondissement* up to the edge of the isolated Chapelle quarter, whose pretty covered market is generally unknown outside the area. And, down below, it would also take in the ever-changing Goutte-d'Or and continue on to the Gare du Nord. However, we should resist the temptation to move on to the Parisian plain below, by way of the Rue des Martyrs, the Rue du Faubourg-Montmartre, and finally the *grands boulevards* which are a long way from Sacré-Coeur. Even

if we extended our stroll it would be impossible to see everything in the course of a single walk.

Almost halfway up, between the steep, deeply quarried slopes and the slow inclines which slide down towards the alluvial plain, a line of boulevards link a series of fairly uninteresting intersections, bearing such evocative names as Clichy, Blanche, Pigalle, and Barbès. These *places* follow the line of the old "tax" or "toll" wall which surrounded Paris from the end of the Ancien Régime until the Second Empire.

Frequently choked with traffic, the boulevards cut across yet also link, from east to west, several neighborhoods whose different characters are scarcely reflected in the formal façades that line the way. The key points along the route may not be registered with the Monuments Historiques; nonetheless, they do have a story to tell: the anonymous *rond-point* or circus at Place Clichy, the Moulin-Rouge, the Métro viaduct. The true spectacle

At the summit of Butte Montmartre, Sacré-Coeur raises its massive white domes high against the heavens over Paris. The much maligned basilica, built as a votive monument designed to heal the wounds suffered by France and its people during the Franco-Prussian War, has survived to become one of the key symbols of Paris. It stands on land once covered by monastic vineyards, now reduced to a tiny *clos* replanted in the ninteen-thirties and maintained by the Montmartre municipality.

here is to be found mainly in the crowd, in the local fauna emerging at sundown, a fauna not necessarily native to the area.

The wide boulevards so clogged by day with tourist buses come vigorously to life after dark, but the animation is nothing compared to the mobs of former times. In the early nineteenth century, artists and prostitutes from the "foothills" of the Butte, north of the 11th *arrondissement*, used to climb the Rue des Martyrs to stretch their legs or have a drink at the Pigalle *barrière* (toll gate). The Moulin de la Galette, a *ginguette* (open-air music hall) and then, under Louis-Philippe, a *bal* (dance hall), attracted a popular crowd, and so other places of entertainment proliferated. The merry-making enterprises of the lower Butte consolidated their position following events that were to have a profound effect on Boulevard Rochechouart and Place Blanche ten years apart: the opening of the first Chat Noir, followed by that of the Moulin-Rouge. Another significant moment was the arrival of Toulouse-Lautrec in 1880.

The Goncourt brothers and Émile Zola had explored La Chapelle and the Goutte-d'Or, taking careful note of what they found: a seltzer-water factory, pot houses everywhere, excellent sheeps' trotters at Chez Thomas; the restaurants and other establishments where Nana, the daughter of Gervaise, learned her street-wise lessons at an early age; the Bal du Grand Turc, in the Rue des Poissonniers; the Château-Rouge, now the name of a Métro station east of Montmartre. Chapter eight of Zola's *L'Assommoir* remains the best source of information about the restaurants and places of entertainment that once glittered along the ring boulevards at the foot of the Butte.

Slightly to the west, Francis Carco and Henry Miller haunted the shadows, gaudy lights, and sordid poetry of lower Montmartre. "On a gray day in Paris I often found myself walking towards the Place Clichy," wrote Miller. "Montmartre is worn, faded, derelict, nakedly vicious, mercenary, vulgar." Aragon then added à propos the cabarets: "The revolver is never far away when the *maître d'hôtel* bends over the champagne buckets."

Henry Miller loved the Place de Clichy – "la Cliche" – which straddles the 8th, 9th, 17th, and 18th *arrondissements*. It still remains a crossroads for vast numbers of people, an urban territory a bit deficient in class but rich in every other color, where people of all hues jostle together in the hurried indifference of a weekday or in

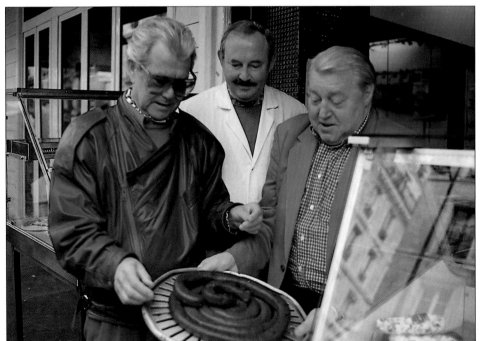

the crush of a Saturday night. The terrace at Wepler is a good place to spend a half-hour on a Saturday afternoon in springtime, facing the statue of General Moncey, to appreciate the diversity of the passing crowd. Henry Miller had a great affection for this establishment, which he discovered in 1928: "I looked forward with pleasure to spending an hour or two at the Café Wepler before going to dinner. The rosy glow which suffused the place emanated from the cluster of whores who usually congregated near the entrance."

Henry Miller, who discovered Wepler in Place Clichy in 1928, writes in *Quiet Days in Clichy* of having seen "a whore with a wooden leg" fall dead drunk across one of the little tables on the terrace where he often whiled away his Sunday afternoons.

Two Montmartre stars shopping for *charcuterie* on their home turf: Michou, diva of a tiny transvestite club in the Rue des Martyrs as well as a popular eccentric on the hill's south slope; and Édouard Carlier, an important restaurateur on the north slope. Here, in the Rue Lepic, they make a final purchase before settling down to a Sunday lunch among friends.

Beauvilliers, a romantic restaurant halfway up the north slope of Montmartre, perches on a corner at the top of the Rue Lamarck, where the quarter's famous steps begin their steep tumble. Also making their way down the hill are the flowering terraces over which Beauvilliers looks, from a dining-room richly redecorated by the owner, Édouard Carlier. Paul Bocuse, the Haeberlins, and Mireille Mathieu are among the many who hold Beauvilliers in great affection.

Wepler, at 14 Place de Clichy, celebrated its centenary in 1992, a little late since it was built in 1880 on the site of one of the many pot houses huddled near the *barrière*. Its clientele has grown younger, but the oyster man still cracks open bivalves to take away, a tradition now otherwise lost in the neighborhood. The establishment frequented by Miller was immense, including as it did an American bar, billiard rooms, and a dance floor. Much of it disappeared in the nineteen-fifties to make way for a cinema.

"I love that big music box, as large as an ocean liner," said Léon-Paul Fargue. "Le Wepler in Place Clichy abounds in marvels, such as the Concours Lépine. Most of all, there is drinking and eating. And rooms everywhere, open, closed, hidden. . ."

Not much is known about M. Wepler, a native of Eastern France. The Bessières, owners of the business since 1970, came from the Aveyron, like so many proprietors of brasseries and bistros. Without even having to cross the street, the present manager of Wepler also renovated Charlot I Merveilles des Mers at 128 bis Boulevard de Clichy. The other Charlot, the "King of shellfish," at 12 Place de Clichy, now belongs to the Blanc brothers.

It was one Charles Lombardo who, having proved his talent as an oyster man at Marius, in the Rue du Faubourg-Saint-Martin, bought the first house to become Charlot and began selling oysters and seafood. He sent for his sister and brother-in-law and put them in charge, but eventually they all quarreled. For reasons unknown, Charles Lombardo, called Charlot, left the first Charlot just after World War II and took over an establishment called Astor to create the new shellfish establishment which the Blancs have now redecorated in Art Deco style, complete with peacock-embellished façade.

Running along the border of the 18th and 9th *arrondissements*, the Boulevard de Clichy prolongs the Place all the way to the abrupt elbow turn caused by a much-visited cemetery and the Butte itself. In fact it follows the line of the old *Fermiers-généraux* wall, which marked the point at which taxes were paid and which veered away so as not to cut through an orchard belonging to the nuns of Montmartre. Beyond the site of the former Gaumont Palace, in its time the most remarkable movie house in Paris, and the end of the short Avenue Rachel, the north sidewalk along the Boulevard de Clichy is home to a whole series of electronic-game

Montmartre's Beauvilliers is distinguished not only by its name, taken from an aristocrat who, on the eve of the French Revolution, opened the first real restaurant in Paris, but also by the many details of its décor and service, its flowering terraces, and its breathtaking view over Paris. Indeed, Beauvilliers is in a class by itself.

shops, souvenir boutiques, pizzerias, porno theaters, sex shops, and the last *chansonniers*. The Moulin-Rouge, rebuilt and refurnished, has long been an important item in the iconography of Paris.

The Moulin-Rouge, which is the same age as the Eiffel Tower, was inaugurated in October 1889. The event, magnified by a aggressive publicity campaign, created a great sensation during the year of the Universal Exposition. Everyone went up to Montmartre to applaud Valentin le Désossé, La Goulue, La Môme Fromage, Grille d'Égout, and Rayon d'Or.

The establishment eclipsed the Moulin de la Galette, drew to Pigalle and Blanche a public which until then had not ventured beyond the Boulevard Rochechouart, and triggered the creation of a rival, the Casino de Paris in the Rue Blanche. The complex, which operated night and day, offered a lavish array of distractions, including the huge ballroom, stages, and a garden with donkeys to ride as well as an enormous plaster elephant planted at its foot.

Yvette Guilbert made her debut on one of the small stages, but without much success. Louise Weber, known as La Goulue – the "Glutton" with the famously limber

legs, black silk stockings, and high, helmet-like chignon – enjoyed a great and long success. Magnificently vulgar, this queen of the Moulin-Rouge did not age well. She ended up a decrepit old woman selling roses to couples on the terrace at Graff, a brasserie adjacent to the great complex where she had been adored alongside Valentin le Désossé, a dancer of quite acrobatic gifts.

The Moulin-Rouge bunt down in 1915, reopened in 1921, became a movie house, and then went through many ups and downs. Still identified by its windmill, the property was bought in 1962 by the owner of the Lido. Since "Frou-Frou" and "Frisson," his reviews in "F" have met with steady success: "Fascination," "Festival," "Follement," "Frénésie," "Femmes, Femmes, Femmes," "Formidable." The can-can is still danced every night by forty beautiful girls, their nudity embellished with strate-

gically arranged plumage. Still part of the act is the aquatic ballet in the transparent pool. A continuous supper theater, like the one at the Lido? Certainly, even during the worst of the slump in Paris's restaurants and cabarets, huge tourist buses never ceased to park below the emblematic mill.

Where is it, Place Blanche with my mill,
My tabac, my corner bistro and café?
Everyday, it's Sunday under the hill.
Where now the chums with whom I used to play?

The Place Blanche, whose name recalls the carts that once carried plaster from the Montmartre quarries, came into notoriety along with the Moulin-Rouge. Until the nineteen-seventies, it remained a center of after-dark vice, like the Place Pigalle. There is always a crowd under the glaring, flashing neon, but it is by morning that we

The Lapin-Agile (formerly Lapin à Gill), an area so named at the turn of the century and once fought over by artists and *les apaches* (young hooligans), survives today as the arch symbol of Parisian bohemia, complete with its repertoire of old popular songs and accordion accompaniment. The hill's little *clos*, or vineyard, lies just below, but the acidic wine it produces poses no threat to the cherry *eau-de-vie* traditionally preferred at the Lapin Agile.

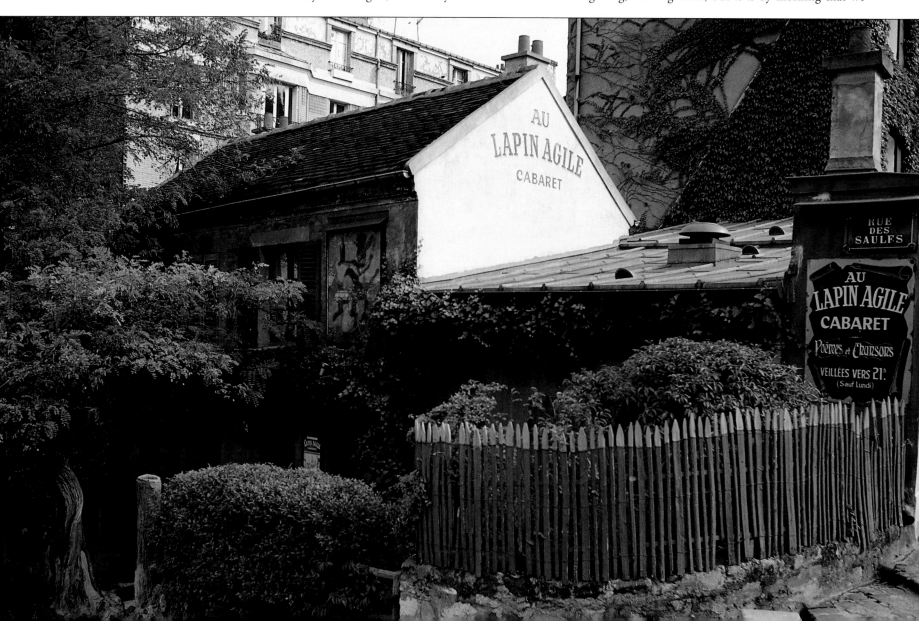

should visit the Rue Lepic, one of the most important commercial centers in Paris, at least along its lower stretch. If somewhat less picturesque than formerly, owing to the departure of the year-round merchants, the street remains a visual feast of open, well-stocked shopfronts, one following closely upon the other. Adding to the colorful, inviting scene are the many stalls which virtually spill over the full length of the sidewalk. Like Abbesses, the Lepic market does not specialize in extraordinary produce, but the increasingly gentrified quarter can boast of having retained much of its proletarian vitality.

Perhaps there are no good restaurants in this part of Montmartre, but that remains to be proved. The south side of the Butte would indeed lack gastronomic charm were it not for the Conticini brothers, who have reinvented, with occasional startling effects, the cuisine and the *pâtisserie* at La Table d'Anvers, 2 Place d'Anvers. Despite a few disconcerting experiments, their restaurant rises well above the average, and their unconventional menu is marked by bright ideas.

Now we should swing round to the other side of the Butte, in the Rue Lamarck, where there is a restaurant worthy of the term, but not before calling on Michou. Today a television diva, Michou reinvented satiric *travesti* (female impersonation) in the Rue des Martyrs, almost opposite a certain Madame Arthur now of a very certain age. A much-loved Montmartre personality and a great advocate of the neighborhood, Michou is out of the ordinary in every way. There is no star parodied by his boy/girl who does not love him, no shopkeeper in the quarter who does not stop to gossip as he makes his morning rounds, always in Montmartre of course, and no old lady who does not declare him adorable. His famous little cabaret is packed night after night, and has been for the last twenty-five years. There is nothing spectacular about the supper-theater program, but it never fails to entertain.

For good eating there is Beauvilliers, where Édouard Carlier – or Doudou, as Michou would say – has consumed a thousand and one bottles of champagne, shared with the *maître d'hôtel*, a personality in his own right and a friend of both Mireille Mathieu and Bocuse. (The great houses of Rheims and Épernay ought to erect statues to the two Montmartre stars, for their crazed devotion to "bubbly".) Highly original and very pretty, the restaurant with its terraced garden – heavenly in the summer – has undergone constant renovation over the last twenty years under a restaurateur passionate about all the arts of the table. Carlier is similarly driven to share with his patrons his love of carefully prepared, unusual dishes and exquisite flavors still redolent of the *terroirs* from which they come.

At Beauvilliers, 52 Rue Lamarck, there are extremely attractive chairs, charming cotton table linen, rare *objets*, and a great deal of imagination. Surprising and excessive, Édouard Carlier could be accused of a thousand faults. Notable among these is the desire, shared by few of his fellow chefs, to remain attached to a restaurant created some twenty years ago, when it is much more common for the transition from his 'design-and-bar' background to serious restaurant ownership to be little more than a brief fling

The Rue Lamarck circles around the Butte and leads the stroller right up to the surroundings of Sacré-Coeur, with all of Paris spread below. Close by this much-maligned basilica is the Place du Tertre, a landmark avoided by Parisians, who dislike encountering in Paris the tourists they themselves are in Venice, Piraeus, or Seville. A village esplanade full of strange anachronisms, the tiny old square can, depending on the time and the mood, seem delightful or detestable, but the invading foreigners and provincial visitors feel no obligation to judge.

The *place*, named for its location, a *tertre*, meaning hillock, assumed its general form in the seventeenth century and then remained a village square until the absorption of Montmartre into greater Paris at the end of the nineteenth century. Thinly replanted with mean little trees, the Place du Tertre belongs mainly to anonymous artists, some of whom may be gifted, but this is hardly the place to find out. They offer little repetitive pictures of scenes of Montmartre or Paris, nudes meant for respectable drawing-rooms, flower paintings for the unsophisticated, some undemanding abstraction. French or foreign, the painters carry permit cards issued by the Paris City Hall. Thus armed, they have made themselves the lords of their minuscule domain, sometimes as subtenants of other card-holding artists. The Place du Tertre has therefore become a kind of free state within a commune – upper Montmartre.

Even the thronging tourists have sense enough to avoid the tables that crowd the "terraces", nothing more than

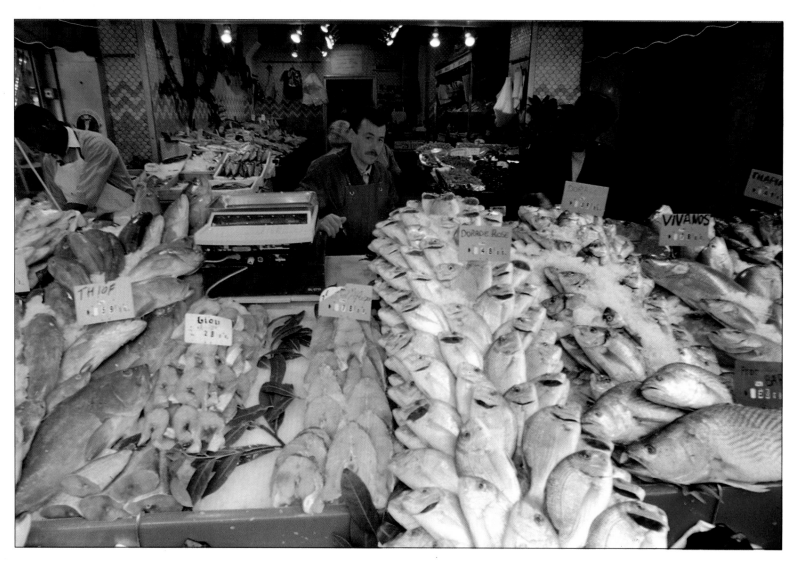

The busy Rue Dejean lies at the edge of the Goutte-d'Or, a quarter that fairly throbs with social mobility and the dynamism of a working-class population largely dominated by first- and second-generation immigrants from the Antilles and both North and Central Africa. Here, a fishmonger stocks produce from the warm-water parts of the world.

Terminus Nord, a contemporary of the eponymous station nearby, is much favored by suburbanites and travelers using the main lines of Paris's vast railway network. With its authentic 1925 or Art Deco interior, Terminus Nord forms an important link in the Flo chain of historic brasseries in Paris.

narrow strips of sidewalk. La Bohème du Tertre, a well-managed café despite its strategic location, occupies the site of a hotel/restaurant that was famous before World War I as a gathering place for artists, models, students, and various other revelers. This was La Mère Catherine, which replaced a "restaurant" that one Catherine Lamotte had opened in 1793. According to a plaque, it was here, after the fall of the Napoleonic Empire in 1815, that the Russian cossacks billeted in Paris launched "their famous *bistro*" – Russian for "quickly" and intended for the waiter – whence came, if not very plausibly, the French term *bistrot*, meaning a café.

L'Auberge du Village, Crémaillère, Chez Eugène, and Au Clairon des Chasseurs surround the square. Patachou, a fairly chic restaurant/tearoom, is distinguished by its thrilling panoramic view of Paris. Nothing in its present atmosphere would inspire an affectionate recollection of a woman who, not too long ago, was one

of Montmartre's great personalities. Bourgeois Parisians, not especially concerned with cuisine, and showbiz types prefer Graziano below the Moulin de la Galette, where the fare is decently Franco-Italian, served in a pleasant environment, at prices that in the evening can become a little steep, at least for local taste.

Where could one purchase a bottle of the extremely rare but mediocre wine of Montmartre, the product of a pocket-size vineyard replanted during the thirties and solemnly harvested every autumn? The few hundred bottles of this vinegary municipal wine are sold to benefit good causes on the Butte and bought by those with an appetite for curiosities. The symbolic "Clos de Montmartre," maintained in memory of the bygone era when the Butte supported many vineyards, contains some two thousand plants, most of them "classic." Riskily exposed to the north, it stands below the Montmartre Museum and overlooks the Lapin Agile. Originally, both

the villagers of Montmartre and Parisians cultivated vine-yards on these heights between quarries and market gardens. When the monks of Saint-Denis abandoned their Clignancourt vineyard, they took care to retain their *droit de pressoir* (right to operate a wine press), from which they earned a good income. Meanwhile, the nuns of the big abbey on the hill favored viticulture, knowing consumers that they were of the little *guinget* (acid) wine.

East of the Butte there is the giddy tumble of steps that plunge laterally towards the populous Barbès quarter – the very cosmopolitan Goutte-d'Or – whose townscape and population have never ceased to change since the time of Gervaise and the Assommoir, the "grogshop" where the characters of Zola ruined themselves with drink. Named Goutte-d'Or after some local wine, also acidic, the neighborhood grew up around 1830, just when France was helping itself to Algeria, and then became Algerian when the nation lost its North African colony. Now undergoing massive renovation, after reaching the depths of undesirability, the neighborhood still holds a certain terror for Parisians, who believe it to be rife with more toxins than actually exist and danger-ously crowded with the Third and Fourth Worlds. For two or three generations now, Tunisians, Moroccans, and Algerians have been a dominant element in the Goutte-d'Or. Yet, despite its poor Louis-Philippe or banal contemporary architecture, the quarter has more personality than a good many others. Couscous can still be bought by the bag, and Islamic butcher shops abound, but the North Africans are now leaving the area to the populations of sub-Saharan Africa and the Antilles.

The Rue des Poissonniers, by which fresh seafood arrived in Paris before the advent of rail freight, belongs to both the old and the new residents, but the *boubous* with their joyously motley colors now dominate, as in the Rue Dejean, where fish little known in Europe is sold: thread fin, thiof, and tilapia. In the Rue de Suez, one shop announces: "Here, products from Cameroon, Senegal, and the Ivory Coast." Across the street, another shop imports foodstuffs from Haiti, the Antilles, and Africa. Not far away, the Golf Alimentation sells edibles from Sri Lanka. However, it is in the Rue Léon that our promenade will end, freshened up with Antillais beer, Turkish or Greek sandwiches, and *frites*. A fine lesson in civilization, five meters as the crow flies from the white mosque-like masses of Sacré-Coeur.

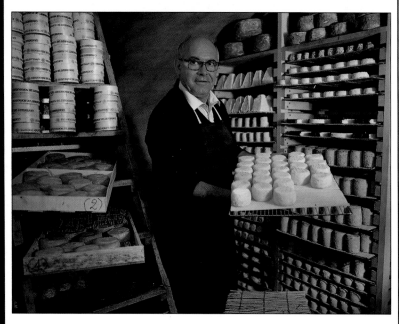

Alain Dubois, who operates two exemplary shops in the Rue de Tocqueville and the Rue de Courcelles, is one of the super-professionals who have helped re-establish the eminence of cheese, the farm production of which was once threatened with extinction. Rather than tilt at windmills or curse the industrialists or technocrats in Brussels, Dubois simply busies himself with dozens and dozens of cheeses, which he either ripens himself or finishes off the ripening process begun elsewhere.

Opposite: Simon Duval, acknowledged king of andouillette "à la ficelle" *(long, thin tripe or chitterling sausage), supplies several of the best restaurants and bistros in Paris. A one time butcher turned* charcutier tripier, *Duval still maintains his shop in a small house in the suburb of Drancy. At the bottom of the garden behind the house is the master* charcutier's *"laboratory." In 1976, Duval, who now works with his son, received the diploma granted by the AAAAA (Association Amicale des Amateurs d'Andouillette Authentique), a very serious "friendly" association of gourmets devoted to authentic* andouillette. *But while never deviating from his primary commitment, Duval is almost as good at making* andouille *(a fatter version of andouillette), Lyons sausage, and pork pâté.*

The most unusual épicerie of not only the Marais but of the whole of Paris is Izraël in the Rue François-Miron, where the owner maintains a rich confusion of everything that is wonderful to see and smell. The super-abundant stock includes rare spices and spirits, loukoums, stuffed grape leaves, maté, and whatever can be stored in gunny bags, jars, or boxes with mysterious labels.

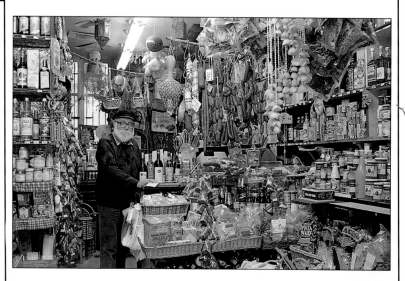

Parisians lack many things but nothing that would ever cause them to perish of hunger. There is literally everything in the way of foodstuffs to be found in numerous shops throughout working-class and middle-class neighborhoods alike, in big department stores with food sections dedicated to gourmet products, and along streets lined with opulent display windows whose alimentary riches may well spill out on to open-air stalls. (How on earth can such a mass of edibles remain in orderly stacks?) Real barrow merchants are now rare, except along the fringes of major markets, but many sidewalks are still the territory of the serious food buyer.

"The Arab on the corner," who does his customers a favor by remaining open late and by catering for their every need, may sell mass-produced foods at premium prices, but he also humanizes the stuffiness or cozy banality of certain residential streets, which otherwise go dead after seven o'clock in the evening. Vietnamese selling beautiful fruits and vegetables from meticulously maintained stalls have long since become a familiar sight more or less all over the capital. Parisians with a continuing sense of their native province or a generations-long sense of identification with one *arrondissement* are rare in the central sections of Paris. This is where shops stock more things to wear than to eat, where bakers may very well be no more concerned about making bread than service-station managers are about the refining of petrol, and where the display windows of *charcutiers/traiteurs* may be less appetizing than merely neat. On the other hand, some streets retain the characteristics of a permanent market, streets which are all the more inviting because they are not fashionable.

The untidy descent of the Rue Mouffetard is famous, with its numerous restaurants at the top, most of them Greek and not very interesting, and its food merchants below, bursting with produce that can sometimes be quite expensive. The Rue de Seine offers an agreeable mix of cafés, *pâtisseries, traiteurs*, an important florist, and many shops, alongside the street stalls of the Rue de Buci. The Rue Clerc explodes with produce between the Avenue de La Motte-Picquet and the Rue de Grenelle. In the 15th *arrondissement*, not too long ago the site of huge slaughterhouses, the Rue du Commerce still merits its name, thanks to the many food shops that flourish there. The well-heeled yet often colorless 16th *arrondissement* has attracted several of the capital's best butchers, poulterers, *pâtissiers*, and *traiteurs*; moreover, there are plenty of good food shops around La Muette and the Rue de l'Annonciation. The 17th *arrondissement*, although largely middle-class, has some fairly dismal areas as well as a few genuinely chic bits here and there. Fortunately, the quarter retains several large remnants of its former working-class character, as well as excellent food outlets in the Rue Poncelet and, especially, the Rue de Lévis.

If the summit of Montmartre has lost its produce markets, the nearby Rue des Abbesses and Rue Lepic make for wonderful strolling on the western slope. On the eastern slope there is plenty of local color around the Château-Rouge Métro station. Also to be cherished are the cosmopolitan flavors of Belleville, the Rue de Trévise, Rue Richer, and Rue Bergère; the exoticism of the quarter around the Place d'Italie as well as that of the 13th *arrondissement* with its Tang brothers and its Paris Store; the comforting traditionalism of the Rues Montorgueil and Daguerre; and the deluxe classicism of the Place de la Madeleine. Paris gradually loses its humanity as the office buildings proliferate, but the gourmet *flâneur* can still find a great many quarters in which to perambulate with pleasure, with or without a fixed destination. However, certain shops and big stores are worth a detour, even a journey.

The GaultMillau and Pudlowski guidebooks — rivals that differ mainly in tone — are equally useful, abundantly illustrated, and full of good addresses for fine eating. It would be impossible to summarize what these indispensable vade mecums of the food shopper say about hundreds of alimentary enterprises in the course of hundreds of pages. There are the Bell Viandiers of the 6th and 14th *arrondissements*, the Lamartine butcher shop in the 16th, the small landmarked butcher shop in the Square de la Rue Borchant, and the meat markets of the Rue Marbeuf. Paris also means Poilâne, which makes only one bread, but what marvelous bread! It means as well Fournil de Pierre, Au Bon Pain as it used to be in its landmarked shop on the Rue Popincourt, the Moulins de la Vierge, À la Flûte Gana, and Ganachaud.

Paris is the city of *charcutiers*, such as Jaouen, Pou et Schmid; of *traiteurs*, such as Flo Prestige; vintners as diverse as Legrand, Estève, Danflou, and Les Caves Taillevent; and both chocolate-makers and confectioners, among them Christian Constant, Robert Linxe, and Dalloyau. It would take an entire chapter to deal with the many activities of Gaston Lenôtre, omnipresent *pâtisseur, traiteur*, and friend of all the great chefs, especially Paul Bocuse. Still further chapters could be devoted to Berthillon and the other virtuosos of the freezer, as well as to the major cheese sellers who have come to the fore in the wake of Androuët (Barthélemy, Marie-Anne Cantin, Dubois, Alléosse, La Ferme Saint-Hubert, Tachon), but this would require a new book altogether.

Finally, would it be too much to claim that Paris has reinvented cheese during the last two or three decades or, at least, that the finishers have done much to revive cheeses virtually forgotten or scandalously industrialized? Or that Paris contributed to the renewal of certain vineyards by rediscovering the so-called "little" wines blessed with quality, character, and moderate prices? Cheese and wine — they make a meal all by themselves.

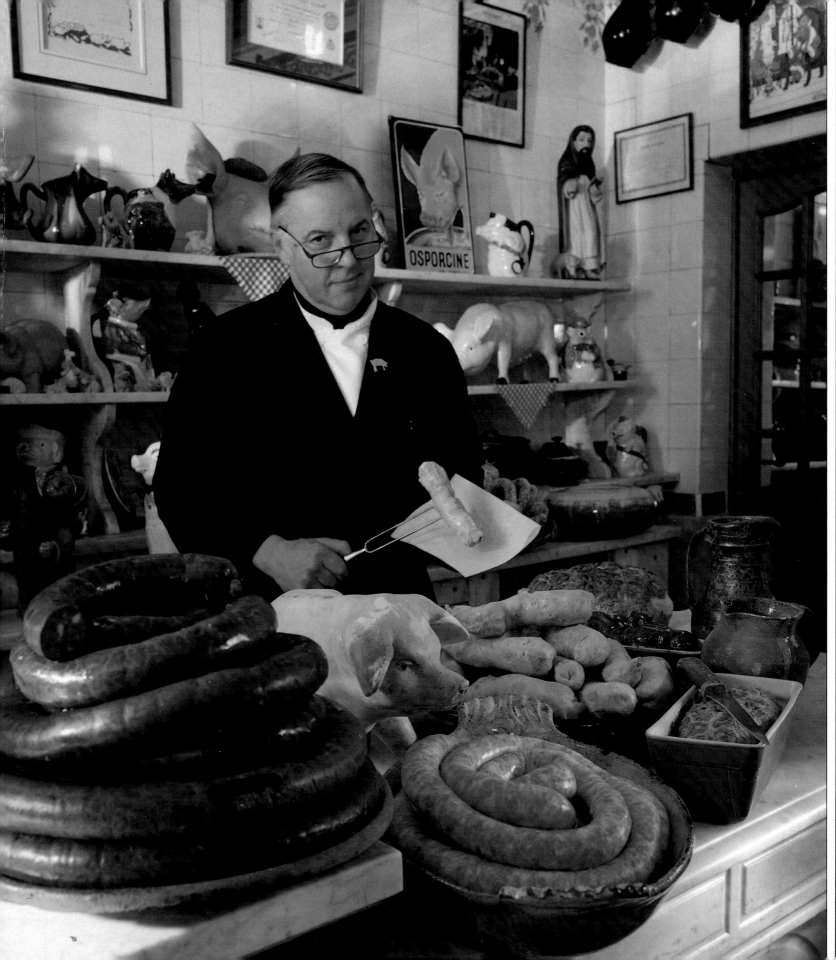

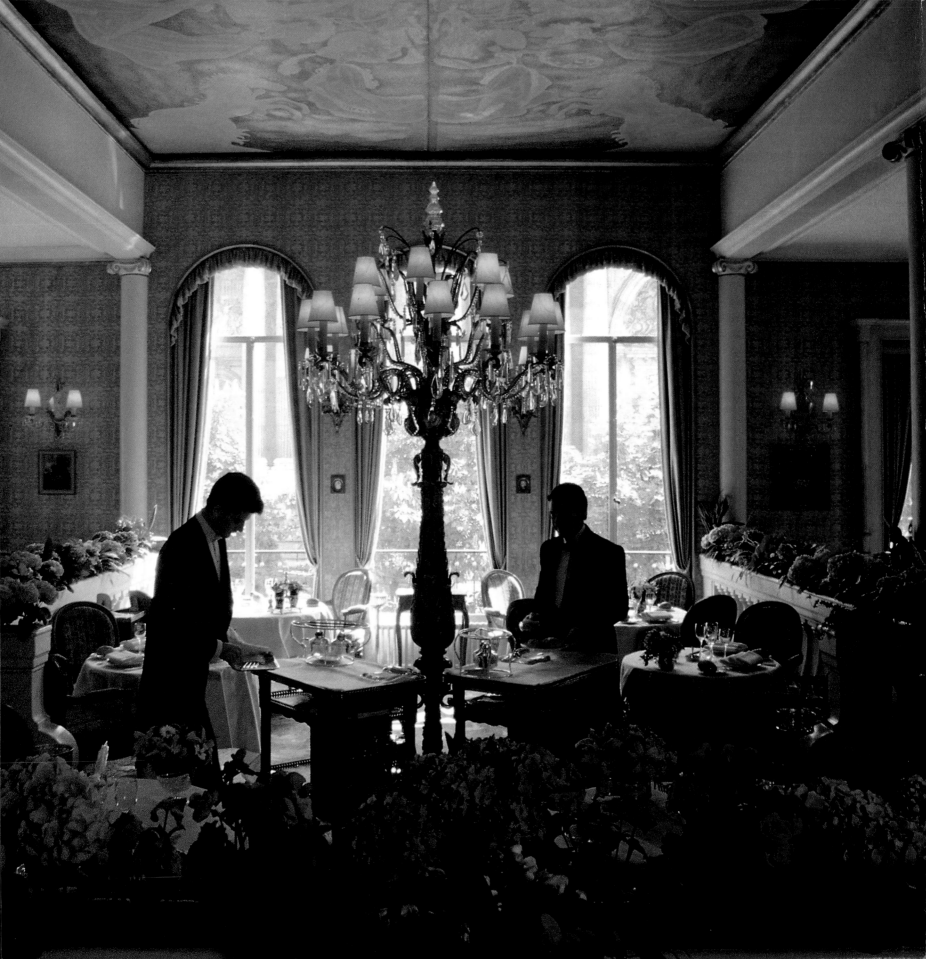

Lush gardens bounded by the Place de la Concorde to the east, the Presidential Palace to the north, and the Seine to the south serve as a prologue to the Champs-Élysées and its breathtaking sweep upwards to the Arc de Triomphe. Here, the great Napoleonic monument acts as a frame to set off La Défense and its own magnificent arch, a colossal, late-modern structure minimalized by distance, some two miles to the west. In the glades of the gardens where the Champs-Élysées begins lie several semi-secluded pavilions housing luxurious restaurants, whose fame, however, cannot compare with that of Lasserre, close by on the Avenue Franklin D. Roosevelt. The neighborhood of the Champs-Élysées brings us into the First World of expense accounts, social sophistication, BCBG (*bon chic/bon gens*, meaning prestigious) addresses, high fashion, and culti-vated palates. This is the Paris of starry menus and smart restaurants, the haunts of journalists and publicists, "club" terraces, and beautifully appointed dining-rooms, but also the Paris where brasseries are no more pricey than in Eastern France, where the word *bistrot* is sometimes pronounced with a conspiratorial wink over some celebrated chef. The area around the Champs-Élysées is where inventive chefs occasionally join forces with imaginative restaurateurs, where the final reckoning can soar out of sight or glide along at reasonable elevations.

In 1992, a youthful eighty-year-old named René Lasserre celebrated the fiftieth anniversary of the world-famous restaurant he founded in the Avenue Franklin D. Roosevelt. It has long since become one of the great symbols of Paris.

The luxurious and distinguished Hôtel Plaza-Athénée appears to be exercising discretion even in the way it projects its awnings towards the Avenue Montaigne. If not the most beautiful hostelry in Paris, the Plaza-Athénée is certainly the one with the greatest chic, a status held for most of the eighty years since it opened. Deeply comfortable and eclectic in style, the hotel boasts two restaurants: the extremely formal Régence-Plaza, whose sumptuous décor makes it seem a dining-room from another age; and Le Relais-Plaza, a favorite rendez-vous for a very Parisian, monied clientele content to pay dearly for a classic cuisine.

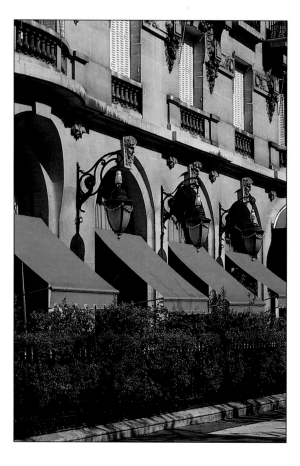

L'Élysée-Lenôtre, one of the timeless dining venues in the gardens on either side of the lower Champs-Élysées, was reactivated by the great *pâtissier/traiteur/restaurateur* Gaston Lenôtre. Having made his mark among serious gastronomes, Lenôtre is now a viticulturist at the Château de Fesles in Anjou. This has left Paul Huyart in charge of the kitchen at the restaurant in its elegant, greenhouse-like Belle-Époque building, where he offers a cuisine of great precision and flavor. Meanwhile, Lenôtre, who is the most active of would-be retirees, keeps an eye on the *pâtisserie*.

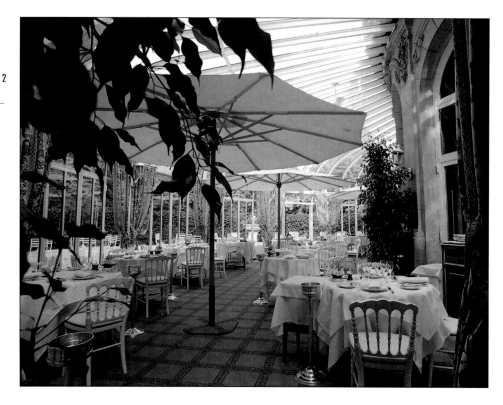

The 8th *arrondissement* which borders either side of the Champs-Élysées has its complement of diners who select restaurants on the advice of their hired chauffeurs. Moreover, the penniless young people parading up and down the great avenue throughout the weekend, from the Rond-Point to the Étoile, and the suburbanites arriving by RER (underground express trains) are in no position to toss an American Express gold card on the saucer holding the *addition*. These days, one can even find a few *zonards* (dropouts) determined to re-create *Saturday Night Fever* on the Champs-Élysées, which continues to be the world's most beautiful avenue, even as it undergoes rejuvenation, physical as well as social. This has brought a second row of trees, new benches, street lamps, and waste baskets (designed by Jean-Michel Wilmotte), and the suppression of parking on the new granite-paved sidewalks.

Bereft of cuisine in the grand gastronomic tradition, the avenue nonetheless offers a vast variety of eating places aimed at every conceivable taste and pocketbook. However, they do not include Lasserre and Taillevent, Le Petit Montmorency, Les Princes, Chiberta, or Les Élysées du Vernet, where chef Alain Solivérès fills the glass-roofed dining room with the fragrances and flavors of Provence. These culinary wonders lie just off the Champs-Élysées, leaving it to McDonald's, Burger King, Quick Hamburger, Bistrot de la Gare, Hippopotamus, and various pizzerias, which alternate with a few impersonal cafés and two "real" restaurants, the celebrated Fouquet's and Copenhague. And, of course, there is the Drugstore Publicis, which during the sixties gave Parisians the illusion they were living *à l'américaine*.

In the mid nineteenth century, the broad strip of garden sidewalk that once ran along the carriageway, from the Concorde to the Étoile, was full of life, thanks to all the entertainments there: concerts, the Empress's circus, the Folies-Marigny, the Palais de Glace (skating rink), marionettes, Punch and Judy, goat- and donkey-drawn carts. The perambulating crowds consisted of fashionable society and Proustian figures, *flâneurs*, *putains*, and small children. Proliferating restaurants and cafés grew ever more decorative under the Second Empire, adopted the Art Nouveau style around 1900, and experienced varying degrees of success.

The Pavillon Ledoyen, the tenant of a fine city-owned building in the gardens behind the Petit Palais, came into

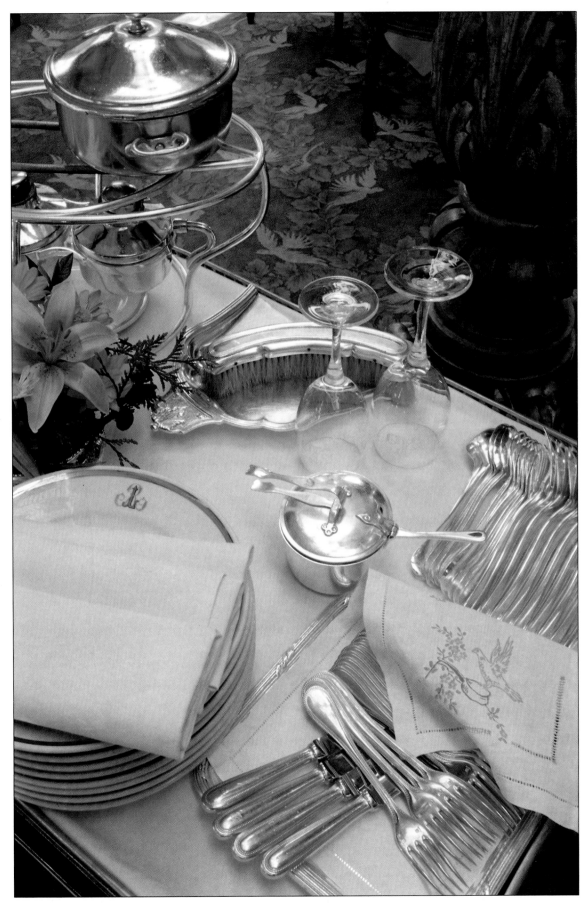

World-renowned Lasserre occupies a site, between the Champs-Élysées and the Seine, that had always been considered barren terrain as far as commerce was concerned. The story of the great restaurant began during the Occupation, in 1942, when René Lasserre bought a fairly rudimentary structure built to house a bistro during the 1937 World's Fair in the garden of a private mansion. Given the wartime scarcity of foodstuffs, Lasserre made a go of his business by serving salads of Jerusalem artichokes, Vichy carrots, and sautéed cauliflower, together with bread, charcuterie, and meat, providing the customer could pay with ration tickets as well as with money. In 1951, René Lasserre had everything demolished and the house was then rebuilt in record time. So skilful was the work of reconstruction that the restaurant reopened after only a few days, whereupon it became the very model of luxury for such establishments and entered the golden years of its international success. Under the much-discussed retractable roof, the dining-room turned into a stage for a double drama, that of the service and that of the clientele. René Lasserre, a great professional and an exemplary *maître d'hôtel*, always loved silver, crystal, and fine linen, but André Malraux, a loyal customer, admired above all the owner's "firm, welcoming hand on good days and bad alike."

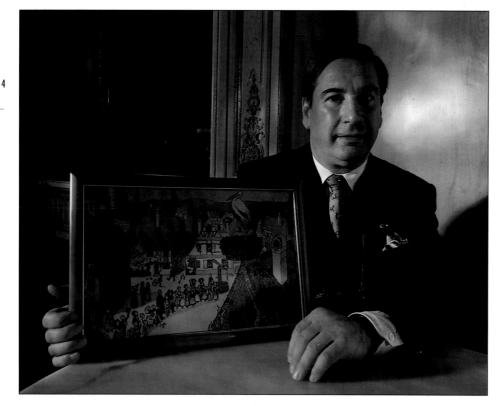

its period of glory after 1960 under the aegis of Gilbert Lejeune, a former *maître d'hôtel* at Lasserre. Later, the establishment again became a center of fashionable attention when Régine, "queen of the night," took over the dining-room, with the kitchen left to Jacques Maximin, an incisive if not very adventurous chef. Yet another new era began in 1992, this one ushered in by Ghislaine Arabian, an excellent cook from Lille. But who was Michel Ledoyen? He entered history at the beginning of the French Revolution when he took over a simple *guinguette*, or open-air café, and attracted members of the Convention, including Barras, the Jacobin who led the *coup d'état* against Robespierre.

In the gardens on the opposite side of the Champs-Élysées, Gaston Lenôtre, *grand pâtissier*, *traiteur* and, more recently, wine grower, has brought new life to the Pavillon de l'Élysée, a radiant Belle Époque venue constructed like a circular greenhouse. The inevitable name: L'Élysée-Lenôtre. Within the same part of the gardens there is also Laurent, at 41 Avenue Gabriel, another historic site, this one distinguished by its "Pompeian style" dating from the mid nineteenth century, when the restaurant was also known as "the lovers' chalet." Sensitively renovated and blessed with the most beautiful terrace in Paris,

Laurent offers a delicate and meticulously prepared cuisine, at prices that are the steepest among all the local two-star restaurants.

Lasserre! First of all, there was the man, beloved and respected by the entire membership in the select society known as Traditions & Qualité. Of course, he was also a true professional. The creator and owner of a timeless restaurant, with a staff of more than eighty, René Lasserre was still going strong well beyond his eightieth birthday, an occasion marked at the end of 1992 by the presence of the world's greatest chefs, his friends. Born in Bayonne, the son of a *restauratrice* widowed when very young, René arrived in Paris in 1925 and made his debut in the branch of Drouant at the Gare de l'Est. Small and live-wired, he found himself nicknamed *la Puce*, the Flea.

"There is no age to begin. Nor to end! The man who taught me my profession was already a *maître d'hôtel* in 1885. . . . I was not yet thirteen, by two months, when I was hired. I threw myself into the job. The director took me under his wing, and I became a *chef de rang* at sixteen. My assistant, whom I paid out of my own pocket, as was the custom, was twenty-eight! It was not an easy life, but I was proud of my work. I recall how indignant I felt when some customers remarked, out loud, that they had been served by kids. . ."

It was forty years ago that René Lassere began operating his famous retractable roof. The decision to serve his clients the real Parisian sky created as much surprise as the decision, of ten years earlier, to settle down in a "desert" – Avenue Franklin D. Roosevelt! "When I decided to run my own show, that location wasn't worth anything. Today, the site remains apart from everyday life, what with the avenues and gardens, the quays, the Seine, the Grand and Petit Palais, the Concorde. The President of the Republic on one side, the Invalides, the Ministry of Foreign Affairs, and the Chamber of Deputies on the other. No neighbors. I must find my clientele in quarters on which the house turns its back.

"The only advantage of the location: there was room, I could expand. I built in the garden opening on to the avenue, in front of the existing house. I had no problem with the last of the tenants: she became my *vestiaire*.

"I borrowed 32 million old francs, which seemed enormous, but the rate of interest was low. My idea was merely to install a bar on the ground floor, where I specialized in the Porto Flip, a "rich" aperitif whose

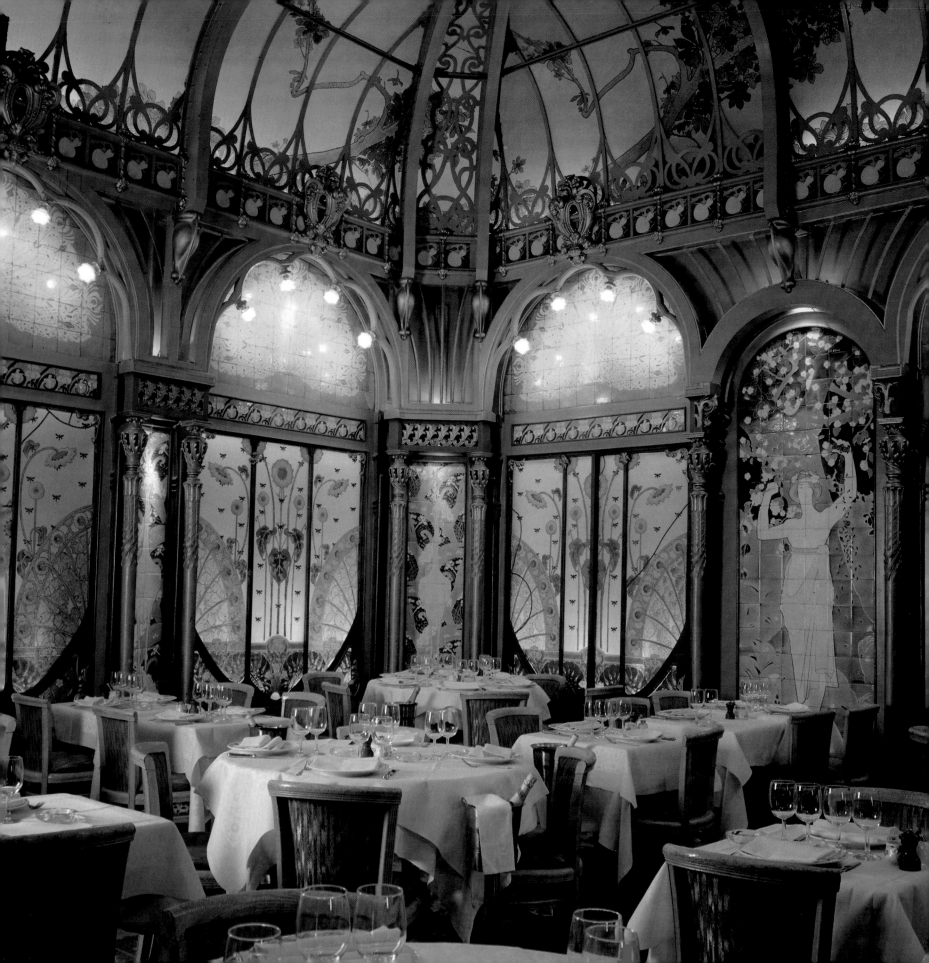

calories were welcome after years of scarcity! There were three musicians, and people were eager to relax. But my goal was still to open a restaurant.

"The retractable roof worked for the first time in 1952. I had selected round tables, rather than the rectangular ones then *de rigueur*, so that people could feel as if they were alone without the space being actually partitioned. I raised the outer part of the room to permit guests to view one another from a distance and enjoy the spectacle of the whole room, while keeping their own distance. At a time when women wore all kinds of hats, the effect was quite striking. . ."

Like the great fashion houses, the major restaurants stay clear of the Champs-Élysees. All the more reason, therefore, to shed a tear for the Berkeley, which in the years before 1968 drew millionaires, stars, and the generally well-off to the Rond-Point. It also attracted such apprentices as Alain Senderens, Henri Gaugeron, and Joël Robuchon, all of whom suffered in an archaic, overheated, low-ceiling kitchen, while simultaneously learning invaluable lessons about the coming revolution in *haute cuisine*. "It was for me a great school," recalled Robuchon, who had begun in fish, moved to sauces, and

replaced first one cook and then another. André Moreau, the chef, proved himself a master, with an exceptional technique.

Yvan, whose name graces the signboard in the Rue Jean-Mermoz, was still a child when Pierre Lazareff was asking for his simple sole at the Berkeley. Today, Yvan Zaplatilek is a handsome young man, mature, lively, attentive, and astute in his kitchen. What has made Yvan the darling of café society? A "personalized" welcome, at least for personalities, a cheerful décor, and a simple, good, yet delicate cuisine, all at reasonable prices. And very Parisian.

In the Rue Marbeuf, *qualité/prix* arrived without any help from Yvan, as did the friendly reception and the genuine friendship. During the nineteen-sixties, the Grill Marbeuf led the way and others followed. Paul Benmussa came next, launching Chez Edgar with the success we know today (his partner was Edgard Saada, one of Paris's night owls). Originally an engineer, Benmussa became the most visible of restaurateurs, cultivating the media crowd, the real natives of this part of town, welcoming stars of television, with politicians both in and out of power. Well-separated booths, to permit seeing without

Taillevent, one of Paris's most fabled three-star restaurants, means cuisine of the highest quality, not necessarily classic but not fanciful either, and always precise, delicate, and absolutely reliable. Jean-Claude Vrinat, the demanding and exceptionally close-eyed watchdog over what is a truly deluxe restaurant, insists that his chef, Philippe Legendre, avoid all tricks and achieve something like calm perfection in every dish sent out from the kitchen. And he expects equal rigor in the dining-room, as well as in his own performance. What more could one say about the high seriousness of a restaurant that has now become a veritable institution with a global reputation and an assured clientele of the most distinguished? Vriant is also famous as a major connoisseur of great wines from every region and an astute discoverer of well-developed "little" wines. His daughter, Valérie, aims equally high, now that she is responsible for Les Caves Taillevent, the family-owned wine shop in the Rue du Faubourg Saint-Honoré.

Jean Laurent, who formerly managed one of the most amiable of the "intellectual" cabarets, showed a magical touch when he switched to restaurants, revealing an exceptionally fine 1898 décor in the course of reconstruction work on the building that would house his Fermette in the Rue Marbeuf. A moderately priced and extremely popular restaurant, La Fermette Marbeuf 1900 was then redone throughout in its original Art Nouveau style, with elements added from a Maisons-Laffitte winter garden.

overhearing, unpretentious dishes, relatively moderate prices – the success continues.

Guy-Pierre Baumann, an Alsatian, has returned to Strasbourg, where he runs a hotel and restaurant empire. In Paris, however, he had reinvented *choucroute* in all its variations, with results that his compatriots at first mocked and then applauded. He made his mark at 64 Avenue des Ternes (still a good address), but then moved to 15 Rue Marbeuf, after renovating the premises at ruinous cost. And he still puts in an appearance. Moreover, the *choucroute* remains triumphant – the much-imitated version with fish continues to be inimitable – and the meats, prepared and cut by a peerless professional, are generally excellent. No superfluous luxury: simple, unfussy reception, and the friendliest prices for equal quality in the neighborhood. As Parisian as it is Alsatian.

Jean Laurent is no harder on his customers, who express their gratitude by returning in droves. His Fermette 1900, at 5 Rue Marbeuf, is more 1900 than *fermette* (weekend cottage) but nonetheless registered with the Monuments Historiques, for its ravishing Art Nouveau interior. Long hidden behind rubble and false partitions, the stained glass, ceramics, and graceful, gazebo-like metal structure were rediscovered in 1978 during reconstruction and conscientiously restored. The rest of the interior was then carefully redone in the same style. The clientele consists of theater folk, affluent people who go out often, informed provincials, and journalists.

Taillevent, on the other side of the Champs-Élysées, returns us to the world of luxury, Traditions & Qualité (a label claimed by the Haeberlins, Guérard, Bocuse, the Troisgros, Robuchon, Terrail, and the best of the best), rigor and urbanity, gorgeous cuisine, and high prices that are infinitely more justified than at numberless places charging just as much. Classic, but of its own time, and steeped in a cosseted dignity, Taillevent minds its manners and maintains its aristocratic reserve, transcending fashion. Since 1950 the establishment has occupied a grand 1855 *hôtel particulier* in the Rue Lamennais, a mansion decorated with eighteenth-century panelling. This richly distinguished restaurant gives the impression of having always been there. Who would question the authenticity of a "Louis XVI" staircase arranged like the one at the Petit Trianon?

A squab at Taillevent

A dish without pretensions, composed of a tender Bresse squab, plump and perfectly cooked, and served simply with a few chanterelles and onions. Deliciously satisfying!

Philippe Legendre, who is capable of genuine originality in his cuisine, without overdoing it, understands how to obtain the best results from beautiful produce cooked with simplicity and great tact. A bass lightly seasoned, a superb veal chop garnished with vegetables, for example.

But what wine goes with a squab of such exceptional quality? A fine Saint-Julien with a beautiful "presence," according to Jean-Claude Vrinat, who visits and revisits the best vineyards in order to keep his cellar well stocked. Why not a beautifully aromatic Ducru-Beaucaillou? Taillevent, it is well worth remembering, happens to be one of the truly great French restaurants where fine wines of good vintage are reasonably priced. And this was already the case in the Rue Lamennais even before the recession of the nineteen-nineties, which forced other luxurious establishments to modify their markups.

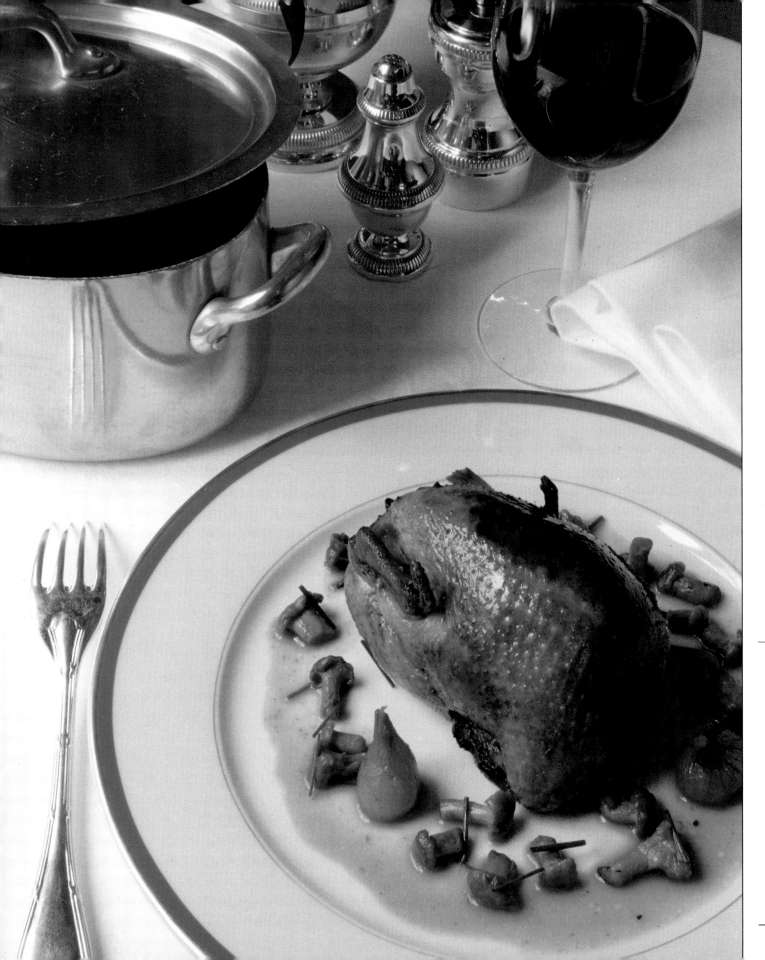

*A squab
prepared at
Taillevent*

*Taillevent
15 Rue Lamennais
Paris VIII*

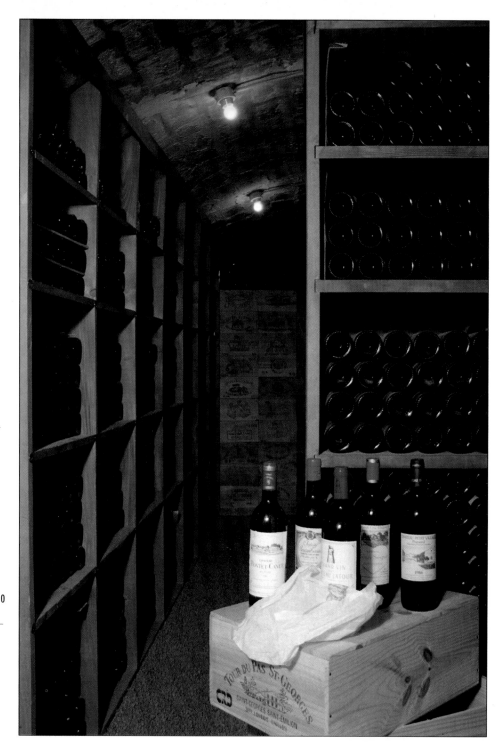

It is at Les Caves Taillevent that Jean-Charles Pivot, excellent viticulturist and brother of Bernard, the famous television personality, introduces his Beaujolais Nouveau every year. The shop stocks, along with the great wines, a number of high-quality, well-made "little" wines.

fell in love with the restaurant business. "The first Taillevent opened in 1946, Rue Saint-Georges," Jean-Claude Vrinat explained. "For me it was a palace, that little house, a corridor with charm, where twenty-five or thirty people could be served. . . My father moved in 1950, into this old mansion formerly occupied by an English-style club, which explains the unusual look of the dining-room.

"My earliest gastronomic memory: cheese soufflé, Taillevent's great speciality. When I came to the Rue Lamennais and began working, it was still on the menu. I had the greatest difficulty removing it. . . At that time the house was still essentially a businessmen's restaurant, with few women at lunch, when every table was taken, and few people in the evening.

"My first job here was administrative, but very quickly I got involved with food preparation. In the morning, I worked in the kitchen, at noon in the dining-room, during the afternoon I turned to the whole of the administration, the evening found me back in the dining-room. An on-the-job education. The profession was very closed, and everyone wondered what I had done. . ."

Taillevent – Michelin three stars, 19/20 GaultMillau – now has a personnel of about fifty, half of them in the dining-room, the other half in the kitchen. The chef: Philippe Legendre, formerly assistant to Claude Deligne, the long-time king of the kitchen. Public side: Jean-Marie Ancher. A fairly young staff.

The cellars are admirable, filled with outstanding bottles at just the right price. Vrinat, who discovered vineyards in the course of Sunday outings with his father, pays close attention to his wines, following them from vintage to vintage, which is where his daughter's vocation may lie. Valérie has now taken charge of Les Caves Taillevent, a shop opened in November 1987 at 199 Rue du Faubourg-Saint-Honoré. Here all the bottles on view are dummies, to preserve the wine. But 40,000 out of a total of 400,000 can be obtained immediately from a temperature- and humidity-controlled cellar. So vast is the stock that it even contains a few "little" wines at correspondingly small prices.

Now we return to the Champs-Élysées. And where better to talk about the quarter than at Fouquet's, which could hardly be more different from every other establishment on the avenue? On the corner of Avenue George V – the street with the grand hotel of the same

Taillevent perpetuates the surname of a fourteenth-century cook, the author of a learned book, *Le Viandier*, but the restaurant belongs to recent history, a history intertwined with that of a dedicated man who was never trained in cookery: Jean-Claude Vrinat. At Taillevent since 1962, Vrinat is the son of the founder, André Vrinat, an engineer who became general director of Potel et Chabot, the centenarian *traiteur*, and simply

name, as well as the Prince des Galles and the Crazy Horse Saloon – Fouquet's has a century of Parisian stories to tell. A promotional book, albeit a well-documented one, published on the occasion of the restaurant's ninetieth anniversary, reels out house anecdotes by the score, such as the time Aristide Briand had lunch with Theodore Roosevelt, or the breakfast ordered by Jean Gabin and Michèle Morgan.

In 1898, Louis Fouquet bought the tavern on the present site and began catering to coachmen. The possessive form of the name adopted for the restaurant reflected the period's anglomania, spurred on by the francophile Prince of Wales, who became Edward VII in 1901. Fouquet was succeeded by Léopold Mourier, the owner of Chez Foyot, a place of some reputation, and Le Café de Paris, as well as, later, Le Pavillon d'Armenonville. Mourier cultivated the racing fraternity returning from Longchamps and Auteuil, reorganized the house, spared no money on mahogany, and installed a dining-room upstairs. The house then passed to Maurice Drouant, of the great restaurant in the Place Gaillon, and then to Drouant's nephew, who renovated Fouquet's just before its fiftieth anniversary. In 1976, a year following the demolition of Claridge's, the only grand hotel on the Champs-Élysées, Maurice Casanova bought Fouquet's.

A night owl, as well as a genial *pied-noir* (Frenchman born in Algeria) long resident in Saint-Germain-des-Prés, Casanova linked his destiny to a Fouquet's become rather elderly, but then proceeded to remake it into the preferred restaurant for opening-night celebrations and the place where the glitterati go following the César awards (the Oscars of the French film industry). In 1980, Casanova proposed that the Champs-Élysées be officially classified, ten years before the city launched its campaign of renovation. He also succeeded, with a group of friends, which included Roger Hanin and Robert Sabatier, in having Fouquet's registered with the Monuments Historiques. This was a time of great crisis, brought on by the owners of the building and the ground below, who wanted to break the lease and rebuild the site as a shopping mall.

On 6 December 1988, Fouquet's was officially inscribed as a "memorial site of the cinema," a place that remains a "testimony to the great cafés of the Champs-Élysées."

T his stroll through the *Beaux Quartiers* is just one of several gastronomic expeditions which can be made through Paris's so-called "Smart Quarters," where Croesus himself might pause at discovering what feasts money can buy. At the same time, these same neighborhoods also harbor honorable brasseries and bistros so welcoming as to be almost too popular. However, visits to Amphyclès and Apicius will have to await another day, as will calls at the excellent Clos Longchamp, the peerless Italian Sormani, Le Petit Colombier, the Rôtisserie d'Armaillé, the Cougar, Gérard Fauché, the historic Barrière de Clichy, the Rue de Lévis, Fred, Robert Marc's bistro, etc., etc. West Paris boasts more good and truly distinguished restaurants than can be found in most European capitals!

The 17th and 18th *arrondissements*, together with the contiguous 8th, would never win prizes for their food markets, despite the presence of several excellent shops. What these quarters have attracted are some of the world's very best chefs and a substantial number of discriminating restaurateurs. To account for this happy circumstance, one has only to note the affluence of the local inhabitants whose means and appetites assure the development of culinary talents. Put another way, the best of such talents discover the greatest encouragement to do their best when situated

9 3

Jean-Claude Ferrero, at his restaurant in the Rue Vital, has made himself the master of "all-truffle" menus. There is simply nothing he does not know about truffles, which he employs in his cuisine with as much joy and verve as he does mushrooms.

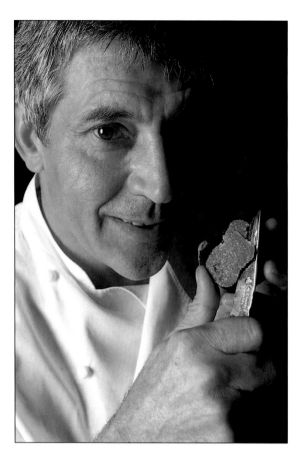

within social precincts where expense accounts are a way of life. It is no accident that Henri Faugeron has crossed the Seine, that Joël Robuchon has settled in the 16th, that Francis Vandenhende and Denise Fabre have located Le Manoir de Paris on the ground floor of La Niçoise, itself a place of great charm, in the Rue Pierre-Demours. And it was not by chance alone that in 1983 the Ferreros, freshly arrived from Briançon in 1979, chose to attach their name to a chic, champagne-colored mansion in the Rue Vital, after a brief tenure at Le Marcande in the 8th *arrondissement.*

The delicate power of an original cuisine, the proximity of the Étoile, Michelin's two *étoiles*, and Gault Millau's 19/20 helped cushion Guy Savoy (18 Rue Troyon) against France's recent economic slump. The crisis all but bankrupted the clientele normally eating in the big wood-paneled dining-room hung with lithographs and abstract paintings. Correspondingly, it filled the popularly priced *bistrots annexes* such as Savoy's Bistrot de l'Étoile at 13 Rue Troyon, or the one at 75 Avenue Niel, or yet another at 19 Rue Lauriston. To this galaxy should be added another Savoy spin-off, La Butte Chaillot in the Avenue Kléber, a relaxed restaurant with

a modernist setting designed by Pierre Parat, one of the architects responsible for the sensational sports complex at Bercy. A planned enlargement promises to endow the Butte Chaillot with a handsome new dimension.

Guy Savoy, who is not Savoyard but rather Dauphinois, began as an apprentice *pâtissier*, in his native Bourgoin-Jallieu, a village that also produced Roger Verger, the "launcher of restaurants" whom Savoy came to know through Bernard Loiseau, which explains how he ended up at the famous Barrière de Clichy. In 1969-70, and again at the end of 1974, he worked under Louis Marchand, an exemplary professional, and learnt everything he needed about culinary honesty and meticulousness, as well as about rugby, a sport he came to like as much as Marchand. Is Savoy paying tribute to Bourgoin when he offers desserts which are far more extraordinary than those normally found at multi-starred establishments? In 1973, following a long stay with the Troisgros, he began working at Lasserre:

"What most fascinated me about Paris was that on the Champs-Élysées one paid 3 francs 75 for a *menthe à l'eau*, which cost only 1 franc 20 at La Tour-du-Pin in Isère. I learned that life here is not the same as elsewhere, that it is hard, but it also seemed evident to me that only here could I practice my *métier* as I understood it. It was easier to begin here with nothing but my name than it would have been in the provinces, where most of the important restaurants are family affairs.

"I was a junior assistant of nineteen accustomed to a quasi-family ambience at Roanne. In Paris everyone had his own life; there was no time for a drink after work; the *chefs de partie*, almost all married, went home. . . René Lasserre, a very affable man, asked me where I lived, as he handed me my first paycheck. 'In a maid's room in Neuilly.' He wished me good luck, saying that he too had lived in a maid's room in Neuilly at the beginning of his career. I was very touched.

"I stayed for three years at the Barrière de Clichy, where I had carte blanche, and then I moved to the Rue Duret in 1980. It was here that I received my two stars, but the house, despite the appointments, was more cramped than intimate. . ."

Guy Savoy carried his stars to the Rue Troyon, where they could shine more easily, after Gilbert Le Coze, his predecessor, packed up his stars and left for success in the United States. In 1994 the New Year began with a

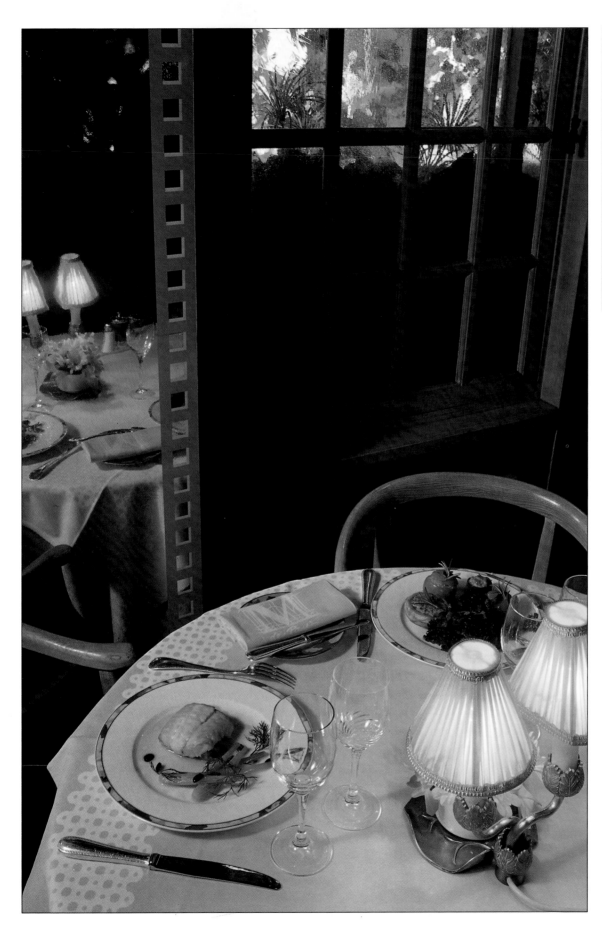

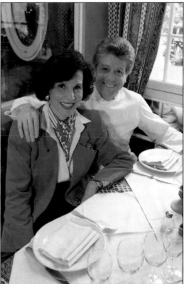

In the world of Francis Vandenhende, a restaurateur in the grand tradition, and his wife, Denise Fabre, there is first Le Manoir de Paris on the ground floor, a place of soft light and lovely stained-glass windows, and then, on the floor above, the refreshing sweetness of La Niçoise. While the one offers an ambitious, highly developed cuisine, the other features the appetizing flavors of Provence. Upstairs or downstairs, the couple make certain that the sun shines in all their various dishes, served at 5 Rue Pierre-Demours. Thanks to her appearances on television, Denise Fabre has become the best-known Niçoise, or Niçarde, in France.

fresh décor, made necessary after a fire blackened the old one at the beginning of winter.

Now a cautionary tale about restaurant hubris. About twenty years ago, the GaultMillau guide stunned its readers by confirming that it could cost as much as 200 francs a person to dine Chez Denis. This was double the typical *addition* at Taillevent and two and a half times the average check at Michel Guérard's Pot au Feu, just before the chef gave up on Asnières. Self-taught like Jacques Manière, his genial contemporary, and as concerned about foodstuffs, Denis Lahana, known simply as "Denis", first came to notice in the nineteen-seventies, thanks in large part to praise from the journalists he invited to hear his incisive lectures. And while tentatively appreciated by sophisticated gastronomes, he was all but worshipped by the high-rollers among his clientele, who cheered him on as he boasted of being the most expensive chef in town. A near-maniacal perfectionist, inventive, believing it normal, unlike Manière, to buy and sell at the price of gold, but no better rated by Michelin than Manière, the Bordelais Denis had taken up cooking out of sheer passion for it, cheerfully admitting his lack of traditional training. Then he added: "I have eaten up six inheritances in great restaurants; I know what fine cuisine is." However, the extravagant Denis ran into fiscal difficulties as soon as the less *nouveaux riches* among his gourmand customers found the house's *chauds-froids d'ortolan au chambertin, salmis de canard sauvage*, and *chartreuse de faisan* overpriced.

After Chez Denis on the corner of Rue Rennequin and Rue Gustave-Flaubert met its inevitable end, the house remained closed for quite a while before Michel Rostang took over the lease. The son of Jo Rostang, whom the media had followed from Grenoble to Antibes, where he had acquired La Bonne Auberge, Michel had just come from the provinces even though earlier he had also worked at Lasserre, Lucas-Carton, and La Marée. His cuisine proved innovative, modern, and very likable, at the other end of the scale from the *grande bouffe riche* – the heavy gorging banquet – favored by Denis.

Gault and Millau reread every ten years : "Denis is such a great chef that we feel obliged to ask: 'Where can one eat the best truffles in Paris, the best duck, the best lobster, the best *foie gras*, the best *cèpes*, and the best wild-game mousse, as well as the best *cassoulets, choucroute* . . .

A lyonnaiserie by Michel Rostang

He who can do the most can also do, not the least, but rather the simplest. Michel Rostang may work with sophistication and authority in his sumptuous, exquisitely decorated restaurant, but in his "annexes" he avoids complication. Here, the important thing is to make the food good, without unnecessary flourishes, at prices that for Paris are reasonable. Le Bistrot d'à Côté, established in 1987, harks back to the Lyonnais origins of a chef so Parisian that he could only be from the provinces. One proof is sabodet *served on a bed of lentil salad.*

A speciality of the Lyonnais and the Dauphiné, the thickly sliced sabodet *seen here came from Colette Sibilia, whose hand-made sausages are known throughout Lyons. The name of this flavorsome product, made from pure pork in a traditional manner, derives from* sabot, *signifying the wooden-shoe shape the sausage once had. What goes with it? A good-quality Beaujolais, one that is not too fruity, would make a fine accompaniment to this agreeably nourishing dish. However, a* fillette *of Côtes-du-Ventoux, an elegantly fresh little wine adding minimally to the bottom line of the final tab, would also work to excellent effect.*

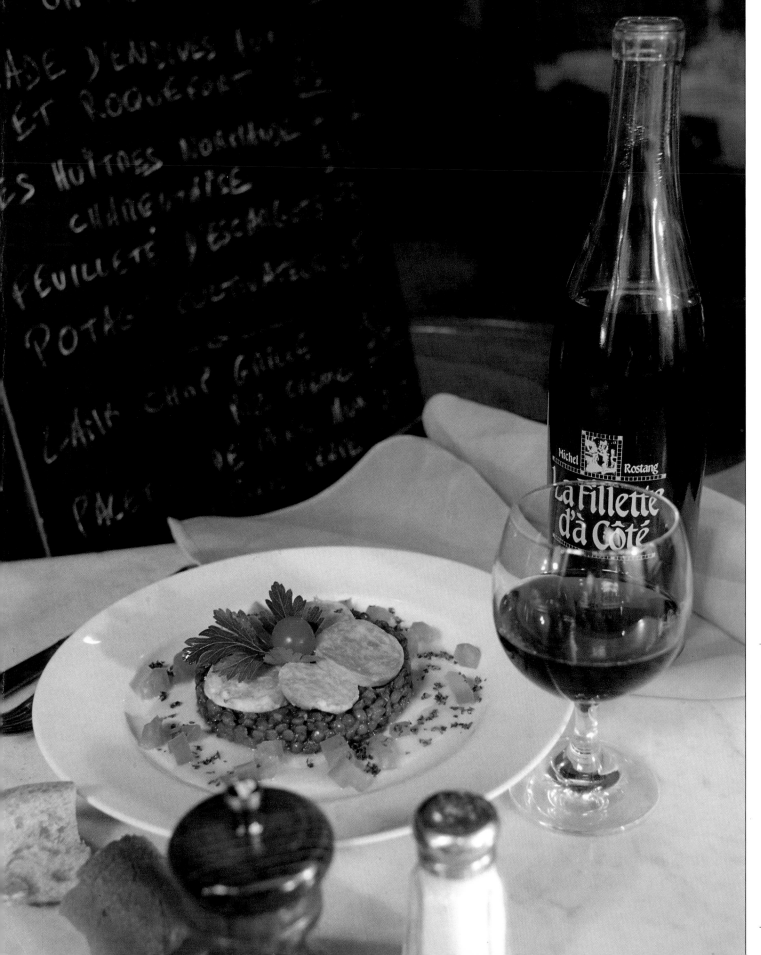

A
lyonnaiserie
by
Michel Rostang

Le Bistrot d'à Côté
10 Rue Gustave-Flaubert
Paris XVII

Michel Rostang
restaurant gastronomique
20 Rue Rennequin
Paris XVII

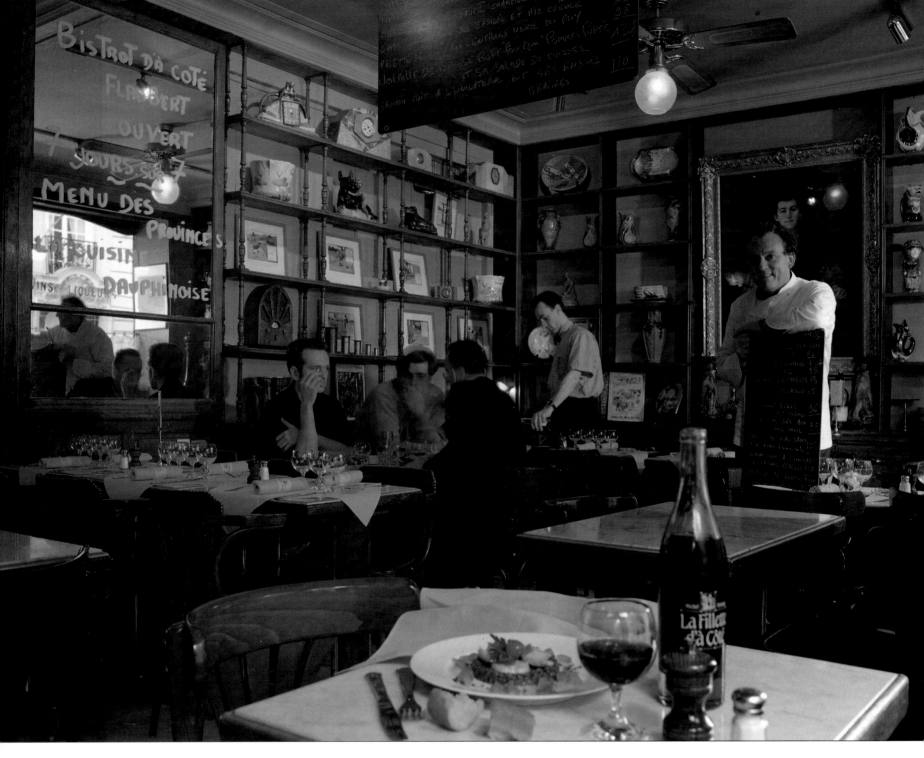

Michel Rostang is the owner and guiding spirit of several excellent bistros, each of them known as Le Bistrot d'à Côté plus the name of the street. Although seen here in the Rue Gustave-Flaubert, the Dauphinois chef can normally be found practicing his virtuoso skills at his two-star, high-style restaurant at 20 Rue Rennequin.

finally, everything?' The immediate, automatic response: Chez Denis." (1974.)

"Admirable, little Rostang . . . who gave us one of the memorable meals of last spring, forgetting the cost: *salade tiède* of lobster and artichokes in basil – a gastronomic masterpiece, the first fresh morels with the first green asparagus, very firm lobsters sautéed in hazelnut butter, a prodigious roasted John Dory with a very green sorrel sauce, a Bresse duckling in a blood sauce of infi-

nite lightness, cooked extremely rare but cut so thinly that this was hardly noticeable, all before a lovely selection of chocolate cakes and along with rare, exquisite Burgundies." (1984.)

"The years pass without leaving any lines on the smooth face of this choirboy of the ovens, who from time to time lets himself go a bit wild, or on his cuisine, the calm virtuosity of which finds inspiration in the Lyonnais, the Savoy, and Provence, but always

with a certain reserve and a measured, controlled freedom of invention. . . An exhilarating cuisine, full of finesse, whose flavors fit together down to the last millimeter." (1994.)

With his two Michelin stars (since 1982) and his 19/20 GaultMillau rating, Rostang became a *succursaliste* – an expert at sprouting branches – even before Guy Savoy, the other *cuisinier/auteur* on the north slope of the Étoile. In 1987, he opened his first *cantine/annexe*: the charming Bistrot d'à Côté at 10 Rue Flaubert. Then came the Bistrot d'à Côté Villiers, followed by the Bistrots (less) d'à Côté in Neuilly and on the Boulevard Saint-Germain. With their kitchens and dining-rooms all run by former employees of the starred "mother house," these young restaurants in the old bistro manner share the same menu, composed of hearty, generous dishes like those in Lyons, while each offers its own *plats du jour*. The concept has been stunningly successful.

On the border between the 16th and 17th *arrondissements*, very near the Étoile, Prunier-Traktir has come miraculously back to life. None other than Jean-Claude Vrinat now orchestrates the business, which however is not just a *succcursale* or spin-off of Taillevent. The celebrated old house at 16 Avenue Victor-Hugo had been closed for four years when the architect Yves Boucharlat, following his work for the Haeberlins in Alsace and for Bocuse in Lyons, undertook to reconstruct the upstairs floor, where the dining-room had never matched the magical quality of the main floor designed in 1925, Art Deco's *annus mirabilis*.

Prunier-Traktir was originally opened by the son of Alfred Prunier, the founder, fifty years earlier, of Prunier-Duphot near the Place Vendôme. Émile Prunier, who oversaw every last detail and even designed the bar stools, commissioned Auguste Labouret to design the façade and Louis-Hippolyte Boileau to decorate the downstairs. Ten years later, Labouret designed the universally acclaimed first-class dining-room on France's greatest luxury liner, the *Normandie*; Boileau, the architect of the Hôtel Lutétia and the extension of the Bon Marché department store, was to become one of the architects of the Palais de Chaillot, the only large monument in Passy, a quarter given over largely to private residences.

Although passionate about mosaics, marquetries, and incrustations, Émile Prunier was equally involved with the produce of rivers, lakes, and seas, as well as with their

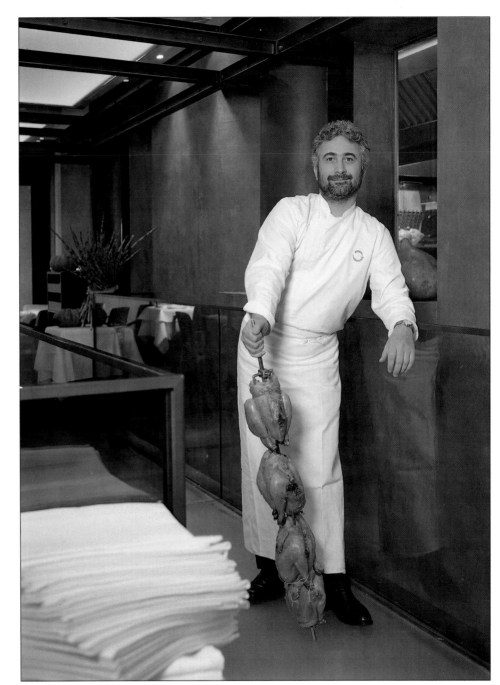

natural habitats. He took up oyster farming, built fish ponds, rigged up trawlers, refitted freight cars to handle live fish, and encouraged sturgeon fisheries in the Gironde in order to have French caviar on his menu.

Registered with the Monuments Historiques, the part of Prunier dating from the nineteen-twenties cannot be touched, and even the upstairs renovations had to be approved by the architects of the Bâtiments de France. Vrinat and Boucharlat opted for an ultra-contemporary but suave, low-key style – in the hope that their 1994 work would be found classifiable in the twenty-first

Guy Savoy – like Michel Rostang, Jean-Paul Lacombe in Lyons, and now many others – is an astute *succursaliste*, meaning an operator of moderately priced "branches" serving excellent bistro fare prepared and served by staffs trained by the master himself. Often the *cantine/annexe* is located next door, across the street, or around the corner. There is, however, only one restaurant called Guy Savoy, a splendid, two-star success at 18 Rue Troyon.

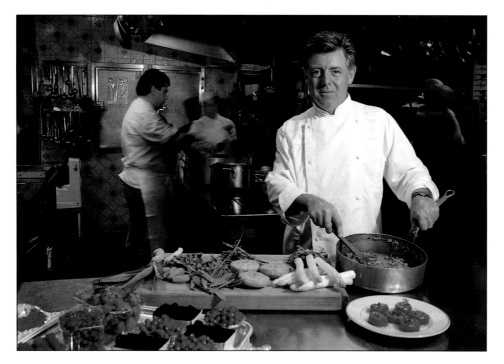

Henri Faugeron, a deceptively calm man, disdains theatrical effects, generally avoids the media, but works with passion and continues to create new dishes, long after his many innovations that helped to usher in *nouvelle cuisine*. His food, though sometimes served in tiny portions, is often quite grand. One must pay attention to appreciate his flights of fancy and inventiveness, for they tend to be subtle and refined. Faugeron is, after all, a good Corrézien with a solid mastery of the classic repertoire, which, however, he never treats in a literal manner. For this two-star, three-toque chef, as well as for the best of his rivals and their imitators, the secret of successful cookery is to work only with the best materials in a well-equipped and well-organized kitchen.

century. While the kitchens were being rebuilt and the upstairs redecorated, an archivist was researching the old house recipes, as well as the menus, which had become collector's items. Clam soup, Boston filet (beef with oysters), and sheeps' trotters in *sauce poulette* will make it into the next millennium.

The *Beaux Quartiers* are not ideal for *flâneurs*. Slicing through them is the wide Avenue Victor Hugo, whose formality and quiet, residential character do not lend themselves to random strolling, despite the elegant, enticing shop windows that glow by night as by day where once stood the house of Victor Hugo. Around the circular Place Victor Hugo are to be found an attractively traditional Marquise de Sévigné shop and a bakery, À la Petite Marquise, which sells tasty Viennese breads. Farther along, at 125 Avenue Victor Hugo, sugar-coated almonds, pralines, and a thousand other sweets can be had at Le Duc de Praslin. Still farther, at no. 184, Boissier has, for some ten years now, been a magnet for Parisians addicted to fine candies and pastries.

Claude Peyrot, the always astonishing chef at Vivarois, holds court at no. 192. Now brightened and made more welcoming with a bit of retouching, the beautiful dining-room still retains its cool, severe, strictly contemporary furnishings, all ahead of their time, when restaurants were still dominated by gilt moldings, crystal chandeliers, and Louis XIII-cum-Napoleon III, if not by some variant of Slavik's authentic/phony bistro style.

Peyrot, somewhat out of the mainstream of the gastronomic world, may be a man of shifting moods; he is certainly a man of character. Twenty years ago, when one report had him striving to "reawaken" his restaurant, he surprised everyone with a delicate, new cuisine with nothing at all "somnolent" about it, a performance that Michelin applauded with three stars, at least for a time. He continues to offer extremely personal dishes, some of them passing fancies, others permanently placed on the menu. And while greatly admired, he does not send the critical community into transports of ecstasy. None other than the very strict Robuchon commented in 1993: "Peyrot is underrated. Well out of the ordinary, as both a man and a cook, he belongs among the greatest of our time! I have come to believe that this exceptional person is unjustly and widely misunderstood – as was Delaveyne, who left his mark on an entire generation and revealed many culinary truths, but who has been judged by minor events that came late in his career."

Like Alain Senderens, like Joël Robuchon, who was his neighbor in the Rue de Longchamp for more than ten years, Henri Faugeron is one of the provincials who learned their lessons at the Berkeley. Son of a *hôtelier/restaurateur* in Maymac, in the Corrèze department, Faugeron began his apprenticeship in the family house and then worked for two years in Poitiers, not far from the place where Robuchon made his debut. By 1969 he had arrived in the 7th *arrondissement* where, at the Belles Gourmandes, he commanded attention by his light touch, inquiring spirit, and urge to create. In brief, he became a *nouvelle cuisine* star whom Michelin rewarded with two stars in 1975, two years before Gault and Millau coiffed him with three red toques, citing his talented inventiveness.

The long Rue de Longchamp, once trod by Chaillot parishioners making their way towards Longchamp Abbey, could for a while rejoice in the two Michelin stars captured by the old Jamin, the restaurant of Raymond Jamin, a friendly man who might change chefs but always kept lamprey, sweetbreads with mushrooms, and *bordelais* rib of beef on the menu. Henri Faugeron and his wife Gerlindé (an Austrian music-lover turned charming hostess) have made their two stars twinkle quite differently. Master of a wide-ranging, functional cuisine, Faugeron decided to gamble a bit, and he won. Quite simply, he retained his contemporary style but without

insulting tradition and then occasionally slipped in a few richer, delectably bourgeois regional dishes. What resulted were dishes created by a solid Corrézien capable of the most exquisite delicacy. Ideally, they should be consumed with wines chosen by Jean-Claude Jambon, voted the world's best *sommelier* in 1986.

Let us return now to Joël Robuchon, the only Parisian chef whom the 1994 GaultMillau rated 19.5/20. Ratings conferred by others can always be disputed, but this 19.5 is not out of line with the perfect cuisine of a chef given to exemplary rigor, who in a dozen years has never been caught relaxing his standards or resting on his laurels. On one occasion the famous *purée* seemed to us more butter than potatoes. But then why did we ask for a second helping, a request made to Jean-Jacques Caimant, the *maître de salle* who officiates with all the grace possible in the steeliest profession. On another occasion, the desserts struck us as notch below the main dishes. But why not go for the ice-creams, which are not wheeled about during the entire meal, "as at Robuchon"?

Meticulous presentations, surprisingly strong yet infinitely nuanced flavors, constant search for perfect harmonies, all laid on strong but without overwhelming the taste buds, a style that is still distinctive, exemplary steadiness. . . But to go on would risk understating the case for a "cook for the century," in whose restaurant one never feels overcharged, whatever the *addition*. The gastronomic media and guidebooks have so outdone one another in their praise of Robuchon that no superlative remains in stock.

At the end of 1993, a year of recession in France but not *chez* Robuchon (whose customers reserved a bit less in advance but spent more, up to $200 (£135) a head without complaint), the great chef and his well-tried team moved from the old Jamin house in the Rue de Longchamp to a Belle Époque mansion at 15 Rue Raymond Poincaré. Next door is the Relais du Parc, an independent yet interdependent "little" sister house, which is neither a bistro nor a brasserie. Here one can eat well for less money, and very pleasantly in the summer, when tables are also set out in a long courtyard with a holiday air reminiscent of Deauville.

"We were all delighted with this change of address," says Robuchon. "In the Rue de Longchamp, there were twenty of us in a ridiculously small kitchen, terribly on top of one another, and the dining-room staff didn't have

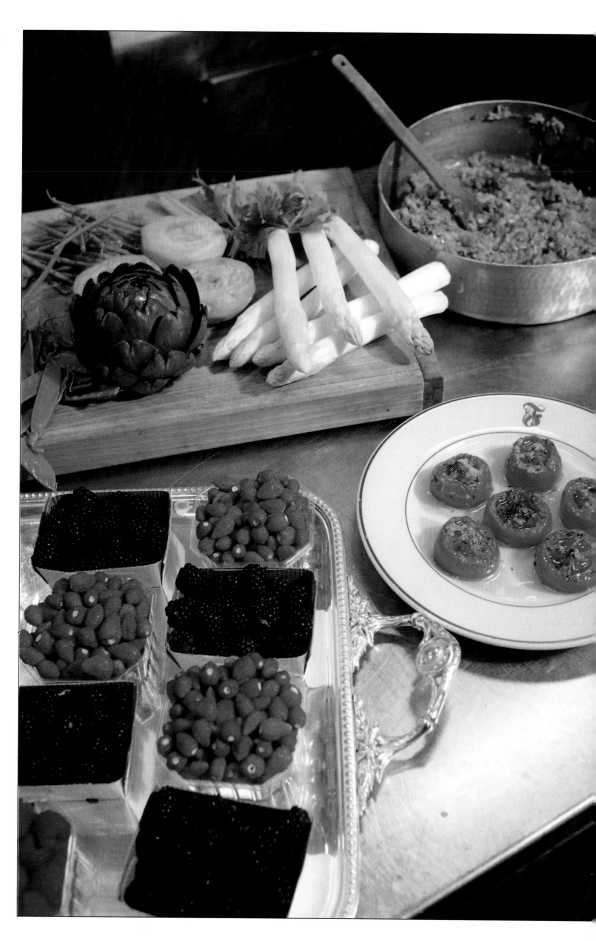

On the night before Christmas Eve 1993, Joël Robuchon joined with Jean-Michel Bost, his *chef de rang*, Jean-Jacques Caimant, his manager and long-time colleague, Gonzague Charpentier, his *maître d'hôtel*, and Antoine Hernandez, his *sommelier*, to pose long enough for this group portrait for *Gourmet Guide to Paris*. Robuchon was leaving the Jamin premises on the Rue de Longchamp, which he had taken over in the autumn of 1981, and moving to the Avenue Raymond-Poincaré. At the old address he had won three stars from Michelin; at the new one, GaultMillau, among other authorities, named him "chef of the century." Slowly but surely, Robuchon has established himself as one of the most celebrated chefs ever.

much more space for circulating between the tables. Every movement had to be carefully calculated, to the last millimeter. Now we have a tool perfectly designed for our work – 200 square meters for the cooks – although the dining-room allows for two places less than at Jamin. I installed stations that we never had before, for appetizers, for cold preparations, and for desserts. . . Crustaceans now have their place next to the fish, and I have reorganized the sauce station. . . We work better, faster. We must always press ahead with the cooking, even for those things normally requiring time. Customers don't want to wait, especially at lunch. Dishes needing forty minutes of slow cooking have to be rethought, to save ten, twenty minutes. Reconsider, modify, search – all this is more readily done in a favorable environment with good equipment."

Robuchon made his debut in Paris in 1964-65 at the Vert Galant, a restaurant on the Quai des Orfèvres then in vogue. Next came the Berkeley: "This was the establishment where I learned the most, thanks to a chef who told us it was a matter of produce, who taught us that we could achieve perfection with a simple potato lightly browned on all sides, crusty on the outside, soft on the inside. . . But it was hard. We wore forage caps, not toques, so as not to touch the ceiling, which was very low. The

ovens were coal-fired, and had to be restoked even during meals. We were covered in black. . . Later, I worked at Frantel Rungis, from which I moved to Concorde-Lafayette. A giant operation, one of the largest in Europe. It prepared up to 4,000 meals a day, sometimes more. Next came Nikko, which seemed tiny to me. . ."

At Nikko, Robuchon began to be known and, having mastered his *métier*, he decided to set up under his own name. Marcel Trompier, the owner of La Marée, told him about Jamin. "I had no money," Robuchon continued. "I sold my apartment, and Marcel Trompier was kind enough to negotiate for me. . . At first I felt a bit uncomfortable, because the soul of Jamin was still there. He was an important person, who left his mark on the profession. It troubled me that I was taking his place. And then, things went well. He had put a horseshoe in the floor when the restaurant was being built. . ."

Robuchon kept the Jamin name for his restaurant in the Rue de Longchamp. Now, however, the signboard carries his own name, thirty years after his arrival in Paris. "I'm from Poitiers. When I left my native province I was thrilled but lost. The first time I took the Métro it struck me as fabulous. The Eiffel Tower, the Arc de Triomphe, the taxis of the period, the form of the G7s, still hackney cabs, the police with their képis and sticks. . .

In January 1994, Joël Robuchon took possession of 59 Avenue Raymond-Poincaré, a splendid mansion built by the architect Charles Letrône for a rich industrialist. It had been decorated by Christian Ferré-Duthilleul to evoke the luxurious residences of the Belle Époque (a manner that could be called mongrelized Art Nouveau but for the style's "wet noodle" associations that scarcely seem appropriate in the context of a three-star restaurant). Scrupulously refurbished, the house retains its beautiful wrought-iron staircase, its neo-Renaissance, neo-Louis XV, and neo-Dutch Baroque interiors, and its ornate, illusionistically painted library.

"The great monuments are still there, but what moves around them has changed. Today, the contrasts with the rest of France are less marked. Paris has lost some of its personality – the provinces have moved on and copied it – but it retains its special character as far as restaurants are concerned. Here people are alert to fashion, watch out for the latest thing, get bored quickly. . .

"The clientele has expanded and become better informed. Has it progressed much? Many people cling to received ideas. Formerly customers did not always live in extraordinary palaces, but they had the restaurant habit and often knew what they wanted.

"I was amazed by Les Halles when I first arrived. Another world right in the middle of Paris. It was a fantastic bazaar, an immense fair. There was everything, everywhere, a place to get lost in. In the food shops, kept mainly by elderly Parisians, who were less friendly than provincial shopkeepers, you could find any number

of things, rare products, but the quality was not always as good. . .

"In cities like Poitiers, you have three or four reputable suppliers, and you don't have to look any further. In Paris, you are often tempted, but you don't find the same climate of confidence, and you can be a little afraid of being taken advantage of.

"Today, provincial cooks can more easily procure the best fruits and the best vegetables, at least those of their own region, but we are practically in the same league when it comes to other products used in resaurants, notably meat and fish, which we have delivered direct. A clear disadvantage, on a different level, is rent, all the expenses, salaries, and high costs that squeeze margins and push up prices.

"We can't be simplistic when we compare Paris and the provinces. At the moment, the tendency is to say that the provinces are displacing Paris in the realm of

Robuchon is the first chef of this *fin-de-siècle* to depart from the contemporary norm and set up in an elegant environment like those favored by the three-star chefs of several decades ago. Having long worked in painfully confined quarters, he was determined to treat himself to an immense, well-earned kitchen, a kitchen approaching the magnitude of his talent.

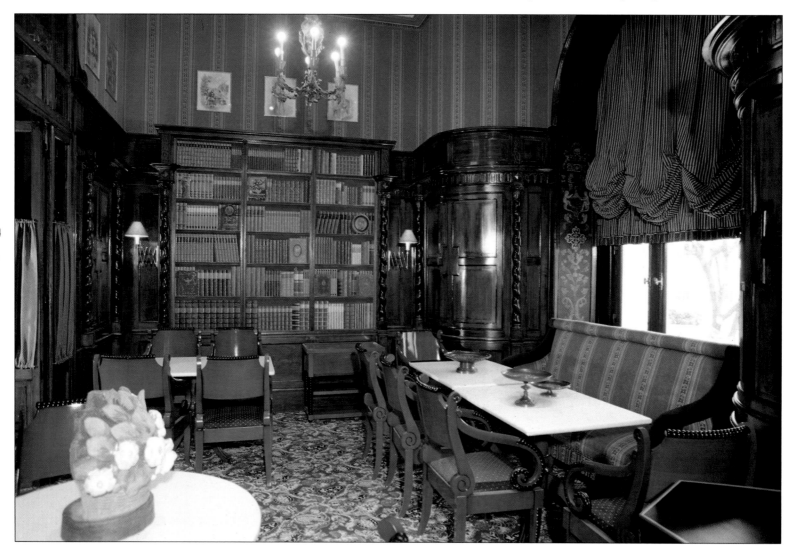

Le Relais du Parc, next door to Robuchon's three-star restaurant, owes the composition of its menu to the great, much adulated chef himself, but it remains independent despite interdependence from its legendary neighbor. The dining-room is pleasant and the terrace marvelously uplifting on fine days (suggesting more Deauville than Paris). As for the cuisine, it is simple though not banal, good, and mercifully not expensive.

gastronomy. After placing Lyons first, they give the honors to Alsace, which plays its regional qualities for all they're worth. . .

"Many provincial chefs are exemplary, in style, in craftsmanship, in presentation. Outside the dynasties and the 'greats' already established for a long time, there are the Bras, the Loiseaux, the Gagnaires who stand out by their strong personalities. Maximin, an innovator, has brought regional cuisine – *la cuisine du terroir* – very much into its own. Amat, whom I don't know, has profoundly impressed the professionals who have worked with him. We must also not forget people like Bruneau in Caen, Robin in the Loire Valley. . .

"But frankly I think it's Paris, all things considered, where one eats the best, when everything has been taken account of. Because here we have every cuisine, because here it is easy to find good fresh products, because the potential for customers is such that there will always be a demand. . ."

Tomato millefeuille with crabmeat by Joël Robuchon

Created dishes, reinvented dishes, all of them exploding with flavor, all made with precision – and delicious to look at (one can also eat with the eyes!). Joël Robuchon utilizes wonderful materials, works imaginatively but without excess, seasons with a sure touch, cooks with precision, and serves beautifully. His signature is unmistakably there, on everything he does, and to note it is to accord him the highest possible compliment.

This tomato millefeuille layered with a sublime mixture of crabmeat, watercress, and herbs, so harmoniously and tastefully presented, proved the glory of two seasons while Robuchon still reigned at the old Jamin in the Rue de Longchamp. After enjoying a fine summer in 1992, the dish, with its light and agreeable consistency, reappeared a year later, from spring to autumn, and now stars at Robuchon's new restaurant in the Avenue Raymond-Poincaré.

Catherine Michel, a thoughtful and well-informed journalist who helped edit a collection of recipes by Joël Robuchon, said of his cuisine:"Quite simple and self-evident on the plate, it is achieved with absolute rigor and with meticulous care in every detail." Oddly enough, the tomato millefeuille did not appear in Ma cuisine pour vous, which nonetheless abounded in such inventions as skate fin with artichokes, fresh cod sautéed with aromatics, and skate cheeks with cabbage. Robuchon himself helped prepare the recipes for publication.

Tomato
millefeuillle
with
crabmeat by
Joël Robuchon

Joël Robuchon
59 Avenue Raymond-Poincaré
Paris XVII

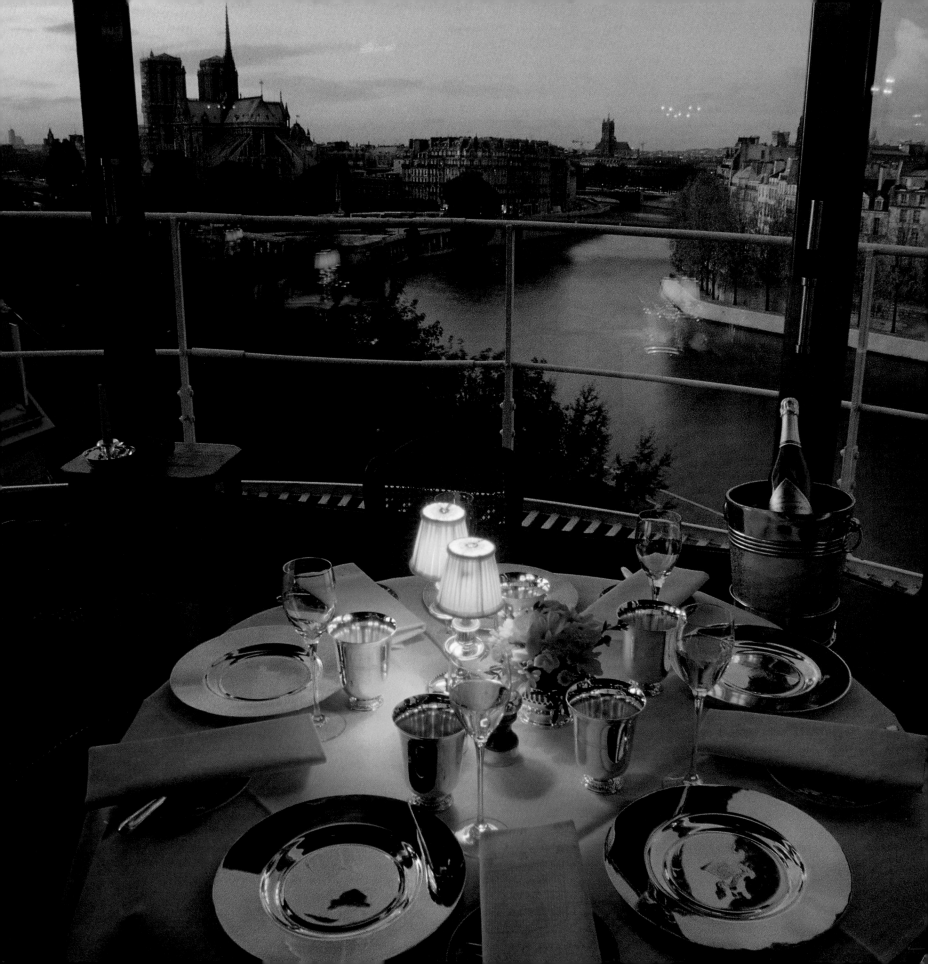

A t the crossroads of land and sea, Paris grew into the capital of France by appropriating the Seine, shaping it to its own end with bridges, colonising its banks and even reshaping its course. The underlying structure of the city is derived from the river, which constitutes its main axis even today, despite the decline of waterborne commerce which made the waterway an asset of paramount importance before the advent of railways. Even with massive urban redevelopment, the mobility and mixing of populations, the inexorable spread of anonymous office buildings, upstream Paris still differs from downstream Paris, in plan and spirit alike. The Right Bank and the Left Bank remain steadfast in their separateness and charming individuality, linked though they are by a multitude of bridges, the Métro, and the RER. On the eve of the year 2000, Montmartre continues to be as far away from the Montagne Sainte-Geneviève as Mont Blanc is from the Pic du Midi.

The old Seine was a river of intense human activity until the arrival of motorized tugs and barges, which themselves have now been largely displaced by huge *bateaux-mouches* – waterbuses – loaded with tourists taking in the spectacle of Paris along its traditional lifeline. The Seine tended to be forgotten after the building of roads along its banks. During the nineteen-eighties,

La Tour d'Argent, a restaurant like none other, with the sky directly overhead and all of Paris on its plate. Here, in his belvedere above the French capital, Claude Terrail has played host to *le Tout-Paris* and *le Tout-Monde* as well, treating them to a view of both the city's past (Notre-Dame Cathedral) and its present (the Pompidou Center). They also taste the most succulent ducks to be found anywhere while, with their eyes, devouring the Île de la Cité, the Île Saint-Louis, Sacré-Coeur, and all the other historic delights of *la ville lumière*.

Ice creams and sorbets by the dozen, as well as delicate *granités* – these are what make Berthillon one of the glories of the Île Saint-Louis. Although expensive, Berthillon is so consistently excellent that loyal customers can sometimes find themselves queuing for hours. The first Parisian *glacier* to be cited as *très bien* in the post-war era, Berthillon continues to figure among the best, indeed to be the best.

however, it regained some of its former importance following further works which allow both Parisians and tourists to muse on the water's sparkling reflections, secure from the automobile traffic.

For hundreds of years, the Seine made the mills turn and supplied the capital with agricultural products, mainly from upstream but sometimes shipped by canal as well. By 1215 the records speak of "granaries on the water." The miniatures in *La Vie de Monseigneur Saint Deny*, a fifteenth-century work, depict the life on the river in all its movement – the hustle and bustle, of fishermen and their boats. While cows were still being pastured at the tip of the Île Notre-Dame, now the Île Saint-Louis, the Place de Grève, today the Place de l'Hôtel-de-Ville, became Paris's principal port, a place where the arrival and distribution of goods provoked a jostling, animated scene on the land as much as on the water. Before the coming of the railways, overland transportation was slow and painful, far more difficult than travel by river, despite the floods, the unevenly maintained towpaths, and such occasional impediments as watermills and fisheries.

Developed by the "water merchants," the Grève port, a short stretch of embankment (*grève*) between a pair of watermills, brought together a richly colorful collection of boatmen, porters, innkeepers, and traders. When Louis IX (Saint Louis; *r.*1226-70) allowed the burghers of Paris to elect their own representatives at court, the municipal magistrates chose as their head a member of the powerful corporation which held the monopoly for river traffic, along not only the Seine but also the Marne, the Oise, and the Yonne. The seal of the *marchands de l'eau*, depicting a ship that was already emblematic of a much older form of navigation, was eventually incorporated into the arms of Paris.

Paris had other ports on the river, gently sloping banks with rudimentary facilities which permitted dockers to unload heavy materials. Among these were charcoal and then coal, which the *patois*-speaking Auvergnats shipped in their *sapines* – primitive plank rafts which were meant to be dismantled after a single voyage, upstream to downstream. The fuel was delivered to housewives, who used it in poor little braziers or in *potagers*, the ancestors of modern cooking stoves. Coal provided the principal culinary combustible until the advent of "gas on every floor." As for the Auvergnats and their assimilated neighbors,

the Limougeauds and Aveyronnais, they became the first Parisians from the provinces, people known for their bistros selling wood and coal. The industrious, often caricatured *bougnats*, whose tiny taverns comforted the laboring classes with liquid refreshment and a means of getting warm, remained a distinctive presence in the big city until just after World War II. Many cafés and brasseries are still in the hands of their descendants, now located away from the river, since the railways triumphed over river transport.

Poultry and game markets served housewives on the Left Bank, which also had a bread market (Quai des Grands-Augustins). The Notre-Dame arm of the river, a stretch of the Seine with purer water, gained a fish market that lasted from the sixteenth century all the way to the Belle Époque. It comprised a flotilla of fish traps or nets stocked with live fish, as did a similar market on the Quai de la Mégisserie near the *bateaux-lavoirs* (laundry boats).

Who would eat without drinking? As the Seine flows, so flow the wines. The boatmen discharged their barrels at Bercy, on the Quai de la Rapée, so that they could be warehoused outside Paris before the toll gate. (There is still a Port de la Rapée, situated in front of the screen of modern structures hiding the Gare de Lyon, but it has been a good while since anyone rolled casks there.) Before 1860, when the commune was annexed by Paris, the Bercy warehouses constituted Europe's largest wholesale wine and spirit market. Inevitably, the fried-food *guinguettes* or cafés proliferated all along the quay, among them Le Rocher de Cancale and Les Marronniers, which attracted great crowds of *bons vivants* at the beginning of the nineteenth century.

Upstream from the Bercy sports palace – that green pyramid that once appeared futuristic but now seems completely part of the Paris cityscape – there survive a few vestiges of the old wine village, as rigorously gridded as a Roman *castrum* planted with tall trees. Bercy had its avenues, streets, and lanes, and the village formed a whole world in itself until 1970. The merchants who still roll their casks on the pavements find it difficult to adjust to the 300-meter-long building that lies perpendicular to the Seine and blocks off the horizon towards Charenton. Opened in the spring of 1994, this concrete container provides a thousand *cabines* to middlemen in the food and drink business – *les arts de la table* – as a place in

which to display their samples of magnificent food and countless beverages.

Reserved to professionals, this now houses the Institut National des Appellations d'Origine and several hundred different businesses, but it still lacks tenants for a good many of the offices. Meanwhile, construction work will continue until the new Meteor Métro line opens, with a Dijon station planned to serve the complex, beginning in 1996. When completed, the Bercy-Expo facility will include the old warehouses refurbished as conference centers, the former storage pavilions of the Saint-Émilion neighborhood rebuilt to accommodate 120 shops (open to the public), and a great variety of restaurants.

On the Left Bank of the Seine, the Science Faculty of the University of Paris now occupies the site of a wine market established in the seventeenth century. On orders from Napoleon, the original buildings had already been replaced with cellars and storerooms that could hold up to 200,000 hectoliters of wine and 160,000 hectoliters of spirit. Also on the Quai Saint-Bernard is the recently built Monde Arab, a post-modern glass-and-steel masterpiece designed by the French architect Jean Nouvel. It puts the dismayingly banal Science Faculty complex, opposite, to shame. The penthouse of the Monde Arab is given over to a panoramic restaurant, the adjective unhappily failing to rhyme with "gastronomic." Still, the visual feast makes up for the want of decent edibles, since the perspective of Paris is quite different from any other, disclosing the awesome mass of the Bastille Opera, which seems almost to occupy the foreground just beyond the Seine. One can take the bubble lift to the penthouse and savor the view without feeling obliged to order a meal.

Nearby is one of the most celebrated of all Parisian restaurants, especially among foreigners. La Tour d'Argent, needless to say, is expensive, indeed too expensive in the evening for most mortals. Like all three-star establishments. It is also dear to the heart of those who love Paris, because it allows them to linger over, along with the renowned duck, a heart-stopping view of the Île Saint-Louis, Notre-Dame, and the Île de la Cité: a dazzling, moving, fascinating spectacle, a brilliant piece of urban theater best seen from the front row of tables next to the bay windows or, better still, from the table in the outside corner, where the heavens above are also part of the scene.

Tables are, of course, difficult to obtain and no doubt even more so at dinner than at lunch when, however, the daylight scene is magnificent, whether the sky is a soft blue or shading towards steel gray. At midday, too, the *addition* is much lighter, which allows the "Tower" to fall within the range of many more budgets. Those interested should reserve several days or even weeks in advance, just as for the theater!

The "Tower," thanks to both Claude Terrail and Paris, is a monument from which are revealed Notre-Dame, the Seine and its escort of other monuments. It occupies a place apart in the history of eating and even in history itself. André Terrail, a man of many interests, bought the restaurant some years ago from the famous Frédéric, a chef who cooked in a frockcoat and served his most illustrious diners himself. Claude Terrail, the proprietor's son, was born on the fourth floor at 15-17 Quai de la Tournelle when the restaurant was still housed on the ground floor. Thus, it was truly a son of the house who wrote the book *Ma Tour d'argent*, published about twenty years ago by Stock.

La Rôtisserie du Beaujolais stands on a corner of the Quai des Tournelles and the Rue du Cardinal-Lemoine directly across the street from La Tour d'Argent, whose owner, Claude Terrail, created the moderately priced *succursale* (branch) to save himself from having something like McDonald's as a neighbor. Exemplary in its rusticity, this extremely popular bistro came into being well before such "branching out" emerged as a fashion among prominent chefs. Excellent meats, good Lyonnais dishes, and the best wines of Beaujolais, the last selected by Georges Dubœuf, who all but incarnates the region, and sampled by the great *oenologue* Louis Orizet as well as by David Ridgway, head *sommelier* of La Tour d'Argent.

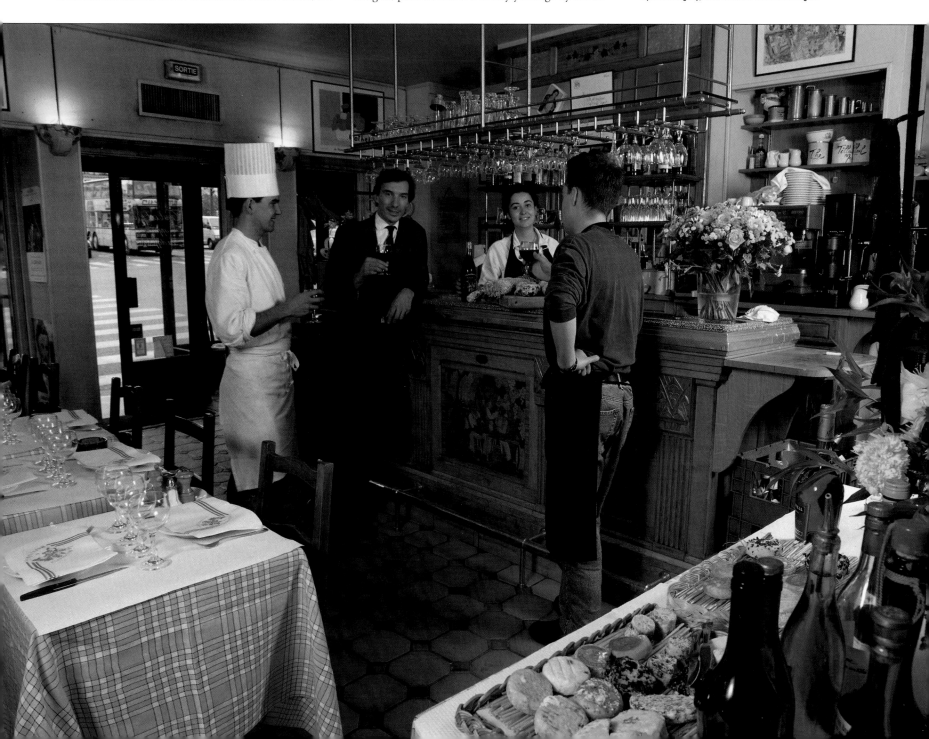

Yesterday, the magic of a railway station cum grand hotel; today the magic of a museum like none other, a place to get lost in among masterpieces of nineteenth-century painting and sculpture. This Belle Époque colossus was built for the Exposition of 1900 and then rebuilt within along contemporary lines to house the Musée d'Orsay. It even boasts a pair of restaurants, one of them lodged directly under the great clock on the same level as the galleries devoted to the Impressionists and Post-Impressionists.

Centuries ago there was already an inn on the rough banks opposite the Île Louvier subsequently integrated with the Right Bank, and the Île aux Vaches, where a ferry brought cattle to pasture. Henri III dined there on 4 March 1582; Richelieu stopped on several occasions in the early seventeenth century; and in the mid eighteenth century it seems that the Marquise de Pompadour sampled the house's champagne. By the eve of the Revolution the establishment had become more a restaurant than a tavern or inn, one which generally resisted changes dictated by fashion throughout the nineteenth century.

Claude Terrail: ". . . the Tower remained silver. It counted among its diners Alfred de Musset and George Sand, Alexandre Dumas, and Balzac, who deplored his not being able to come more often because, he said, of the 'need to reserve a place several evenings ahead.' Napoleon III came in secret to see Marguerite Bellanger. . .

"Finally Frédéric came. . .

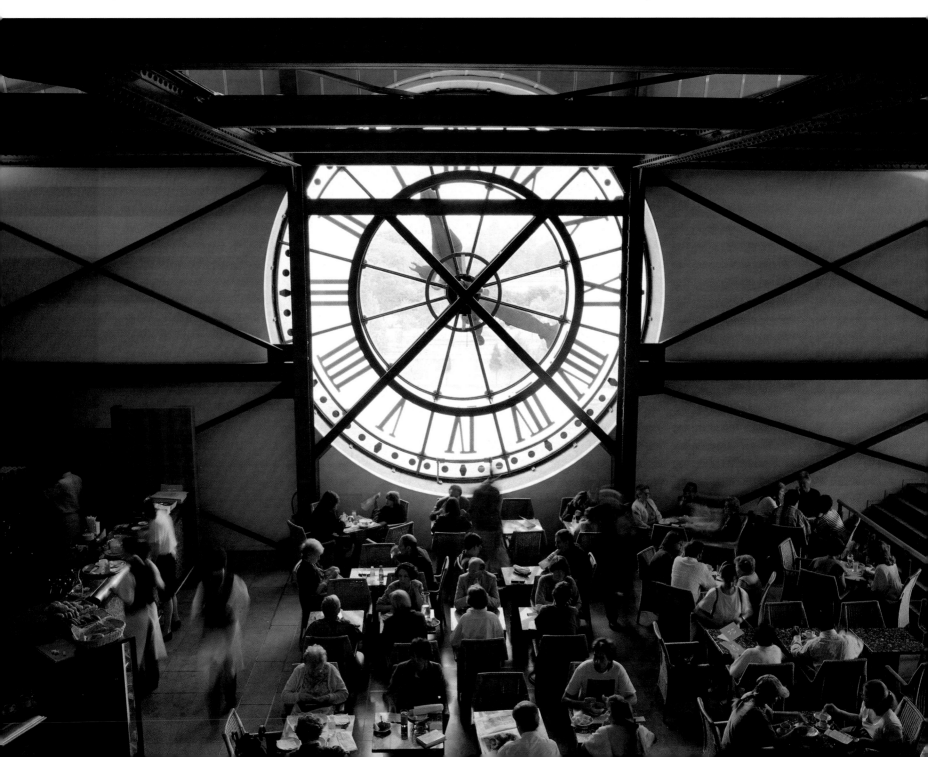

"You had to see him, Frédéric, with his lorgnon, his graying side-whiskers, his imperturbable seriousness, slicing his plump duck, trussed and flambéd, throwing it into the casserole, preparing the sauce, salting and peppering the way Monet painted, with total abandon and yet with the precision of a mathematician. . ."

The drama of serving the duck was and is performed in two acts. First the *filets au sang* are presented and then the grilled thighs. In 1890, Frédéric thought it a good idea to number the Tour d'Argent ducks. As a result, we know that Grand Duke Vladimir ate duck no. 6,043 in 1900. On 16 May 1948, the future Queen Elizabeth of England feasted on no. 185,937. "In the middle of the meal, I had the lights turned out in the dining-rooms in order to show Paris to Their Royal Highnesses as it slumbered, or pretended to, at the feet of that gigantic lantern, the illuminated cathedral. . . After dinner, I suggested a visit to the cellars, and Philip confided in me that he had gained much by his marriage, for when dining at the Tour d'Argent during his bachelorhood, he was most definitely not invited to go sightseeing below ground."

In 1951, General Eisenhower was served duck no. 222,580, at a time when he was still making up his mind about running for the Presidency of the United States. Emperor Hirohito of Japan made a meal of no. 423,900 on 3 October 1971. He had already consumed no. 53,211 on 21 June 1921.

World War II, obviously, slowed down the numbering process, particulary in the dining-rooms the staff called the "free zone," where the French could avail themselves of a princely *prix-fixe* meal consisting of, for example, pink radishes, minced meat, and vanilla ice cream. Upstairs, on the 6th floor, which the Germans had commandeered, things went a little better, if one can believe Ernst Jünger, who dined at the Tour d'Argent in July 1942 and again in February 1943: "The evening, at the Tour d'Argent, where Henri IV had already dined on heron pâté, and where one can see the Seine and the islands, as if from some dining-room in a huge aeroplane. The water, in the brilliance of the setting sun, assumes the pearly tones of moiré silk. The difference in color between a weeping willow and its reflection in the river was lovely to see; the silvery green of the foliage absorbed in its own contemplation became a bit more somber in the waves.

"One has the impression that the people at table up there, consuming soles and the famous ducks, look down like fiendishly satisfied gargoyles and see at their feet the gray ocean of rooftops under which the hungry population scrapes by. At such times, eating, eating well and a great deal, gives one a sense of power." (*Journal*, Éditions Bourgois).

After the fall of France in 1940, Claude Terrail reopened the Tour d'Argent, primarily to keep the Germans from taking control of it. Eventually, however, he crossed swords with them and ended up imprisoned at Fresnes, after which he rejoined the Leclerc division. Terrail returned to the Tour following his demobilization and took up the reins of general manager in 1947. With this, he abandoned his old dream of becoming an actor in favor of assuming the everyday role of an inimitable

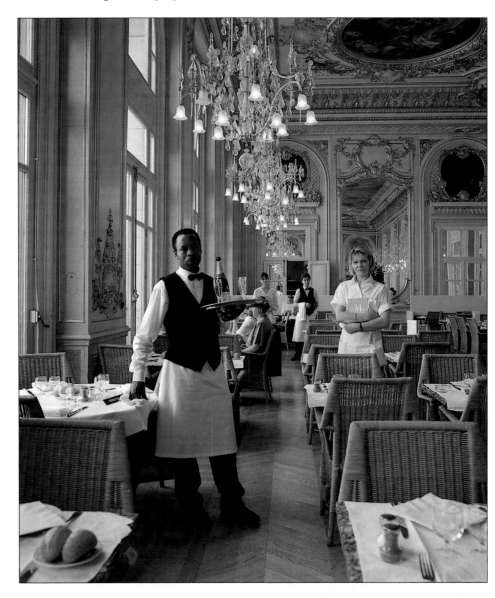

A radiant legacy from the grand hotel that once served the railway station is this palatial hall, where visitors to the Musée d'Orsay can eat simply but well at very decent prices. With its series of tall windows opening to the west, its gilded neo-Rococo moldings, glittering chandeliers, and *trompe-l'oeil* ceiling, the museum restaurant boasts one of the finest dining-rooms in the whole of Paris.

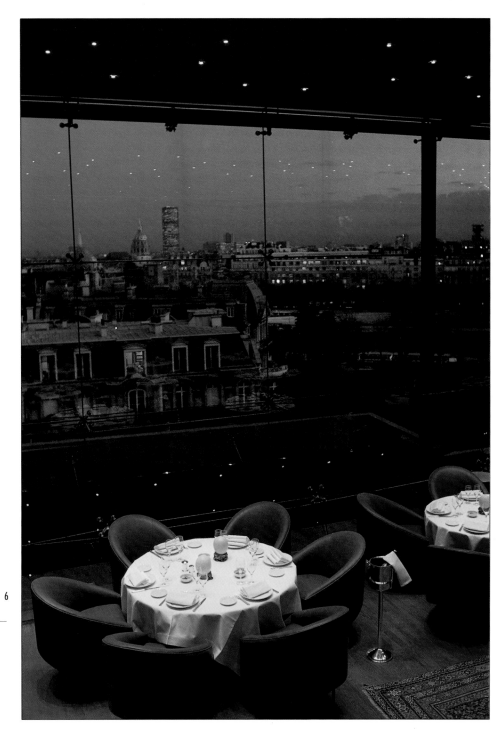

Maison Blanche occupies an enormous glass cube atop the Théâtre des Champs-Élysées on the super-chic Avenue Montaigne, offering an incomparable view over the shimmering Invalides dome, the Montparnasse Tower, the Eiffel Tower and, of course, the eternal Seine. Maison Blanche is an elegant cousin to the panoramic dining-rooms which adorn so many big hotels in North America.

gentleman-restaurateur. In this capacity he has continued to stage, day after day, throughout the last five decades, the ongoing spectacle of a restaurant open to Paris both by day and by night. "We come to 'La Tour' to dine," said Sacha Guitry. "Once there, we simply look."

"The bottom line," declares the trim, erect septuagenarian, a cornflower in his boutonnière, "is the least of my concerns. . . . I am a prisoner in this Tower, which has now passed its four-hundredth birthday and for me

is a theater within a theater. Welcome, welcome, welcome – how best to receive the pubic, this is my primary concern, for every day I take part in a play in which the majority of the actors change. My father bought the restaurant and then the building. Across the street I opened Les Comptoirs de la Tour d'Argent and Le Beaujolais, the latter a *rôtisserie/bistro* like so many that appeared later in Paris, so I wouldn't have a tourist trap on my doorstep."

"I live in a tower, 'La Tour,' where I was born while duck no. 50,000 was being served, where we have now celebrated duck no. 500,000. . . . Like all *châtelains*, I take care of my domain!"

The Seine flows on. Restaurants abound along the river bank occupied by the Tour d'Argent, all the way to the Eiffel Tower (which warrants another gastronomic detour, better taken in another chapter), but few of them are of any note. The Quai des Grands-Augustins recalls the old Augustinian order of hermit monks who were here in the Middle Ages.

On the quay, at the corner of the Rue des Grands-Augustins, Lapérouse occupies the ground and first floors of an *hôtel* dating from late in the reign of Louis XIV. Originally a very simple place serving the poulterers from the big market next door, the café was refurbished about 1850 by a certain Jules Lapérouse, whereupon it emerged as one of the best restaurants in Paris. The extemely discreet salons decorated *à la* Louis XV, in which so many beautiful *gourmandes* allowed themselves to be wined and dined by their well-heeled companions, were filled with a wealthy clientele decade after decade. The establishment returned to favor during the Third Republic when it was managed by Roger Topolinksi, the man who introduced the small flat spoon as the proper tool for tasting sauces. This glorious restaurant, where so many cocottes engraved their first names on the ice creams, using the points of their diamonds, has unfortunately been in decline for the last twenty years. This has been brought about by changes in ownership, changes in the kitchen. But it would be hard to think of Lapérouse only in the past tense.

A bit farther west, on the Quai Voltaire, a simple neighborhood café, where local residents drop in for a leisurely coffee or *apéritif,* or even just for a packet of Gauloises, serves as a front for one of the best-kept secrets in gourmet Paris. This is the much-loved Café Voltaire,

a small but elegant, club-like restaurant whose superb *cuisine bourgoise* and attentive service have long attracted a loyal clientele from the upper echelons of book publishing, fashion, politics, and the affluent of the surrounding Faubourg Saint-Germain, Proust's *quartier noble*. A highly varied menu includes main-course-size salads for the weight-conscious, the freshest *grillades* with creamy *purées* for unreconstructed gourmands, and crisply glazed Tarte Tatin for anyone seeking flavor at its purest and most intense. Uknown to Michelin or GaultMillau but familiar among those who know Paris at its best, the Café Voltaire brings glory to a stretch of the Seine embankment where Voltaire lived in the eighteenth century, followed by Baudelaire, Alfred de Musset, and Wagner in the nineteenth century.

Farther downstream, the Musée d'Orsay occupies the old Gare d'Orsay, a palatial railway station built in two years by the young architect Victor Laloux, who finished the work just in time for the opening of the Universal Exhibition of 1900. Today, the chief signs of the building's original function are the gigantic clocks and the allegorical statues personifying the cities served by the Compagnie des Chemins de Fer d'Orléans. Integrated with the station was a grand hotel with 370 rooms. Between 1977 and 1986, the entire complex was revamped into a museum dedicated to painting and sculpture from 1848 to 1900.

Close by the Belle Époque ballroom, with its glittering crystal chandeliers reflected and redoubled in mirror-clad walls, is a vast, richly gilded and amiably pompous restaurant, itself further enlarged by huge mirrors at either end. The high windows overlook the entrance courtyard guarded by the monumental personifications of the Four Continents and a menagerie of colossal bronze beasts by Antoine-Louis Barye. Directly opposite the restaurant stands the Hôtel de Salm, headquarters of the Légion d'Honneur, behind which the restaurant's diners can watch the sun go down on Thursday, the day the museum keeps late hours. The *à la carte* choices are not wildly attractive, but the fixed menu turns out to be decent enough as well as favorably priced, and the atmosphere overall has a certain poetical charm. The ensemble is much enhanced by the high ceiling with its airy, *trompe-l'oeil* painting, Antoine Enjalbert's over-sized vase decorated with masks, nymphs, and a satyr, and Théophile Barral's *Nude Susannah*, a pale, translucent marble which has darkened somewhat with age. Equally astonishing, but in a different category, is Le Café des Hauteurs installed behind one of the great clocks upstairs near the galleries dedicated to the Impressionists and Post-Impressionists.

The sightseeing boats pause briefly along the Île de la Cité, which has no outstanding eating places, before continuing on to the upstream end of the Île Saint-Louis, where everyone queues to refresh their palates at Berthillon. A pioneer of fine ice-cream, Berthillon remains the most celebrated *glacier* in the French capital. Even a simple vanilla sings out, but the sorbets positively explode!

On the Île Saint-Louis tourists with generous budgets will be comfortable at Le Franc Pinot, a former cabaret known for its seventeenth-century grillework decorated with vines and grapes as well as for its remarkable cellars. These are much appreciated by the film and showbiz world, but the competent though lackluster and expensive cuisine leaves most Parisians unimpressed. More appealing is Le Monde des Chimères in the Rue Saint-Louis-en-l'Île, its interior distinguished by old beams and stone work, as is Le Gourmet en l'Île, also with an attractively antique ambience. This is one of the restaurants offering the marvelous *andouillettes* of Simon Duval, the formidable *charcutier* based in Drancy. Considerably less expensive is the crowded Alsatian Brasserie de l'Île Saint-Louis on the Quai Bourbon.

On the Right Bank Quai de l'Hôtel-de-Ville, Gilles Épié expresses his personality at Miraville, a pretty Italianate house with frescoed walls and marble-tiled floors.

The simple restaurant on the top floor of the renovated Samaritaine department store allows its customers a matchless view over the river, the Pont-Neuf (Paris's oldest bridge next to a pump ornamented with a bas-relief representing Christ and the Good Samaritan), the tip of the Île de la Cité, and the Monnaie or Mint. Farther downstream, beyond the Place de l'Alma, there is the almost peerless Grand Chinois, one of the most refined Asian restaurants in Paris. If you want to continue along the embankment as far as the Palais de Chaillot very simple food can be had at the Grand Totem, lodged within the museum/theater complex. More important, the Grand Totem gives sweeping views over the Chaillot gardens and fountains.

Les Halles before 1968 — to know what the old "belly of Paris" was like, one has only to reread Zola's great novel *Le Ventre de Paris*. Today, almost all food wholesalers operate out of the big national market at Rungis, 9 miles south of the capital, a 625-acre depot and distribution center for perishable foodstuffs. It is made up of some 2,000 businesses whose annual receipts exceeded $300 billion at the beginning of the nineteen-nineties, employed over 17,000 people, and supplied one-fifth of France with fruit, vegetables, meat, sea and freshwater fish, dairy products, eggs, and flowers, brought in from sources all over the globe. Enlarged in 1993, the Rungis market is a self-contained city larger than the Principality of Monaco.

Rungis imports and sells, takes orders, ripens (cheese and bananas, for example), cuts up, packages, and delivers around the clock. Eight hundred and fifty wholesalers, 450 related services, such as banking, transport, and maintenance, and 680 producers combine to provide not only everything cited above but also *traiteur* and related products. It is the "first port of France" (the fresh fish pavilion is open from two until seven in the morning) and one of the world's most formidable florists. The cut-flower pavilion explodes with color and perfume on the eve of St. Valentine's Day, the 1st of May, Mother's Day, All Saints, and Christmas. However, this giant market, which never ceases to modernize itself, is tending more and more towards brokerage, bypassing depots in favor of direct shipment to customers. Such advanced technologies as fax, telephone, telex, and computer are thus put at the service of freshness. Even so, Rungis handles around 2.5 million tons of produce annually.

Star chefs, or those aspiring to that status, and serious restaurateurs shed a tear whenever speaking of the Halles Centrales they knew in their youth. As for Rungis, they go there to be photographed, to maintain friendly relations, or to seek fleeting inspiration rather than to buy produce. Often supplied directly with poultry, *foie gras*, mushrooms, and cheeses, they have their own buyers at Rungis, which keeps them from having to be at the fish pavilion by the crack of dawn, after a night of little sleep. In the mid ninetten-seventies, such major players in the gastronomic world as Jacques Manière and Jean Minchelli (Le Duc) were often to be seen at Rungis, as was Alain Senderens, then in the springtime of his glory. These men had iron constitutions and enjoyed meeting their friends. That was another time altogether. Nevertheless, more than 20,000 regular buyers still frequent Rungis, and thousands of individual restaurateurs or group restaurant managers still use the market directly or indirectly. Rungis is also the primary source for the covered and uncovered markets of Paris, as well as those of the Petite and Grande Couronne. These markets offer the best and the worst, when they play their proper role, and those who buy there should be knowledgeable enough to pick and choose as well as to bargain with a degree of finesse. Sometimes, however, local markets can be a bit ordinary or, in certain neighborhoods, give way to fashion, which can border on the ridiculous: diet products, health food, etc.

True markets, street markets, retro *halles* abound, but no one can know gastronomic Paris without having strolled through the Rue Montorgueil, Place Monge, Rue Mouffetard, Boulevard Raspail, Rue

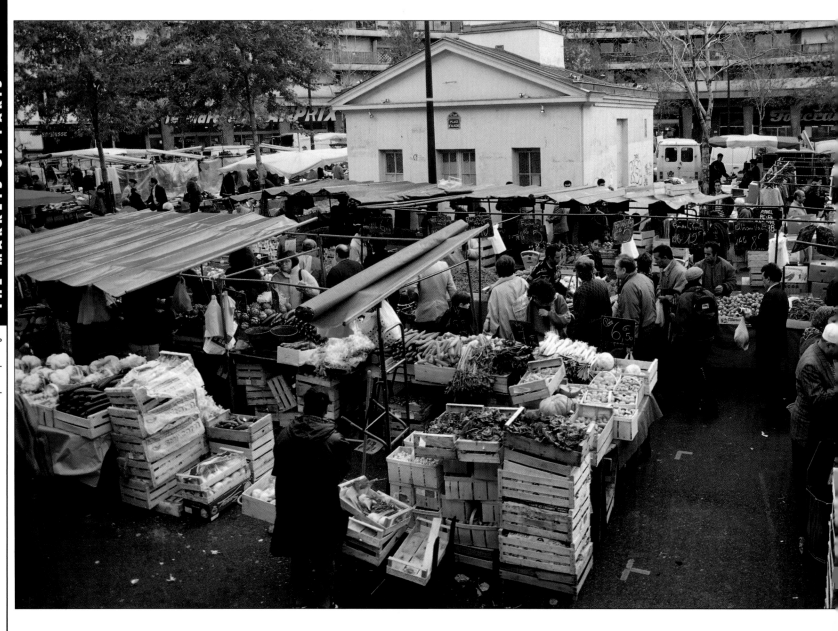

de Seine and Rue de Buci, Boulevard Edgar-Quintet, Boulevard Richard-Lenoir, Boulevard de Belleville, along the Ourcq Canal, Place des Fêtes, Place de la Réunion, Place d'Aligre, Avenue du Président-Wilson, and Rue de Lévis. The Rue Lepic has retained its matinal charm, if not its more picturesque features, while the covered market of La Chapelle provides nothing particularly original, but it is a convivial and pleasant affair, at the heart of an agreeable neighborhood where established shops survive among surprisingly good "Chinese" restaurants.

For something out of the ordinary, there are the short Rue Dejean and the open Barbès market, which runs under the elevated Métro tracks along the Boulevard de la Chapelle. A perfect meeting of site and purpose? Also worth a visit is the Joinville open market, especially on Sunday morning, when the stalls are spread out under shade trees near the Saint-Jacques-et-Saint-Christophe church in La Villette and the spectacle of Louis XIV's canal.

The markets of Paris are delightful places. Among them should perhaps be counted the Saint-Denis market, sheltered within a vast century-old shed a few steps from the Métro station serving the great medieval basilica. The Saint-Denis market is lively, well supplied, very cosmopolitan, moderately priced, and on the accessible north-east outskirts of Paris.

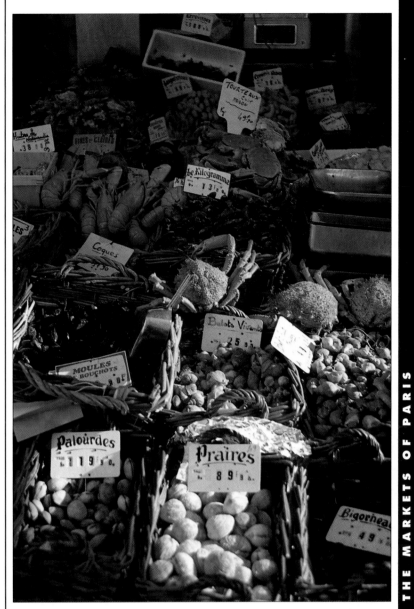

The overlapping Aligre and Beauvau-Saint-Antoine markets, in the 12th arrondissement, *are animated places every morning except Monday and crowded on Saturday and Sunday. With their immense stalls, they combine the attractive disorder of open markets and the more structured approach of well-maintained covered markets. Some twenty butchers, poulterers,* charcutiers, fishmongers, *dairymen and other merchants ply their trade in a hall built in 1781 and rebuilt in 1840 following a fire.*

At Rungis and elsewhere, chefs who are friends, such as Henri Seguin and Roland Magne, often buy at market together. Seguin remains in the peace and quiet of the 12th arrondissement, *which has not yet benefited from the proximity of the new Bercy. The chic and luxurious Pressoir, his restaurant in the Avenue Daumesnil, serves some of the best food in eastern Paris. Roland Magne had the temerity to succeed Jacques Manière at Le Pactole in the Boulevard Saint-Germain after the latter had created the Dodin-Bouffant. An excellent professional with a full mustache, Magne has completely revamped the cuisine and the dining-room at his restaurant. He is also president of the Syndicat Parisien des Restaurateurs de Métier, which has a membership of some two hundred.*

Visited by nearly six million people every year, on fine days the Eiffel Tower really does have to turn people away. In 1993, the managers of the iron-latticed structure gave a party for its 150-millionth visitor, a young woman security guard from Roissy airport. Soon thereafter they initiated a major renovation of the first-level restaurant/tavern, which then reopened in mid 1994, in time for Alain Reix, the director of all the restaurants, to celebrate his first anniversary at Jules Verne, the very successful restaurant on the second level.

The Eiffel Tower is administered and maintained by a corporation in which the city of Paris is a shareholder. While taking no part in the administration of the restaurants (Reix oversees sandwiches, pizzas, and hotdogs as well as the Jules Verne), the corporation derives revenue from souvenir shops, the sale of film rights, and the rental of salons. The most photographed and reproduced icon of the French capital is also very good business, control over which President Jacques Chirac decided to resume shortly after he became Mayor of Paris.

During this period, the Eiffel Tower underwent a complete overhaul, leaving it lighter by some 1,300 tons of excess iron. The security and fire systems have been updated, the old, asthmatic lifts replaced with more powerful ones, and the illumination of the whole structure

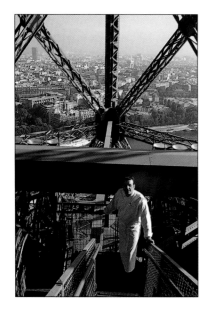

The highest chef, literally, in Paris is Alain Reix, who practices his profession at the Eiffel Tower 380 feet above ground, having prepared for his present post at La Rochelle in western France and at Strasbourg in the east. Down below is the esplanade of the Champ de Mars.

It was in a restaurant on the first level of his colossal iron skeleton that, on 11 September 1889, Gustave Eiffel was reconciled with the composer Charles Gounod, one of the Parisian élite who attacked the great tower during its construction. The restaurant did not enjoy the favor of Guy de Maupassant, who denounced "the canteen cuisine of aerial hash-slingers." In no way a "hash-slinger," Reix is responsible for the restaurant on the lower level, but he cooks on the second level at the one-star Jules Verne.

redesigned to give Paris its most fantastic night sight. Apollinaire called the 984-foot tower a "shepherdess of the clouds," but her makeup needs to be renewed regularly by teams of acrobatic painters. Long before this continuous process began, the structure made the fortune of Gustave Eiffel, the virtuoso engineer whose masterpiece was judged so harshly by France's intellectuals at the dawn of the Belle Époque.

Sometimes on summer days, the gates to the famous monument must be closed once the number of visitors reaches 35,000. Did Paul Verlaine really denounce "this skeleton of a belfry, which will not survive the centuries-old belfries of French Flanders and Belgium"? If so, the poet was not alone in cursing "the famous tower about which the entire earth has gone mad." For every Théodore de Banville who rhapsodized over the "colossus of power and grace," there was a host of noisy detractors and influential critics of the tower.

In February 1887, when construction workers drove the first pickaxes into the frozen soil, Charles Gounod, Charles Garnier, the architect of the Opéra, Alexandre Dumas, Leconte de Lisle, Sully Prudhomme, and Guy de Maupassant – a good part of the French cultural establishment, in other words – added their outraged signatures to a letter addressed to the director of works for the Universal Exposition of 1889. To them, it mattered little that the tower had been conceived as a symbol of the new age of iron, a "folly" on a grand scale that everyone assumed would be dismantled after a decade or two. The cultural élite loathed what they saw as an insult to Paris even before it had been built: "We come, writers, painters, sculptors, architects, passionate lovers of the as yet intact beauty of Paris, to protest with all our might, all our indignation . . . against the erection, at the very heart of our capital, of the useless and monstrous Eiffel Tower. . . Because the tower, which even commercial America would not want, is beyond a doubt the dishonor of Paris! . . When foreigners come to visit our exhibition, they will exclaim in surprise: What! This is the horror the French have found in order to give us an idea of their much-vaunted taste? They would have every reason to mock us, since the Paris of Jean Goujon, Germain Pilon, Puget, Rude, Barye, etc., will have become the Paris of Monsieur Eiffel."

Guy de Maupassant continued the outcry even after the "monster" had been constructed: "I left Paris and

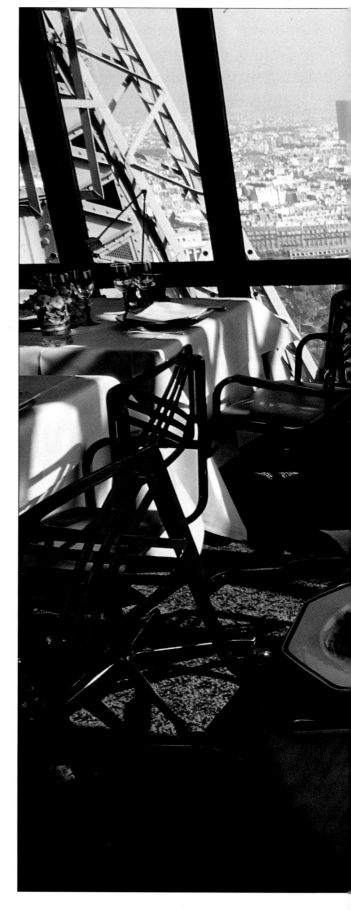

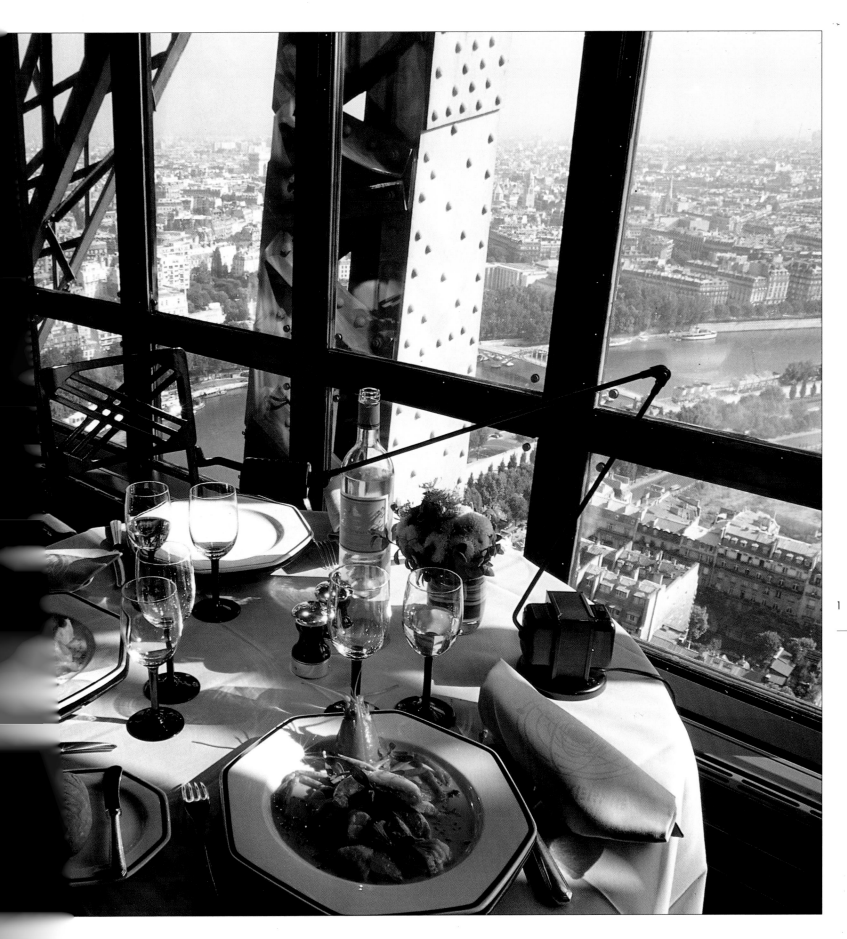

Rising up the flank of the Eiffel Tower in a bubble lift is rather like diving into the sea; it is as if one were letting go and leaving the earth behind. Such a vertical journey through the metal lattices cannot but make one think of the genius who created the astounding tower. In the handsome, trendy bar of the Jules Verne, visitors should not miss the crepuscular luminary effects that unfold in spring as Paris slips gently into the night just before bedecking herself with myriad lights.

even France, because the Eiffel Tower finally troubled me so much. . . I wonder what the future will conclude about our generation if some next rebellion does not unrivet and topple that tall, spindly pyramid of iron ladders, that unsightly and monstrous skeleton. . ."

"Oil well", "the spire of Our Lady of Junk", "ghastly street lamp", "ugly colossus", "Yankee dream", "empty obelisk", "chaos of interlocking beams", "iron mast with hard rigging"! Yet, despite all such abuse, the tower had its unconditional admirers, people moved by its novel beauty and daring. Sully Prudhomme had the courage to retract: "I did not, fortunately, sign and condemn other than by default, and in the presence of the finished and victorious work, I find myself more

comfortable with it than others, enough to make my own judgment. . . This rigid and cold colossus could be seen as a man-made iron witness raised up towards the heavens as a statement of humanity's resolve to arrive and remain there. Such, therefore, is the perspective that has reconciled my eye with this monster, this conqueror of the skies."

A few decades later, Le Corbusier would write: "To the tower I bear the witness of a pilgrim from across the world. In cities, in savannahs, on the pampas, in the desert. . . , the tower has found a place in the hearts of people everywhere, the sign of beloved Paris, the beloved sign of Paris." And so the tower received the accolade of France's greatest Modernist.

The tower, with its 984-foot height, which a television antenna now stretches to 1,051 feet, has long since become an essential symbol of the spirit of Paris. It may very well not grow any taller, but it will certainly expand, at least below, where a two-story underground parking facility is to be built, along with a new subterranean entrance, like the one at the Louvre.

Alain Reix may be the highest-placed chef in the Île-de-France (with a kitchen at 380 feet above ground), but he is no stranger to the nether regions of the Champ-de-Mars, where the storeroom or service center for all the eating facilities at the Eiffel Tower has been installed in an old munitions dump once used by the nearby École Militaire. This is only a short distance from the tower's south-west pier, and it provisions not only Jules Verne and La Belle France (a 200-seat brasserie) but also the snackbars and other "alimentary" outlets. The bust of General Ferrié, the creator of the military radio placed on top of the tower at the turn of the century, stands guard over the underground facility.

The Jules Verne restaurant, a venue intelligently decorated by Slavik, who for once abandoned his familiar *style bistrot*, replaced a rather ordinary brasserie at the time of the general face-lift of the early nineteen-eighties. Reix, the present chef, did his apprenticeship in La Rochelle under Jacques Le Divellec, who is now the seafood king of Paris not far from the Invalides. Reix then made a reputation for himself on the other side of France near Strasbourg. At the Eiffel Tower he heads a team of twenty-eight persons in the "gastronomic" Jules Verne and another seventeen in La Belle France, which was also completely refurbished in 1994 in a likeable "retro" style.

A provincial, now very Parisian, Reix has said: "Thanks to the tower, I've come to know Paris, which I never tire of exploring whenever I have the time to breathe (the crowds continue here from Easter to autumn). Every day I'm amazed to find myself overlooking the entire capital – one never tires of the spectacle – but I'm now quite adjusted. We're not allowed to use gas in the kitchen, for reasons of security. But the electrical equipment is very efficient. . . The only problem is the service lift. Even if deliveries are made daily, Sunday included, it's still better not to leave anything down below. . .

"It's also a bit crowded, though not more so than in many Parisian restaurants. As for the clientele, I had to get used to the very special situation at the tower, to accommodate the wishes of foreigners, who are in the majority, while cooking in a truly French way. I've learnt from mistakes, I'm a bit wiser, and I've simplified my *carte*. Nothing out of the normal."

Three people in fish, six in pâtisserie, well-regulated service, Paris spread out below: the ordinariness of the extraordinary. Jean Cocteau, the author of *Les Mariés de la Tour Eiffel*, wrote: "The Eiffel Tower is a world like

Passengers bound for the Jules Verne embark aboard an elevator reserved for the exclusive use of the restaurant's clientele. A large service lift functions all day long, for deliveries, for staff, and for maintenance. Sometimes the cab waits at ground level, for it pays not to forget anything essential to life at levels where quick errands to outside suppliers are impossible.

Notre-Dame. It is the Notre-Dame of the Left Bank. It is the Queen of Paris."

Rising above the mansards and garrets of Paris, the Eiffel Tower looms over the diners on the tiny terrace of Jean-Pierre and Danièle Morot-Gaudry's restaurant perched atop a rather strange building erected in 1929 on the Rue de la Cavalerie. The chef/owner arrived here in 1977 and began building his reputation as the master of a clever, well-conceived cuisine, regularly enriched with thoughtful innovations and always at reasonable prices.

Earlier Morot-Gaudry had presided over a café-restaurant in the 12th *arrondissement*. Like many others in Paris, this was a simple establishment with gastronomic ties to the Sologne region south of Paris. Still earlier, the chef had spent several years at Crillon in the Place de la Concorde, perfecting his repertoire, while satisfying the demand of the hotel's regular clientele for such unchallenging dishes as *radis beurre, filets de hareng pomme à l'huile*, and *oeuf dur mayonnaise*. Astute handling of the classic bistro formula, a smart new cuisine, and several good, if somewhat expensive, game dishes – especially his powerful yet refined *lièvre à la royale* (hare stewed in white wine with wild thyme) – did much to make Morot-Gaudry a chef to watch.

The hare followed the Morot-Gaudrys when they moved into the bizarre block built by the owner of a taxi company, who wanted a garage for his fleet of vehicles. Above the seven floors reached by way of a double spiral ramp he installed a pelota court (where the Basque game is still played) and another court for tennis. For himself and his friends he also created a club house, a space corresponding more of less to the one now occupied by the restaurant. The curious venue continues to astonish, even if not before the diners have arrived by express elevator and tasted the chef's variations on *coquille Saint-Jacques* or his reinventions of Moroccan *pastilla*. Once night falls, however, the magic of the site takes hold as the great tower turns a tawny gold against the darkened sky.

A brief crow's flight from the Eiffel Tower to just west of the École Militaire, the Morot-Gaudry restaurant has its own modest relationship with the heavens. This is a fine establishment, filled with light from the many windows and graced with a charming mini-terrace. Reservations are essential for those desiring access to the roofs of Paris. However, the food and wine are sufficient to beguile the taste buds quite as much as the view engages the eyes.

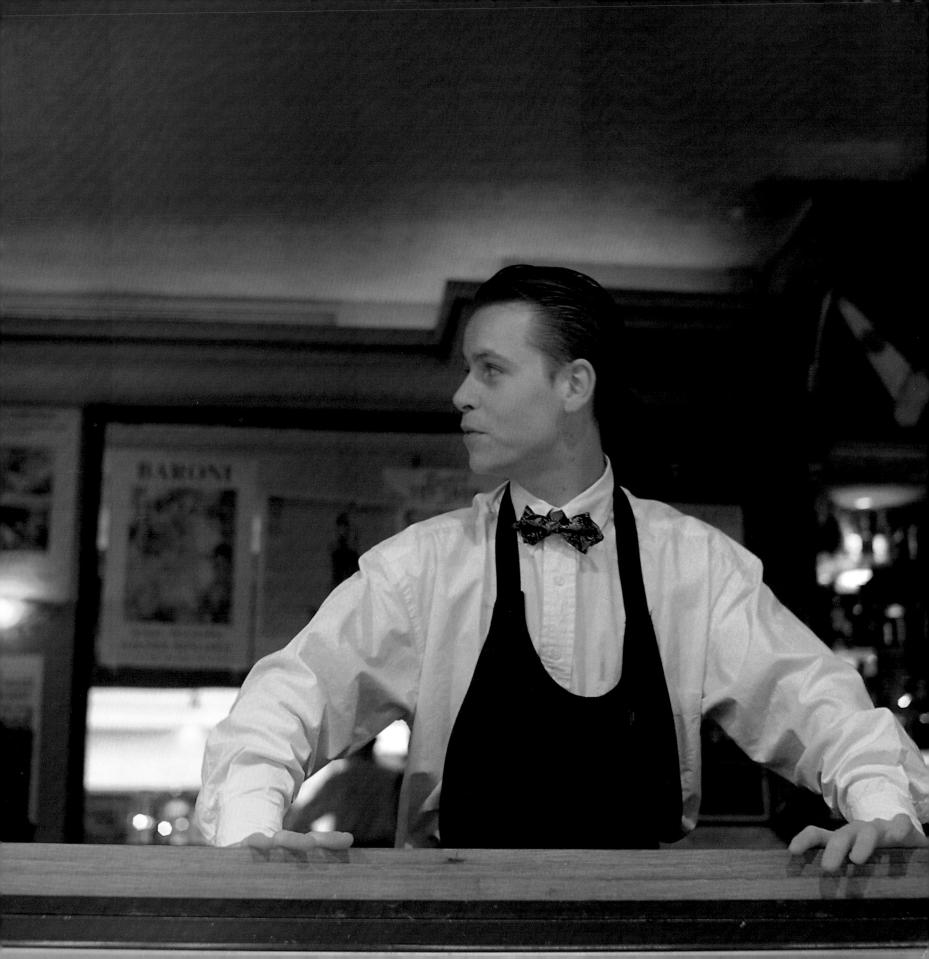

Francesco Procopio, better known as Procope, the Italian who chose this side of the Seine at the end of the seventeenth century, was a restaurateur *avant la lettre* more than *après*. The *rive gauche* , the Left Bank, encompasses several quite different worlds, one intellectual/academic, another high bourgeois/aristocratic, and still another dominated by every fashion and every variety of tourism. In none of these domains could the Left Bank be called the darling of restaurant critics who write guidebooks, because, frankly, the quarter is not one whose cuisine can be judged purely by sampling and tasting. Gastronomically, the area has remained very much the same for the last two centuries, which means it is characterized primarily by literary cafés, bistros catering to students, "artists'" brasseries, and late-night eating places, but there are fewer establishments that gourmets consider "musts" than on the Right Bank.

We should go back where we began, in the era of Procope, when, according to anecdotal history, the *chateaubriand* was invented by a chef in service to the Vicomte François-René de Chateaubriand, the great pioneer of French Romanticism who lived and finally died in a grand *hôtel particulier* in the Rue du Bac. With no confirming evidence that a French version of beef-steak was ever dedicated to the writer, we cannot pay official homage to the "château" on the

L'Arbuci, a lively brasserie in the Rue de Buci, forms part of the restaurant empire of the Blanc brothers, who maintain another fiefdom on the Left Bank at Le Procope, Paris's oldest café, now restored to something like its handsome, seventeenth-century state.

An Aveyronnais who became a small-time *bougnat* (a coal dealer who also served wine and sandwiches) near Les Halles, Marcelin Cazes prospered sufficiently to buy La Brasserie Lipp in 1920. At that time Lipp was a house with a good reputation and a long history, having been established in 1871 by an Alsatian named Lippmann. Only later, however, did the writers of the "lost generation" endow it with global fame.

Left Bank. It would appear equally imprudent to insist that it was in his Rue de l'Université kitchens that the Marquis de Béchameil invented béchamel, the sauce which captivated Carême and outraged the exponents of *nouvelle cuisine.*

More reliable historically speaking is Foyot, long an important restaurant in the Rue de Tournon, whose fame is continuously honored in *sauce Foyot, côte de veau Foyot,* and even *pigeon Foyot.* The first name of the eponymous restaurateur has escaped us, but the rest of it survives because Foyot cooked for King Louis-Philippe before displaying his own name on a café where he became known for having bear cutlets on his menu. The recipes left to posterity were in fact perfected later by the chef/owner Léopold Mourier.

In the spring of 1894, Foyot, an upscale restaurant favored by politicians, became the target of anarchists; their bomb exploded and wounded the Parnassian poet Laurent Tailhade while he was having lunch. Ironically, Tailhade was an admirer of Auguste Vaillant, who had only recently been executed for his attempted bombimg of the Chamber of Deputies. The poet lost an eye, talked endlessly about it, and, seemingly without bitterness, went on to make a career in journalism by expounding a variety of theoretical anarchism. Almost a half-century later, in 1938, the restaurant suffered another attack, this one fatal, when the widening of the Rue de Vaugirard caused the old building to be demolished.

The Rue Mazet, a stump of a street running between the Rue Dauphine and the Rue Saint-André-des-Arts, preserves the memory of Magny, a restaurant often cited by the Goncourts, who dined there regularly from 1862. The philosopher and historian Jean-Paul Aron, mentioned earlier for *Le Mangeur du XIXe siècle,* recalled that the establishment, which merited a couple of stars, owed its literary reputation to "illustrious, rebellious writers, beneficiaries yet transgressors of bourgeois order, participating in the alimentary craze of the nineteenth century. . ." What writer could have resisted sheeps' trotters *à la poulette,* about which one journalist wrote: "Nowhere else is the difficult dish edited with such spirit and such butter"?

On good evenings at Magny, Flaubert cornered Sainte-Beuve to plead the excellence of his work; Turgenev talked about Russian literature; Taine declared that a Parisian is "Parisian more than he is French" and quarreled with Gautier. George Sand listened and spoke little. What could she have said to the author of *Capitaine Fracasse* as he held forth, to anyone who cared to listen, about a diet that had pumped up his pectorals "like those in bas-reliefs"?

Before leaving Magny, which had closed its doors by 1900, we should re-read the Goncourts' journal for the 26 September 1868: "This evening the restaurateur Magny

Marcelin Cazes and his son, Roger, who died in the nineteen-eighties, may be irreplaceable, but Lipp looks as if it will last forever. People go there to be seen, return on Sunday with their families, take late lunches there, and finally dine there very late indeed. The food is neither good nor bad, and nobody seems to care. The coffee, once dreadful, has improved somewhat, and the wonderful Art Deco interior remains untouched. Lipp is, above all, a house with atmosphere. Telling his life story, from the vantage point of 76 years, Marcelin Cazes remembered a pre-war era that seemed only yesterday: "In this modest brasserie, which the father of Léon-Paul Fargue had earlier decorated with ceramic panels, one could already detect the 'club' spirit that has never changed. . . . The weekly periodicals were already talking about Lipp, and Léon-Paul Fargue, a 'pillar' of the house even though a man of sober mien, devoted an entire chapter to it in *Piéton de Paris*."

1 3 1

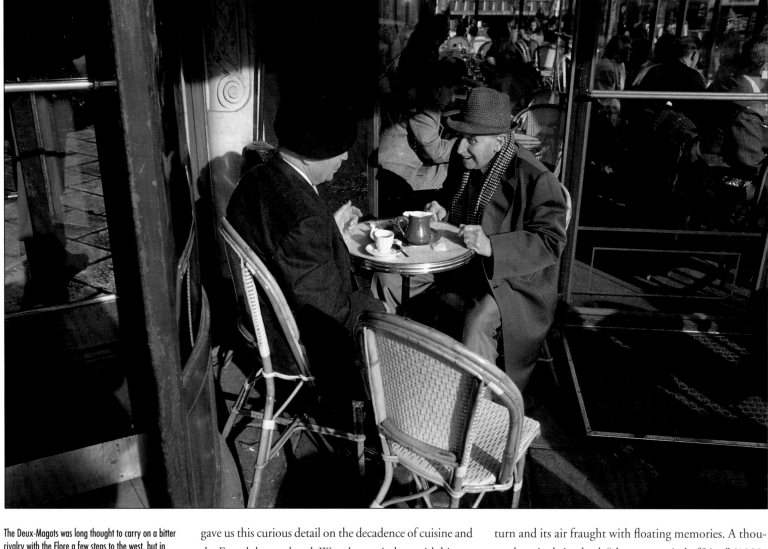

The Deux-Magots was long thought to carry on a bitter rivalry with the Flore a few steps to the west, but in today's depersonalized Saint-Germain-des-Prés, such a problem could scarcely exist, even though the quarter remains charming and lively. The café, whose terrace is supposed to be as "strategic" as the other one, which President Mitterand preferred for his solitary Sunday morning coffee, owes its name to a pair of statuettes representing a somnolent Buddha, both of them fixtures in the dining-room since 1870.

gave us this curious detail on the decadence of cuisine and the French luxury hotel. Were he not in love with his art, he would have followed his confrères and saved 100,000 francs a year on the quality of the butter at the rate of 4,000 francs a years for the twenty-seven years he has been practicing." (At this time a bottle of Château-d'Yquem from a good year was worth around 25 francs.)

Magny yesteryear, Fernande Allard and the great Jacques Manière yesterday, Alain Senderens and Henri Faugeron just a short time ago, Alain Passard and Jacques Cagna today – all have proved and affirmed their imagination, their determination, and their talent on the Left Bank, albeit in different categories. *La grande cuisine* has its place, but the atmosphere here is different from that on the other side of the Seine.

Whatever the category of restaurant, people eating on the Left Bank cannot escape a sense of the area's poly-cultural environment, its ghosts watching them at every

turn and its air fraught with floating memories. A thousand stories bring back "the great period of Lipp" (1920-30, according to Boris Vian), the best years of the Deux Magots (1930-38), during which Montparnasse also remained fashionable, those of the Flore, which flourished during World War II (1938-46), and then the time of the Bar Vert, Tabou, and the apotheosis of the Rue Saint-Benoît, a narrow little street over which the midnight sun rises.

Covering Paris by night would take us somewhat beyond our subject, were it not for Castel, a very exclusive club on the Rue Princesse that for thirty years has been a gathering place for the friends of Jean Castel, a night owl who knows how to drink as well as how to eat. Above its high-decibel basement, Castel combines a very Parisian restaurant and a bistro with a repertoire of fortifying little late-night feasts. In this décor-free *cantine*, the great restaurateurs of Paris are fed *frites*, served by the

slender *filles de chez Castel* or their fleshier mamas. Many chefs and restaurateurs drop in before going on to Rungis: Alain Senderens, Jean Minchelli, who with his brother Paul has reinvented seafood cookery at Le Duc, Olympe and Albert Nahamias, etc.

Saint-Germain-des-Prés, Montparnasse. . . There is no reason to speak of these vital, living quarters in the past tense, for the legends – the Montparnos, the Existentialists – radiate a poetry of nostalgia so powerful that the past seems vividly alive in everyone's memory. The past conjugates very much into the present at Lipp, which has survived Roger Caze and now feeds its customers somewhat less badly than in the past (the coffee has even become drinkable). Up on the Boulevard du Montparnasse the famous Dôme, redone by Slavik, has become a good seafood brasserie, which charges aggressively for its neo-Art Deco décor and the freshness of its fish. A few steps away the immense Coupole has undergone rejuvenation at the hands of the Flo group.

At the eastern end of the Boulevard du Montparnasse, should we venture as far as the alarming Closerie des Lilas, excoriated by the Pudlowski guide and expelled from most of the gastronomic listings? If so, we would seek out the tables so beloved by Ernest Hemingway, at a time when the house was already less respected than during the regime of Paul Fort. In *A Moveable Feast*, however, it was at the Nègre de Toulouse that Hem played with his napkin ring as he examined the duplicated menu: ". . . I read the menu mimeographed in purple ink and saw that the *plat du jour* was *cassoulet*. It made me hungry to read the name."

On the Left Bank it is easy to come up with appropriate quotations, or seek the company of artists and painters more interested in drink than food, more concerned with ambience and sympathetic companionships than meals, or simply without the means to pay for two decent meals a day. Left Bank recollections are rich with scenes set in cafés, brasseries, and nightclubs but poor in anything to do with true restaurants. They have been well described by writers availing themselves of the best pens, the best inks, the worst red wines, and the rawest whiskies. For these witnesses, the "text" is all.

Great and very good restaurants, costly by definition and almost by necessity, are simply less numerous on this side of the Seine, where expense accounts rarely burgeon, even in times of opulence. With one three-star estab-

lishment (La Tour d'Argent), four two-stars (Duquesnoy, Le Divellec, Arpège, and Jacques Cagna) and several one-stars shining like brilliant solitaires, the final total remains small. The situation was comparable a century and more ago. Despite their reputation, Foyot and Magny, the only *grands* amidst a galaxy of uneven establishments, could scarcely hold their own against the great houses of the *grands boulevards*, the Place de la Madeleine, and the Champs-Élysées.

Today it would require a gourmet promenade several kilometers in length were every possibility to be sampled. But for reasons of courtesy and friendship, the outing should include a call on Christiane Massia at her friendly Restaurant du Marché, before moving on to see Roland Magne at his Pactole three *arrondissements* to the east. Christiane, a fine and charming cook in the style of the Landes, plays a leading role in the Parisian syndicate of professional restaurateurs, while Roland, a solid cook with a proud but friendly mustache, is president of the syndicate, to which both the best chefs and the aspiring ones all belong. Beginning at the Relais du Sofitel Sèvres (15th *arrondissement*), one of the most worthwhile of the hotel restaurants, the tour would take in Pierre Vedel (15th), Le Divellec (7th), La Cantine des Gourmets (7th), and

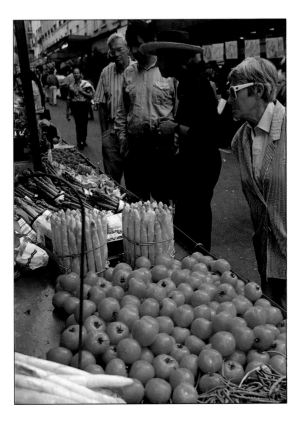

The ancient Rue de Buci counts among the most animated street markets in Paris. One old mansion along this short lane, now restored and occupied by a *traiteur*, served as early as 1729 as the meeting place for the Caveau gastronomic and literary society, which brought together writers, wits, great lords, artists, and *chansonniers*.

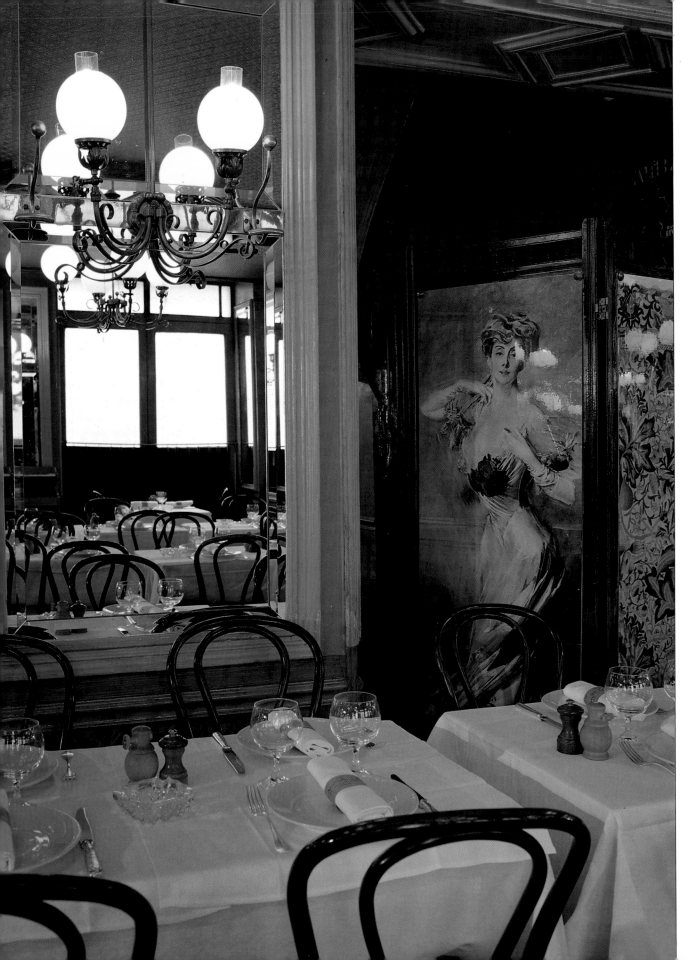

A true/false, or false/true, bistro, Le Bistrot de Paris ages well, gradually assuming its own patina, even though the interior is a pure invention of the contemporary designer Slavik and the restaurateur Michel Oliver. It may yet be registered with the Monuments Historiques! The cuisine also ages well, through rejuvenation whenever needed. The son of Raymond Oliver of Grand Véfour fame, Michel Oliver does not even pretend to manage his own kitchen, having long since learned to depend upon good staff, but he deserves a place in gastronomic history for his invention of the *bistrot-pas-bistrot*, the "bistro" that is actually something else, an elegant and relaxing place where one can eat at less than ruinous prices and in a thoroughly Parisian ambience. In this Oliver *fils* was at least ten years ahead of his colleagues — Cagna, Faugeron, Robuchon, Rostang, Savoy, et al — when he opened the Bistrot de Paris in the Rue de Lille. At a time when gastronomy was less jargon-ridden, who would have thought to use the word "concept"?

Duquesnoy (7th). Beyond a stop at La Cagouille (14th) and Montparnasse 25 (14th) we would soon go beyond the confines of this book. In brief, our meander, from the Invalides to the Boul'Mich, is nothing more than a tease for the taste buds.

At the two-star Arpège in the Rue de Varenne, Alain Passard demonstrates a steely mastery of his profession – no imagination given to extravagance, but a capacity for the unexpected. He succeeded Senderens in an establishment as badly arranged as it was famous. He developed with the utmost meticulousness a "line" of ultra-personal cuisine; this allowed him to indulge his originality even in the most conservative dishes. And he introduced a severely contemporary décor to replace the overcharged mess he inherited. Critics, still searching for the right word, called it "minimalist," though not necessarily with enthusiasm. Generally, they were more interested in the new flavors than in the new interior.

Passard, still on the right side of forty, is the youngest among the "confirmed" great chefs of Paris. Rewarded with Gault Millau's 19/20, as well as a pair of Michelin stars and a terrific press, he has lived up to his promise and promises still more. While still very young, this gifted Breton began under Kerever at Liffré near Rennes and joined Senderens at L'Archestrate in 1977, remaining there until 1979. Then he went off on a tour, which took him first to Boyer in Rheims and then to the Casino d'Enghien, where he became head chef. In 1982, he won

Every tea in the world, at least all the best ones, can be had at Mariage Frères in the Rue des Grands-Augustins. Teas by the dozen, in hundreds of varieties and blends, as well as teapots, candies, jellies, and books. This shop is the offspring of the beautiful parent establishment in the Rue du Bourg-Thibourg near the Hôtel de Ville, and it has been on the Left Bank for some years. Housed in a very old building, the shop includes a tearoom as well.

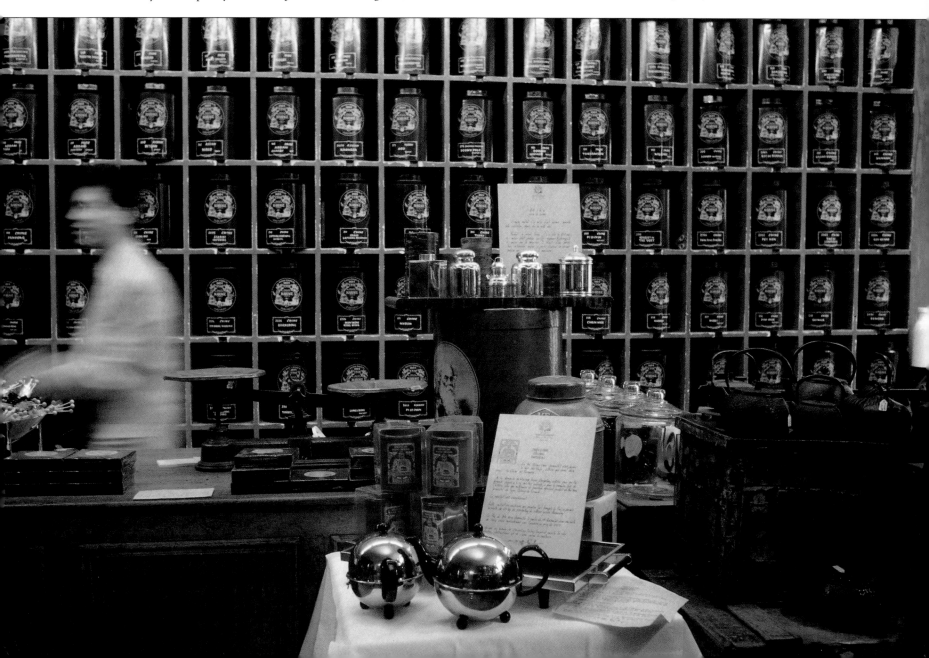

No, this curious presentation
has not received the final
signature of Alain Passard!
And the photographer does not
have a fetishistic fixation
on table linens. He simply had to
work rapidly, without upsetting
either kitchens or dining room,
to make sure the red did not turn too
cold and the yellow grow too warm.

Passard, quite simply
one of the very best within
today's crop of great chefs,
proves his originality at
dessert time just as much as
at any other stage in a meal
at Arpège in the Rue de Varenne.

A case in point is this sober
but vibrantly colored dish.
Tomatoes stuffed with mint, candied
fruits, strawberries, orange peel,
and lemon are caramelized in a
light syrup for an hour in an oven.
Served with freshly churned
vanilla ice cream, the dessert is
extremely popular among regulars
at Arpège, which keeps it on the menu
all year round. Tomates aux douze
saveurs *is best consumed with a*
homely Jurançon.

Arpège, a small *grand restaurant* in the Rue de Varenne, is the creation of Alain Passard, who has won two Michelin stars for his beautifully precise and poetically imaginative reinterpretation of the *grand bourgeois* manner. The Benjamin of Paris's super-chefs, this young virtuoso of fine-tuned flavors vaulted into the forefront of professional cookery at the beginning of the nineteen-nineties. What will they be saying of him in the year 2000? The man is easy to follow, at least for culinary journalists and the writers of guidebooks, but even as these commentators outdo one another in their praise, they still find more to heap upon their talented subject.

a Michelin star and a second one in the following year. Just when he was thinking of moving to Belgium, Passard learned that the Argonne, the old Archestrate, was to be sold. He took possession of the premises at 84 Rue de Varenne on 14 October 1986, and renamed the restaurant "Arpège" – broken chord A permitted him to keep the restaurant's monogrammed china in service.

At La Ferme Saint-Simon, in the Rue Saint-Simon, near France's government ministries and the Musée Rodin, Francis Vendenhende, now with his Manoir in the 17th *arrondissement*, keeps control of his popular establishment. The Ferme is often full to capacity with a civilized clientele delighted with the pretty, rustic cuisine served in an elegantly bucolic setting. More than

*Candied
tomatoes with
a dozen
different
spices by
Alain Passard*

*Arpège
84 Rue de Varenne
Paris VII*

cuisine burst upon the scene, Oliver Junior responded with his clever reinterpretation of the bourgeois repertoire. He also reinvented conviviality and blazed the trail into the kind of authentically inauthentic bistro so adored by the most fashionable female clientele.

It was at the Bistro de Paris that Slavik virtually created his distinguishing style, which left its mark on the nineteen-seventies and even on the nineteen-eighties. Will Michel Oliver's bistro ever be classified, like the Véfour? It was and remains indicative of an evolution in the restaurant business. At a time when bistros/restaurants/rôtisseries proliferate, their spread fueled by an economic crisis that encouraged less prolific spending, it would be just as well to remember that Oliver was ten or fifteen years ahead of the times.

Jacques Cagna still looks amazingly youthful, his evident juvenility even more pronounced now that he has passed fifty. The explanation may lie in the success of his first "annex," the friendly Rôtisserie d'en Face, and the launch of the Rôtisserie d'Armaillé on the other side of the Seine. An inspired chef, Cagna proved his talent in the 17th *arrondissement,* broke free at the end of the seventies, then crossed the Seine and captured his well-earned two stars. His associate in the business was and remains his sister, Annie Logereau. The pair established their *grand* restaurant very elegantly in a distinguished old house at the corner of two narrow streets, the Rue des Grands-Augustins, where Picasso had his live-in studio in the nineteen-thirties, and the Rue Christine, where Gertrude Stein and Alice B. Toklas, another formidable cook, had their residence during more or less the same years. The "protected" façades behind which Cagna holds forth were part of the medieval Collège des Charités-Saint-Denis, founded under Louis XI (Saint Louis).

Ancient stones, youthful cuisine, the heart of Old Paris. Having reached the end of the book, we leave the table on an inevitable note: "to be continued." Other gourmet promenades to follow? This will be decided on the terrace or in the calm dining-rooms of Martin Cantegrit's Récamier. Set back from the heavy traffic of Sèvres-Babylone, this is a restaurant deeply identified with publishing, serious filmmaking, the discriminating palates of the 7th *arrondissement,* and high culture. The civilized clientele remains faithful not only for the savory bourgeois fare but also for Cantegrit's masterpiece: a rich and balanced wine list that is intoxicating merely to read.

Jacques Cagna manages to appear serious despite his look of smooth-faced eternal youth. During mealtime, the two-star chef steps out of his *grande cuisine* restaurant long enough to greet his customers in one or the other of his *succursales* or "branches": La Rôtisserie d'en Face, which is just that in the Rue Christine, and the more recent Rôtisserie d'Armaillé, now running smoothly on the Right Bank near the Étoile and likely to equal the success of its Left Bank twin. The very popular older establishment attracts a mixed clientele rather like the most agreeable restaurants of Lyons, Strasbourg, and Nice.

a fashionable bistro, the Ferme is a relaxed restaurant where even the elbowing is polite. Four numbers along the same street, L'Oeillade, an even more popular revivalist bistro, offers a long menu of flavorsome fare at very palatable prices. Extremely simple yet refined, L'Oeillade perfectly exemplifies the unpretentious Parisian restaurant which has an extended following of happy regulars.

But there is only one Bistro de Paris, the bistro at 33 Rue de Lille, belonging to Michel Oliver. A remarkable cook, an enterprising restaurateur, a true Jack-of-all-trades, this son of Raymond Oliver might have done even better than his father had he succeeded him at the Grand Véfour. History, however, is not written with "ifs". When *nouvelle*

Au Sauvignon, which at the top of the Rue des Saints-Pères could hardly be better situated, is a good if slightly ordinary bistro for outsiders as well for regulars. A few wines (the list is relatively short) and honest *tartines* with *charcuterie* or with cheese. Plus normal prices for the quarter, not quite at the student level and certainly not "working class."

BIBLIOGRAPHY

- Les Années Flo. Published in 1986 to mark the centenary of the Flo restaurants.

- Aron, Jean-Paul. Le Mangeur du XIXe siècle. Paris, 1973.

- Costang, Raymond. Parlez-moi du Fouquet's. Paris, 1989.

- Courtine, Robert. La Vie parisienne: cafés et restaurants de boulevards 1814-1914. Paris, 1985.

- Delpal, Jacques-Louis. Paris. Paris, 1975.
—Paris aujourd'hui. Paris, 1975, 1977.
—Paris jour et nuit. Paris, 1977.
—Paris la nuit. Paris, 1969-73.
—Saveurs de France. Paris, 1986.

- Desnoiresterres, Gustave. Grimod de La Reynière et son groupe. Geneva, n/d.

- Gault, Henri, and Christian Millau. Guide gourmand de la France. Paris, 1970.

- GaultMillau. The Best of Paris, 6/e. Translated and adapted by Sheila Mooney. Los Angeles, 1995.

- Girveau, Bruno. La Belle Époque des cafés et des restaurants. Paris, 1990.

- Guide Michelin France. Paris, 1995.

- Guide Pudlowski de Paris Gourmand. Paris, n/d.

- Kaplan, Stephen L. Provisioning Paris: Merchants and Millers in the Grain and Flour Trade during the Eighteenth Century. Ithaca, 1984.

- Lang, Jenifer Harvey, ed. Larousse Gastronomique. NY, 1988.

- Mennell, Stephen. All Manners of Food: Eating and Taste in England and France from the Middle Ages to the Present. Oxford and NY, 1993.

- Les Restaurants dans le monde et à travers les âges. Grenoble, 1990.

- Restaurants of Paris. Gallimard (Nouveaux-Loisirs) Guide translated and published in the USA by Alfred Knopf. 1994.

- Rodil, Louis. Antonin Carême de Paris. Paris, 1980.

- Shaw, Timothy. The World of Escoffier. NY, 1995.

- Terrail, Claude. Ma Tour d'Argent. Paris, 1974.

- Wells, Patricia. The Food Lover's Guide to Paris. NY, 1993.

- Wijnen, Gaston. Discovering Paris Bistros. NY, 1991.

A SMALL LIST OF (GOOD) ADDRESSES

To help readers deal with their hunger, at the end of gourmet promenades punctuated by all too few rest periods for leisurely consumption, Jacques-Louis Delpal has opened (but only slightly) his little black book of "good addresses."
The number of asterisks corresponds to the average price (in French francs) of an à la carte meal with an inexpensive wine, on a scale of 1 to 4. The page numbers refer to those in the main chapters of Gourmet Guide to Paris:
◆◆◆◆ 600 FF and above
◆◆◆ 400-599 FF
◆◆ 250-399 FF
◆ less than 249 FF

◆◆ **Ambassade d'Auvergne**
22 Rue du Grenier-Saint-Lazare, III, p. 33.

◆◆◆◆ **Les Ambassadeurs, Hôtel de Crillon**
20 Place de la Concorde, VIII, p. 52.

◆◆◆◆ **L'Ambroisie**
9 Place des Vosges, IV. This splendid restaurant offers the powerful, vividly flavored, yet subtle cuisine of Bernard Pacaud in a sumptuous setting (the seventeenth-century Hôtel de Luynes) reigned over by Danièle Pacaud. Excellent value.

◆◆◆◆ **Amphyclès**
76 Avenue des Ternes, XVII. A small but well-bred restaurant with a fine, precise, colorful cuisine by Philippe Groult, a chef trained under Joël Robuchon and well worth following.

◆◆◆◆ **Apicius**
122 Avenue de Villiers, XVII. Harmonious, refined décor, warm, well-ordered ambience, and the fabulous cooking of Jean-Pierre Vigato, who has enjoyed an exceptionally good press during the last few years.

◆◆ **L'Arbuci**
25 Rue de Buci, VI, p. 128.

◆◆◆◆ **Arpège**
84 Rue de Varenne, VII, p. 135.

◆◆ **Baumann Marbeuf (L'Étage Baumann)**
15 Rue Marbeuf, VIII, p. 84.

◆◆◆◆ **Beauvilliers**
52 Rue Lamarck, XVIII, p. 72.

◆◆◆ **Benoît**
20 Rue Saint-Martin, IV, p. 18.

◆◆ **Bertie's**
1 Rue Léo-Delibes, XVI, p. 45. The charm of an English club, but better than in London.

◆◆◆ **Gérard Besson**
5 Rue du Coq-Héron, I. A house of discreet elegance, classic French cuisine, and the personal inventions of Gérard Besson, a professional of the old school who cooks with exemplary reliability.

◆◆ **Le Bistrot d'à Côté**
10 Rue Gustave-Flaubert, XVII, p. 99.

◆◆ **Le Bistro d'à Côté**
16 Boulevard Saint-Germain, VI, p. 99.

◆◆ **Le Bistrot de l'Étoile-Troyon**
13 Rue Troyon, XVII, p. 94.

◆◆ **Le Bistrot de Paris**
33 Rue de Lille, VII, p. 34.

◆◆ **Le Bistrot du Sommelier**
97 Boulevard Haussmann, VIII, p. 19.

◆-◆ **Le Boeuf sur le Toit**
34 Rue du Colisée, VIII. One of the great successes of Jean-Paul Bucher of the Flo group. Jam-packed, open all year and late at night, very Parisian. Wide-ranging menu, correctly prepared food, at decent prices.

Café Beaubourg
43 Rue Saint-Merry, IV, p.29.

Café Costes
4-6 Rue Berger, I, p. 25.

◆◆ **Café Marly**
Richelieu Wing, Musée du Louvre, I, p. 43.

◆◆◆◆ **Jacques Cagna**
14 Rue des Grands-Augustins, VI, p. 136.

◆◆◆ **La Cagouille**
12 Place Brancusi, XIV. Modern décor, a wide, deep terrace, blackboard menu, the freshest of fish, good wines, and excellent brandies.

◆◆◆◆ **Le Carré des Feuillants**
14 Rue de Castiglione, I, p. 35.

◆◆◆ **Charlot**
81 Boulevard de Clichy, XVIII, p. 73. "Le Roi de coquillages" (the King of Shellfish).

◆ **Chartier**
7 Rue du Faubourg-Montmartre, IX, p. 11.

◆◆◆◆ **Chiberta**
3 Rue Arsène-Houssaye, VIII. Gracefully aged contemporary décor, suave, inventive cuisine, and a clientele from le Tout-Paris.

◆◆◆ **Clos Longchamp-Méridien**
81 Boulevard Gouvion-Saint-Cyr, VII. Large, banana-shaped dining-room for the local unit of a large hotel chain. Sparkling cuisine in which flavors of the Mediterranean combine with those of Asia, prepared by the rigorous and talented Jean-Marie Meulien. Wine list by Didier Bureau, a prize-winning sommelier who knows every vineyard, including those off the beaten track.

◆◆◆ **Clovis**
4 Rue Bertie-Albrecht, VIII. Soft, salmon-colored, but somewhat impersonal setting (Sofitel Paris-Arc de Triomphe), attentive service, and a clientele made up substantially of businessmen. Fine, precise, flavorsome cuisine by Dominique Boué, a little noted chef but one of the best among those working in Parisian hotels.

◆◆◆ **Conti**
72 Rue Lauriston, XVI. Well-ordered Italian restaurant serving zesty food cooked by Michel Ranvier, one of the very best French chefs specializing in Italian cuisine.

◆◆ **Copenhague/Flora Danica**
142 Avenue des Champs-Élysées, VIII, p. 45.

◆◆ **La Coupole**
102 Boulevard du Montparnasse, XIV, p. 10.

◆◆◆◆ **Drouant**
18 Rue Gaillon, II. The renovated old restaurant once frequented by the Goncourts. Luxurious Art Deco dining-room and better than decent food. Le Café, the downstairs annex, is simpler, less expensive, pleasantly distinguished, and popular at lunch with businessmen and in the evening with theater-goers.

◆◆◆ Duquesnoy
6 Avenue Bosquet, VII. A pleasantly bourgeois restaurant serving the sprightly cuisine of the ever reliable Jean-Paul Duquesnoy.

◆◆ Chez Edgard
4 Rue Marbeuf, VIII, p. 87.

◆◆◆ Les Élysées du Vernet
25 Rue Vernet, VIII. A large, quiet hotel restaurant with a glass ceiling from the Belle Époque. Generously spaced tables and sunny, often rousing, and sometimes brilliant cuisine by chef Bruno Cirino, a Provençal who cooks like one, with style and invention.

◆◆◆◆ L'Espadon
Hôtel Ritz, Place Vendôme, I, p. 40.

◆◆◆ Faucher
123 Avenue de Wagram, XVII. Bright, ample dining-room with well-spaced tables and a vivid, modern cuisine prepared by Gérard Faucher, a chef given to the occasional touch of quiet daring.

◆◆◆◆ Faugeron
52 Rue de Longchamp, XVI, p. 100.

◆◆◆ La Ferme Saint-Simon
6 Rue Saint-Simon, VII, p. 134.

◆◆ La Fermette Marbeuf
5 Rue Marbeuf, VIII, p. 88.

◆◆◆ Jean-Claude Ferrero
38 Rue Vital, XVI, p. 94.

◆◆ Brasserie Flo
7 Cour des Petites-Écuries, X. An archetypal Alsatian restaurant and the "mother house" of the Flo group, with a period décor and a clientele very much of today. Delicious choucroute, carafes of vivacious Riesling, and reasonable tariffs, like all the constituent members of the Flo group.

◆◆◆-◆ Fouquet's
99 Avenue des Champs-Élysées, VIII, p. 91.

◆-◆ Chez Fred
190 bis, Boulevard Pereire, XVII. A charmingly simple "bistro" in a chic quarter offering honest Lyonnais cookery well prepared by Fred, a real pro.

◆◆ Chez Georges
273 Boulevard Pereire, XVII. A large restaurant/bistro long since grown into something of a neighborhood institution. Savory, deeply bourgeois cuisine without a trace of invention but copiously portioned and well served.

◆-◆ Goldenberg
69 Avenue de Wagram, XVII. The best of the Goldenberg restaurants, which means Jewish cuisine of Central Europe, generously served and finally a bit heavy. Picturesque Yiddish atmosphere full of humor and nostalgia.

◆◆◆-◆ Goumard-Prunier
9 Rue Duphot, I. Rather than weep over the mostly lost Majorelle décor, concentrate on the fish, simply prepared so as not to interfere with the pristine freshness and perfection of the day's catch.

◆◆-◆ Le Grand Chinois
6 Avenue de New York, XVI. Several excellent Chinese dishes, both classic and little known, together with a selection of good wines.

◆◆ Le Grand Louvre
Musée du Louvre (under the Grande Pyramide), I, p. 43.

◆◆◆◆ Le Grand Véfour
17 Rue du Beaujolais, I, p. 38.

◆◆◆ Le Grenadin
44-46 Rue de Naples, VIII. Modern but cozy and intimate, with a beautiful, well-balanced cuisine of sharp, unusual flavors by Patrick Cirotte.

◆◆ Le Grizzli
7 Rue Saint-Martin, IV, p. 30.

◆◆◆◆ Jules Verne
Eiffel Tower, VII, p. 125.

◆◆ Julien
16 Rue du Faubourg-Saint-Denis, X. A glorious 1880 interior crowded with people consuming standard brasserie fare late into the night. A prize venue within the Flo group.

◆◆◆◆ Lasserre
17 Avenue Franklin D. Roosevelt, VIII, p. 82.

◆◆◆◆ Le Divellec
107 Rue de l'Université, VII. An elegant restaurant with a classy, high-profile clientele devoted to the suave seafood cookery of Jacques Le Divellec, who serves only the choicest and freshest of what the waters of the world have to offer.

◆◆◆◆ Ledoyen
Carré des Champs-Élysées, VIII, p. 82.

◆◆ Lipp
151 Boulevard Saint-Germain, VI, p. 130.

◆◆◆◆ Lucas-Carton
9 Place de la Madeleine, VIII, p. 60.

◆◆◆ Le Manoir de Paris
6 Rue Pierre-Demours, XVII, p. 95.

◆◆◆◆ Maxim's
3 Rue Royale, VIII, p. 53.

◆◆◆ Mercure Galant
15 Rue des Petits-Champs, I. Fine old restaurant from the late nineteenth century offering classic cuisine prepared with enthusiasm and amplitude.

◆◆◆ Chez Michou
80 Rue des Martyrs, XVIII, p. 75.

◆◆◆ Morot-Gaudry
8 Rue de la Cavalerie, XV, p. 126.

◆-◆ Nahmias-Olympe-Bassano
17 Rue Jean-Giraudoux, XVI. Albert Nahmias's new bistro is not only simple, friendly, and very Parisian but also quite moderately priced.

◆◆ La Niçoise
4 Rue Pierre-Demours, XVII, p. 95.

◆◆ L'Œillade
10 Rue Saint-Simon, VII, p. 134.

◆◆-◆ Au Pactole
44 Boulevard Saint-Germain, V, pp. 119, 133. The onetime rather cramped fiefdom of Jacques Manière, this restaurant, under Roland Magne and his wife Noëlle, has gained both a new décor and additional space. Magne is not only an excellent, imaginative chef but also president of the Syndicat Parisien des Restaurateurs de Métier.

◆◆◆ Chez Pauline
5 Rue Villedo, I. André Genin remains loyal to the bistrot grand bourgeois tradition, thereby assuring the success of this old-fashioned house. Still, the cookery is relatively light and well thought out.

◆◆◆ Pavillon Puebla-Christian Vergès
Parc des Buttes-Chaumont, XIX. This astonishing restaurant is housed in a former hunting lodge built for Napoleon III. The beautiful terrace extends into the verdure of an enchanting, very varied park. The smiling, sun-struck cuisine is at its best when the chef, Christian Vergès, allows his Catalan soul to have its way.

◆◆◆ Le Petit Colombier
42 Rue des Acacias, XVII. A peacefully rustic "heirloom" house inherited by Bernard Fournier, who does everything, from marketing to cooking, to ensure the survival of France's classic cuisine bourgeoise. The beautiful restaurant has now spread upstairs and even into a second building.

◆◆ Au Petit Riche
25 Rue Le Pelletier, IX, p. 19.

◆◆◆ Chez Philippe
106 Rue de la Folie-Méricourt, XI, p. 15.

◆◆◆ Au Pied de Cochon
6 Rue Coquillière, I, p. 27.

◆◆◆ Au Pressoir
257 Avenue Daumesnil, XII, p. 57.

◆◆◆◆ Le Pré Catelan
Route de Suresnes, Bois de Boulogne, XVI. A Second Empire landmark magnificently restored and then revitalized by the excellent cookery of Roland Durand. The huge restaurant set within a wood is magical in summer but also in winter, when the fireplace crackles with a warming blaze.

◆◆ Le Procope
13 Rue de l'Ancienne-Comédie, VI, p. 129.

◆◆◆◆ Prunier-Traktir
16 Avenue Victor-Hugo, XVI, p. 99.

◆◆◆ Récamier
4 Rue Récamier, VII, p. 136.

◆◆◆ Le Relais de Sèvres-Sofitel
8-12 Rue Louis-Armand, XV. Prestigious, elegantly modern, flagship restaurant belonging to the Sofitel chain, with a serious chef always in charge of the kitchen.

◆◆ Le Relais du Parc
55-57 Avenue Raymond-Poincaré, XVI, p. 105.

◆◆◆ Le Restaurant du Marché
59 Rue de Dantzig, XV. An out-of-the-way, convivial restaurant, with an exuberantly "rustic" décor and the generous bourgeois or Landais cuisine of Christiane Massia, supported in the dining-room by her husband, Michel Massia. Thoroughgoing Parisians, the Massias are destined to find their way into central Paris, almost cetainly on the Left Bank.

◆◆ Il Ristorante
22 Rue Fourcroy, XVII. Tasty Italian fare in the Venetian manner.

◆◆◆◆ Joël Robuchon
59 Avenue Raymond-Poincaré, XVI, p. 101.

◆◆◆◆ Michel Rostang (and 'bistros')
20 Rue Rennequin, XVII, p. 96.

◆◆◆◆ Guy Savoy (and 'bistros')
18 Rue Troyon, XVII, p. 99.

◆◆ La Rôtisserie d'en Face
2 Rue Christine, VI, p. 138.

◆ La Rôtisserie du Beaujolais
19 Quai de la Tournelle, V, p. 112.

◆◆◆ Sormani
4 Rue du Général-Lanrezac, XVII. Pascal Fayet, though a Frenchman, prepares what may be the best Italian cuisine in Paris, traditional but also boldly novel and equal at least to that of Conti. The entire scene is elegance itself.

◆◆◆ La Table d'Anvers
2 Place d'Anvers, IX. Here, in a very pleasant restaurant at the foot of Montmartre, the chef, Christian Conticini, lets his imagination run riot, generally producing gastronomic wonders but sometimes misfiring. The rather uneven desserts - some of them superb, others surprising - are the work of the chef's brother, Philippe.

◆◆◆◆ Taillevent
15 Rue Lamennais, VIII, p. 88.

◆◆-◆ Tan Dinh
60 Rue de Verneuil, VII, p. 44.

◆◆ Terminus Nord
23 Rue de Dunkerque, X, p. 77.

◆◆◆◆ La Tour d'Argent
15-17 Quai de la Tournelle, V, p. 113.

◆◆ Le Train Bleu
Gare de Lyon, XII. Inaugurated in 1901 by President Loubet, this buffet/restaurant upstairs at the Gare de Lyon retains its Belle Époque grandeur, in size as well as in the painted, gilded lavishness of its Art Nouveau décor. The menu is extensive, the food decent, and the service spirited.

◆◆◆ Au Trou Gascon
40 Rue Taine, XII, p. 16.

◆◆ Pierre Vedel
19 Rue Duranton, XV. Bourgeois cuisine with a Languedoc twist served in very generous portions by Pierre Vedel, a true Parisian from Sète on the Mediterranean coast.

◆◆◆ Venantius
16 Boulevard Haussmann, IX. In its opulent Belle Époque venue at the Hôtel Ambassador, this restaurant boasts extremely formal service and the venturesome, eclectic traditionalism of a very talented chef, Gérard Fouché.

◆◆◆◆ Le Vivarois
192 Avenue Victor-Hugo, XVI, p. 100.

◆◆◆ Chez Vong
232 Rue des Halles, I. Asian cuisine, for the most part good, served in an intelligently "exotic" setting.

◆◆ Yvan
7 bis Rue Jean-Mermoz, VIII, p. 87.

A SMALL LIST OF (GOOD) ADDRESSES